anne gould hauberg

fired by beauty

anne gould hauberg

fired by
beauty

barbara johns

University of Washington Press
SEATTLE AND LONDON

© 2005 University of Washington Press
Printed in China
12 11 10 09 08 07 06 05 5 4 3 2 1

UNIVERSITY OF WASHINGTON PRESS
P.O. Box 50096, Seattle, WA 98145
www.washington.edu/uwpress

Library of Congress
Cataloging-in-Publication Data

Johns, Barbara.

Anne Gould Hauberg : fired by beauty /
Barbara Johns. — 1st ed.

p. cm.

Includes bibliographical references and
index.

ISBN 0-295-98569-0 (hardback : alk.
paper)

1. Hauberg, Anne Gould. 2. Art
patrons—Washington (State)
—Seattle—Biography. 3. Women
philanthropists—Washington (State)
—Seattle—Biography. 4. Seattle
(Wash.)—Biography. I. Hauberg,
Anne Gould. II. Title.
N5220.H294J64 2005
709'.2—dc22 2005021096

[B]

5-8

9-12

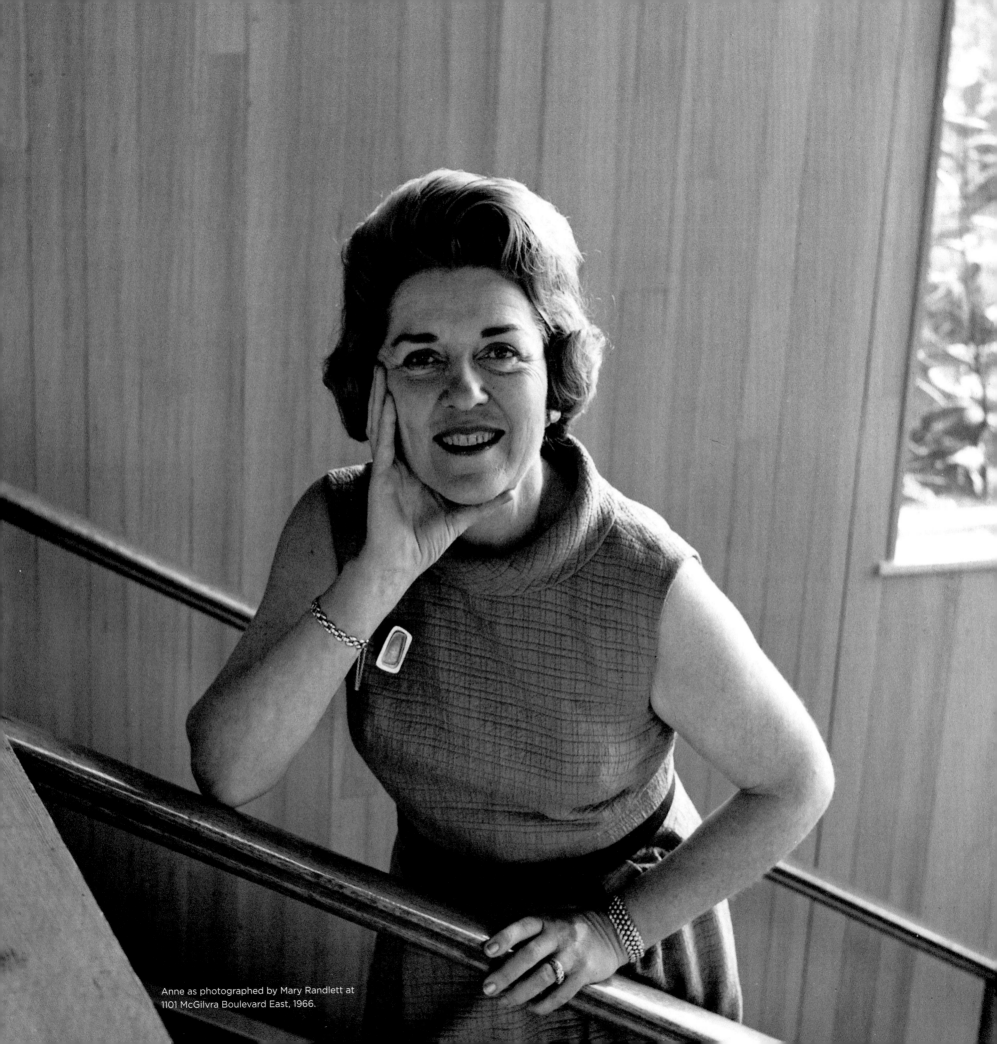

Anne as photographed by Mary Randlett at
1101 McGilvra Boulevard East, 1966.

an appreciation

by jack lenor larsen

Although I've been so fortunate to have known some of the Seattle women who gave Puget Sound its special élan, none has had so broad an influence as Anne Hauberg. Why? Is it only her cockeyed optimism, her conviction that most aspects of life can (should) be better? Or that wonderful amenities are deservedly ours—if not for the asking, ours with some determination in reaching out for them?

While Martin Luther King is remembered for "I have a dream," Anne has many dreams, always for us. While Northwest artists (in the broadest sense of all who create) have always been supported by women, Anne refocuses support to our benefit: "Artists and craftmakers aid us!" Through the artists' vision our insights will clear, our understanding deepen. Once this comprehension has heightened our awareness, so will our sensitivity and sensibility. Or, as Anne explains, this will "help our left brain inform the right." To her, all things bright and beautiful are quite possible. We are only to know this, and collectively reach out for them. All of us! She doesn't only address those few in high places, but all who will listen—and not from a podium, but through personal urging. And sometimes we

do hear, as in the case of the monumental landscaping she envisioned for a raw new Route 5, or building Pilchuck as the world's best glass school.

Then there were those days and evenings when she opened the splendid house Roland Terry had designed above the Tennis Club facing the mountains beyond the lake. Here she shared an enlightened handling of space, view, materials, lighting—and above all, craftsmanship. Before Seattle really had galleries, Anne exhibited in this house art in many mediums. Here some of us saw for the first time art At Home.

Even more spectacular was Anne's approach to entertaining, usually in alliance with Joe McDonnal, who exceeds others in thinking of meals in terms of Happenings geared to please every sense, especially surprise. With lighthearted abandon Joe and Anne cooked up culinary events never before seen or soon forgotten. And, yes, of course, such fetes liberated our imaginations to glimpse other wonders made available through such simple means as empty flowerpots or clear plastic boxes. We considered for a moment taking up Anne's magic wand, to stop being butterfingered and tongue-tied, and to Live! Yes, this is what we had always wanted—a Fairy Godmother!

Crazy Annie! Never once have I heard her bridle at such an accusation. Prophets expect no less and, fortunately, such jibes didn't stop Galileo, nor Edison, or the Wright brothers either. Instead, she admitted to having become "a pillar."

How many decades ago was it that, here in New York, I first heard Anne share her dreams of an art space at the Hauberg tree farm? Sometimes she would speak of a Mark Tobey Museum to share Mark's veiled views of an inner, Bahá'í reality. Other times her vision of an art/people/nature place would be more general, but still remote from the everyday, especially from cars. Instead, there would be people movers; she had conferred with some great minds about it!

Almost four decades ago the artist Dale Chihuly, having so successfully learned to blow glass, came to me with the idea of a new glass school near Seattle—in tents! True, Frank Lloyd Wright's school, Taliesin West, was under canvas, but in the Arizona desert. I suggested to Dale his talking to Anne Hauberg about this. She had long harbored such a dream, if a less specific one. I am happy to have been the conduit, but it was Anne's dream. And her vision ignited the spark in John Hauberg, letting him enter deeply into the world of art and artists, with the means and conviction to realize this great school, major collections, and a downtown art museum with broadly based membership.

Anne Gould Hauberg's world remains wider than his, more inclusive, inviting us all onto a path higher than we know. Not a narrow, restrictive one and not libertine but certainly Free, with our feet still on the ground but heads above the clouds—Come along!

acknowledgments

by barbara johns

This book is planned for publication by the time of the eighty-eighth birthday of its subject, Anne Gould Hauberg. It is a special privilege and challenge to write the story of a living person—to be allowed into her life, to be entrusted with the story, and to know that many people have known Anne longer and more intimately than I and might tell the story differently. It has been my role to piece together the events of a lifetime, to read broadly and listen well, and to find the balance I believe is justified. Both Anne and the book's advisory committee have allowed me this author's prerogative.

I offer my heartfelt personal thanks to the many people who have contributed to this book. Anne is the first among them. She was always warmly welcoming, however formally or informally we met, and each time I marveled at the care in appearance that was second nature to her, as was the eye-openingly colorful way she assembled the day's clothing and jewelry. It was a care that seemed to embody the optimism she has determinedly brought to her life. "Enough of the past," she would occasionally say during our conversations. "I'm more interested in the future." We had known one another in a professional context for a number of years before this project began, but I profoundly value the much deeper way of knowing that writing the story has offered.

Just as Anne has never stopped making connections, many people have been drawn together through the process of making this book. It has been a great pleasure to work with Jack Lenor Larsen, who wrote the spirited "Appreciation" of his longtime friend. From beginning to end, this book was guided by Priscilla Beard. Having presented the idea to the University of Washington Press, she led a dedicated, hard-working advisory committee who joined her in launching the project and raising the funds to support it. They are

Nancy Alvord, Polly Friedlander, Nadine Kariya, Greg Robinson, Leroy W. Soper, Tom Wilson, and Virginia Wyman, who, along with Priscilla, gave generously of themselves to the book. Throughout the writing process, Jean Davies Okimoto offered support of a most meaningful kind, serving as an editorial consultant and providing her writer's perspective to a work in progress, and I thank her warmly.

My access to papers still in personal hands was made possible through the exceptional kindness of several people. Fay Hauberg Page, serving as executor of the estate of her late father, John H. Hauberg, Jr., shared stories generously and gave me free use of the papers that he had kept to the end. She set the example when we met before the book began, and brought with her a bag full of Anne's letters to John during World War II. Corrine Reinbold, operations manager of the Pacific Denkmann Company, offered me unrestricted access to John's personal journals. For help of many kinds, from making appointments to tracking papers, I am indebted to Jeanette Whiteman, Anne's cheerful and very practical assistant. Among the papers in Anne's possession are the interviews and the manuscript of a book about her life that Margaret Marshall was commissioned to write in 1995; the manuscript was never published, but I appreciate having been able to draw upon Marshall's work. Tina Oldknow, author of the book *Pilchuck: A Glass School*, provided me transcripts of the interviews she conducted during her work a decade ago. And Sue Hauberg, Anne's younger daughter, patiently explained to this novice the meaning of the ribbons and awards that are the results of her competitive horsemanship.

The people who graciously agreed to be interviewed and answer questions as part of the research for this book make up a long list, but each made a distinctive contribution that helped shape the story. They are Jennifer Annable, Patricia M. Baillargeon, Fred Bassetti, Priscilla Beard, Toby Beard, Wyn Bielaska, T. William Booth, Thomas L. Bosworth, Cynthia Burke, R. M. Campbell, Dale Chihuly, Mary Cozad, Dee Dickinson, Arthur Erickson, Elaine Ethier, Kay Eyre, Marilyn Fite, Donald I. Foster, Gretchen Gould, John and Margaret Gould, Agnes Haaga, Michael R. Halleran, LaMar Harrington, Sue Bradford Hauberg, Marion Fay Henny, Diane Katsiaficas, Joey Kirkpatrick and Flora Mace, Jack Lenor Larsen, Alan Liddle, Eileen and Wendell Lovett, Myrene McAninch, Joe McDonnal, Kris Molesworth, James Minson, Benjamin Moore, Jeffrey Karl Ochsner, Fay Hauberg Page, Nathaniel Blodgett Page, Grace Park, Anne Parry, Mimi Pierce, Corrine Reinbold, Lorna Richards, Alice Rooney, Gladys Rubinstein, Ginny Ruffner, Elizabeth Rummage, Betsy Russell, George F. Russell, Jr., Chase W. Rynd, Ramona Solberg, Sunny Speidel, Ellen Taussig, Roland Terry, William Traver, Jeanette Whiteman, Tom Wilson, Bagley Wright, and Virginia Wyman.

I am deeply appreciative of those who reviewed the manuscript in draft form, each bringing a different perspective to its content. My thanks to Priscilla Beard, Mary Cozad, Gretchen Gould, and Lee Soper for their care in assuming this task. In addition, John Cava, Dee Dickinson, Vicki Halper, Jeffrey Karl Ochsner, Alice Rooney, Howard Philip Welt, and Jeanette Whiteman reviewed sections of the text in their areas of experience and expertise. Their suggestions have sharpened the text.

To the staff members of the University of Washington Libraries, Special Collections Division, my sincere thanks for their expert assistance. From the research desk, Carla Rickerson, Head of Special Collections, John Bolcer, Nicolette Bromberg, Nan Cohen, Linda DiBiase, Steven Eichner, Kristin Kinsey, Sandra Kroupa, Gary Lundell, and Janet Ness all helped in the search. At Augustana College in Rock Island, Illinois, Special Collections Librarian Jamie Nelson, guided me through the John Henry Hauberg, Sr., papers there.

As the book moved into production, it was a pleasure to work with the University of Washington Press. Director Pat Soden leads the Press in its commitment to Northwest history and culture and has stood enthusiastically behind this book as a contribution to that mission. Marilyn Trueblood, Managing Editor, guided the production process with an experienced hand, and Nina McGuinness, Development Director, backed the fundraising. Sigrid Asmus brought an editor's precision to the text, as she has done to my work in the past, and I value the trusting communication we have developed as a result. Anne Traver, a principal of Methodologie, accepted the charge to create a design that captured something of the color and texture of Anne Hauberg herself, and she and Nancy Kinnear have done so with admirable thoughtfulness, clarity, and style.

My family has stood by with unstinting encouragement. I am grateful to my mother, Helen Jane Gleeson, who is the same age as Anne and whose experiences offered me insight into the war years and their aftermath. To my husband, Richard Hesik, and our daughters and son, who have taught me enough about life to dare to write about it, my enduring thanks for the loving support that enlivens each day.

During the months that I was writing the book, Gloria Steinem visited Seattle, and on May 25, 2004, she spoke as part of the "American Voices" series organized by Foolproof. I made quick notes of a resonant remark. "Generally speaking," she said, "in the past women had to marry what they wanted to become. In the present we are becoming the men we wanted to marry. We need no longer live derived lives." Little about Anne was ever derivative. And she would like the way that this book has connected us all.

why a book about annie?

by priscilla beard, project director

The life of Anne Gould Hauberg is a true testament to beauty. A collector of people and their creations, driven by curiosity and passion, Anne has been the architect, in the broadest possible sense, of trends, programs, and institutions. The Northwest would be a far less colorful place were it not for the unique personal vision, style, and indefatigable energy of this thorougly modern Medici.

The Anne Gould Hauberg
Book Project Committee

Nancy Alvord
Polly Friedlander
Nadine Kariya
Greg Robinson
Leroy W. Soper
Thomas Wilson
Virginia Wyman

I would like to convey appreciation to Leroy Soper, who opened the door to the University of Washington Press; to Pat Soden, for believing in this project; to Barbara Johns, for her grace and brilliant writing; to Anne Traver and Methodologie for bringing the story to life with color and images; and to Nina McGuinness and Hady DeJong for keeping the committee on track.

The Anne Gould Hauberg Book Project Committee has worked tirelessly for the past two years to make this tribute to Annie a reality. Each person brought a unique perspective on Annie's achievement, as well as a genuine commitment to the project. A very special thank you to Greg Robinson who went beyond the call of duty to support the fundraising every step of the way.

This book would not have been possible without the generosity of hundreds of contributors.

stepping out

At eleven in the morning of June 1, 1961,

a tall, handsome woman stepped out onto downtown Seattle's Seventh Avenue.

She carried a rhododendron branch in her hand, a trace of the natural grandeur within which the Northwest has immersed its peoples since earliest memory. She was surrounded by a hundred or more friends—a gathering that might have felt large within the confines of a room but now looked puny alongside the massive earthmoving force already in place there. The women were in suits or dresses and nylon stockings, and some wore high-heeled shoes, while the men among them were in business suits—they had a pressing mission and arrived in their customary social uniform. "Walk the Ditch," "Block the Ditch," the signs cried. "Citizens! Join the Progress Parade. Walk the Freeway Route." The group marched southward down the street. Filling the air with the encouraging beat of "When the Saints Come Marching In" was a marching band composed of a tuba, a trombone, a trumpet, and a clarinet. Alongside rode an escort from the City of Seattle police, men who were trained to do their work without expression. Neighbors leaned out the window to wave their support. The marchers had come to protest freeway construction that would cut through the heart of the city.

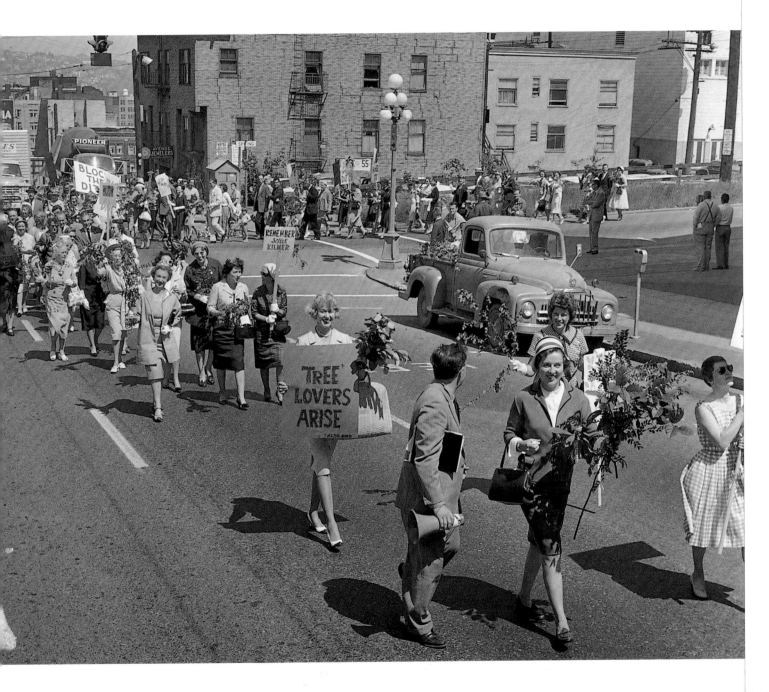

"The Big Ditch." Anne rallied a parade, complete with a band and fronds of greenery, to advocate the construction of a lid over the section of Interstate 5 that would sever First Hill and downtown.

The woman was Anne Gould Hauberg. It was she who had helped instigate the march, gathered a truckload of greens, and hired the band. As a young woman she had studied to be an architect. Her life's training had impressed deeply upon her the value of beauty and a belief in the human need for aesthetic surroundings. She was articulate and emphatic about the influence of good design in the built environment and the consequences of its neglect. She was the daughter of the distinguished architect Carl F. Gould, who had designed many of Seattle's landmark buildings and much of the University of Washington campus. Her mother was an independently achieving woman whose intellectual focus was the history and lore of the Northwest. Anne was reared with the fine-tuned protocols and role expectations with which her father's patrician class was engrained and that her mother had fiercely instilled in their children. Moreover in 1961 she and her husband, John H. Hauberg, Jr., a member of the wealthy and influential Weyerhaeuser enterprise, held positions of prominent social esteem. Both were actively engaged in innumerable cultural and civic affairs. Anne stepped out of this familiar milieu as she stepped into the street to lead the march of protest.

The isthmus of Seattle lay crudely sliced open. The construction of Interstate 5 was underway, and now, in 1961, a massive trench of raw earth coursed southward from the University of Washington neighborhood toward the heart of the city. It was the main artery of a network of freeways planned to reach around and across Seattle's intersecting lands and waterways. To its supporters, many of them members of government, business, and industry, the freeway symbolized progress. To others, it was unspeakable environmental devastation. "The new North-South freeway now extends from N.E. 67th to the cliff above Lake Union," wrote one opponent. "It heaves and rolls over our landscape like a vast concrete caterpillar, up, where the land goes down; down, where the land goes up. On an inhuman scale, it looks seasick."[1] Daily the bulldozers and earthmovers tore up the ground. It took out homes, businesses, people, and communities in its path. With equal regularity the newspapers reported plans, progress, opposition and recrimination, delays and redesign.

Nature had created this narrow landmass where mountain ridges rose out of the water, squeezed between the western shore of Puget Sound and the twenty-mile length of Lake Washington on the east. Giant trees had once grown from the hills, nourished by the Northwest's rain and mist. Across the Sound to the west lay the rugged peaks of the Olympic Mountains; to the east was the Cascade Range, to the south the volcanic peak of Mount Rainier rose from sea level over 14,000 feet, and on clear days the glaciered cone of Mount Baker appeared on the north horizon. In this place of breathtaking natural beauty, nineteenth-century settlers had established a community where an arc of the Puget Sound shoreline provided a

harbor and the banks of the Duwamish River, a site favored by the native people who had long occupied the land, promised rich farmlands. The ambitious newcomers had denuded the slopes, turning trees to lumber, and, as a city grew from the settlement, laid a grid of streets up and over the hills. Houses and businesses filled in the isthmus along those streets between the Sound and Lake Washington and fanned out north and south past Seattle's hourglass center.

Thwarting the freeway was no longer possible. The goal of the march was to mitigate its downtown rupture by the construction of a lid overhead. Architect Paul Thiry had proposed a grand boulevard and park, a design complete with engineering requirements and cost projections. The city council approved a revision of his concept. But construction and financing deadlines, pressures from downtown businesses to complete construction, and continually rising cost projections killed the proposal. Not for fifteen years did a more modest park, known as Freeway Park, finally bridge the gap from downtown to the First Hill neighborhood rising abruptly east of downtown. Anne is credited as its instigator.

As she would time and again in endeavors that bore her stamp, Anne embraced the need and the vision—the detail and the whole picture, the immediate and the future. She was captivated by the creative possibility in an artist's solution to a situation others might approach more routinely. Her studies in architecture had instilled a predilection for problem solving. And she took action; for her, to take the risk of action far surpassed the consequences of inaction. She became known for her visionary stretch, her creative gusto, and the dogged persistence with which she pursued an ideal. She was often the source of ideas, although not always the project leader. She drew connections. She created opportunity. This is the story of her contributions to art, craft, design, and education, and their interconnection.

Seattle's downtown, looking northwest toward Puget Sound and the Olympic Mountains, 1954

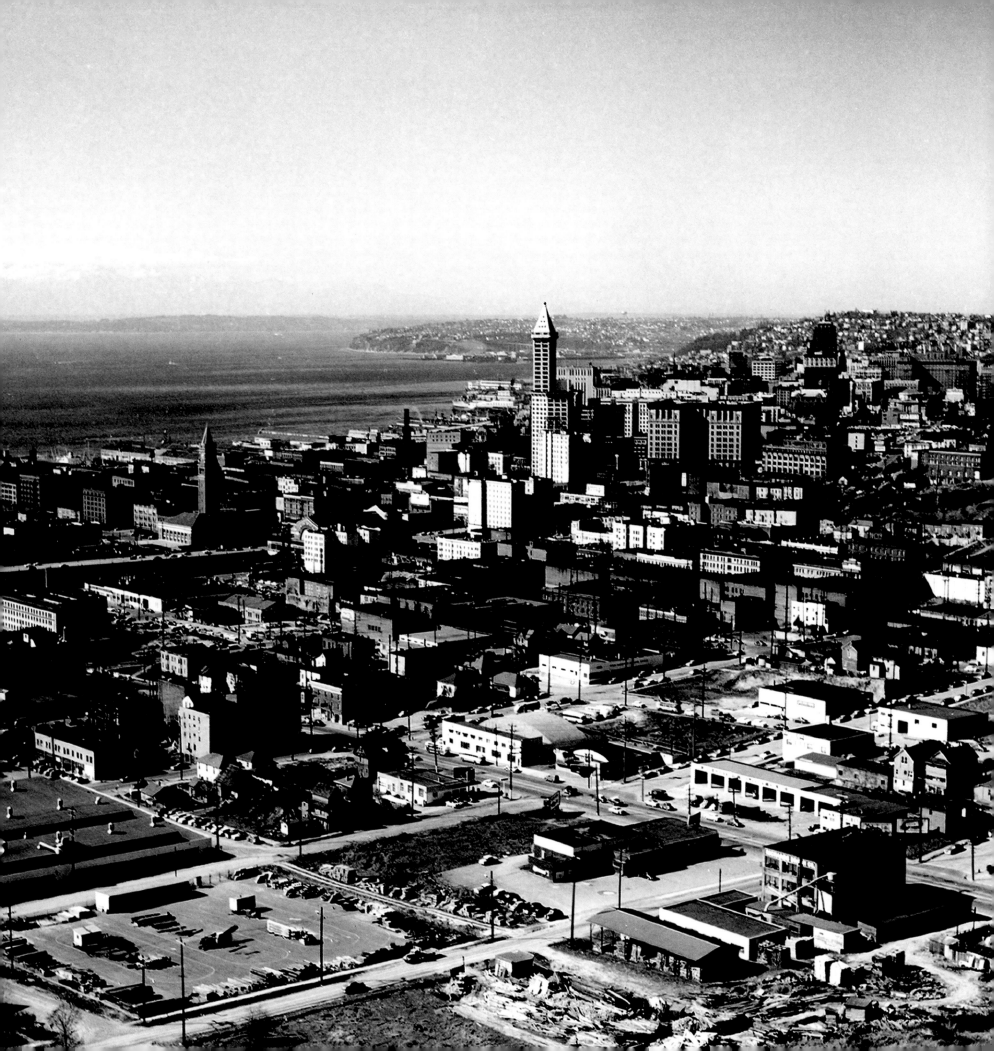

a colorful legacy

She was christened Annie Laurie Westbrook Gould.

As a young woman, she shortened her name to a dignified "Anne Westbrook Gould," but the "Annie" by which she is known to those close to her has deeper roots than an affectionate nickname. She was the namesake of her paternal grandmother, matriarch of a proud New York family of Dutch and English descent. On her mother's side, the younger Annie was the third generation in Seattle. She was born in 1917 in a city so young that the first white settlers had arrived only sixty-three years before her birth. She was, moreover, the third generation on Bainbridge Island, where her grandparents, parents, and she savored summers and many special times. Both sides of her family, conscious of their legacies, proudly traced their lineages to the founding years of the nation. Both had a strong creative drive, although creativity was expressed in a different style in each family. She came from a heritage of builders and creators, of people filled with curiosity and a pronounced ethical sense of contributing value to the community around them. It was a potent legacy for the future Anne Gould Hauberg.

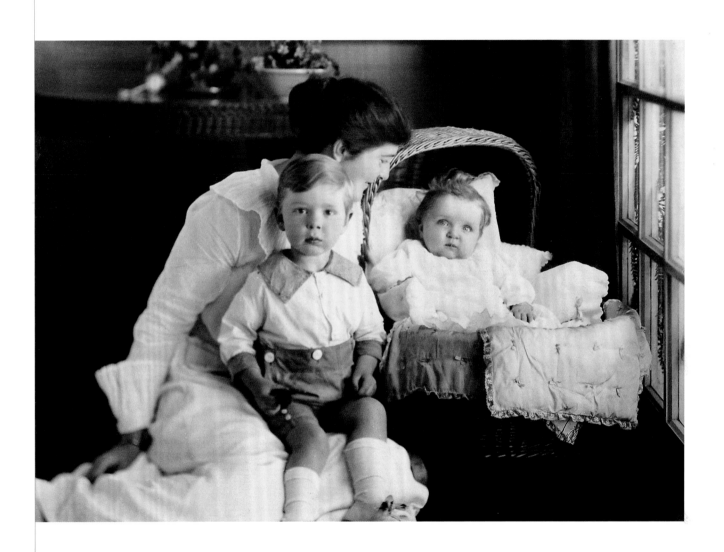

Dorothy Gould with Carl Gould, Jr., and Anne, ca 1918.

Her maternal grandparents arrived in Seattle early in 1889, nine months before Washington became a state and three months before Seattle's Great Fire. They stayed to prosper. John Purinton Fay and Alice Ober Fay were both from old Massachusetts families, and each had ventured west. Alice Ober's family counted themselves among the original settlers of the Massachusetts Bay Colony. John Fay's ancestors stretched back to an earlier John Fay, who at age eight had arrived from England on the *Speedwell* in 1656. Anne's grandparents bore their pasts proudly while they ventured toward the future with a will that perhaps matched their ancestors'.

John Fay studied at Harvard Law School, but then chose to leave his family home in Massachusetts to move to Nevada, where he found the pioneering West a promising challenge. Here he met Alice Ober, a teacher. They were married in San Francisco in 1889, where he worked as a lawyer for the Great Northern Railway (now Burlington Northern Santa Fe), and two months later sailed north to Seattle. In the wake of the Great Fire that leveled most of downtown, only three months after their move, he established a thriving law practice, becoming one of the city's most respected citizens and attorneys, as well as a substantial landholder. Active in civic affairs, in 1912 he ran as the Republican-Progressive candidate for Congress, the reform ticket led by Theodore Roosevelt, on a platform that included the abolition of child labor, national suffrage for women, "reasonable conservation of natural resources," and government employment programs to build needed infrastructure.[1] Although he was among those defeated in the Wilsonian landslide, he went on to achieve his most significant public service following his appointment to the University of Washington Board of Regents. During his tenure he led a change in the university curriculum from high school– to college-level standards. After his death, an alumni report from Harvard described him as "a pioneer of intellectual life of the Northwest. . . . He had inherited with his [old New England] social leadership a high regard for and a deep interest in all cultural matters and in his new home became a leader in politics, not from any desire for personal advancement, but urged by a strong sense of civic responsibility. Widely read, a fine scholar, an impressive and powerful speaker, black-haired, over six feet tall, the possessor of an unusually attractive and magnetic personality, . . . he will always be considered to have been one of the [Northwest's] most able, most unselfish and most far-sighted builders."[2]

Alice Ober Fay, Anne's maternal grandmother, shared John Fay's intellectual drive as well as his colonial roots. Exceptionally well educated for a woman of her generation, she graduated with highest honors from Wheaton Female Seminary (now Wheaton College) in Massachusetts and then taught Latin, botany, and geology in Michigan and Nevada. She bore six children, three daughters and

Alice Ober Fay, Anne's maternal grandmother, prized learning and pursued it throughout her life. Undated.

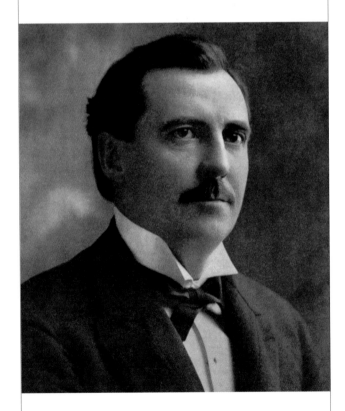

John Purinton Fay, Anne's maternal grandfather, moved to Seattle three months before the Great Fire of 1889 and prospered as a lawyer and property owner. Undated.

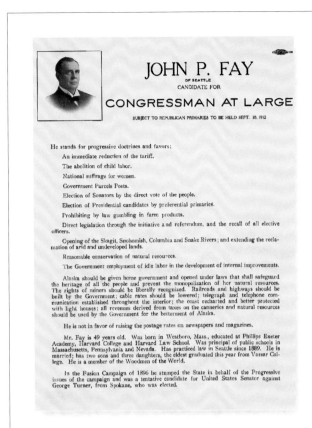

In 1912 John P. Fay ran for Congress on the Progressive Republican (Bull Moose) ticket, led nationally by Theodore Roosevelt. His reformist platform called for national suffrage for women, the abolition of child labor, and conservation of natural resources.

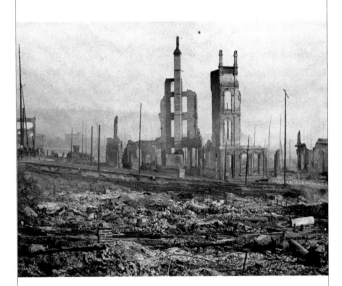

Little was left of Seattle's business district, now called Pioneer Square, in the aftermath of the fire of June 6, 1889. John Fay's office was in one of the few buildings built of fire-retardant materials.

three sons.[3] The first was Dorothy Wheaton Fay, born in Seattle in 1890 and named after Alice's college; she would one day be Anne's mother. Alice Fay was an avid reader and gardener. She was also a woman who asserted her independence, which made her a somewhat unconventional mother. By family accounts, she secluded herself in bed with her books for as long as three weeks, while the family cook looked after the family and household. More audaciously, after the birth of four children, she left with their son Temple (called Bunty), then age five, on a trip to Europe, and, once she had arrived, cancelled a prepaid tour and stayed abroad for a full year. Alice's absence left Dorothy, age ten, at home with younger siblings and held responsible for their behavior by the household staff. Ten years later, in 1910, Alice would take four of her children on a European trip, this time including Dorothy. Filled with insatiable intellectual curiosity, Alice Fay was to continue her quest for learning throughout her life. Living in Tucson in her seventies, she took courses at the University of Arizona and enthusiastically described her philosophy class to her granddaughter Anne, then in college. She was called an emotional firebrand, but Anne would remember her grandmother with tender affection.[4]

Both parents encouraged their children's individuality and the pursuit of education. They provided also for memorable family experiences together. Following the custom of established East Coast families, in 1906 the Fays built a summer retreat on a forty-six acre beachfront property on northeast Bainbridge Island. It was a mile of tidelands and apple orchards that would become the source of special delight for three generations. Alice gained a keen knowledge of marine life and astronomy, interests that in future years she would share with grandchildren as they sat with her on the beach.

Although they prospered in the Northwest, Alice and John Fay also experienced profound losses. The Fays' second son, John Bradford, died at age eight of burns from a home accident. In 1915 another son, Winthrop Herrick, who had been a leader of his class, died of influenza just as he was completing high school. That year marked other changes in family life. To ease the grief of the loss of a second child, the Fays left the First Hill neighborhood, home to many of Seattle's pioneering families, to live in an apartment building they owned on Queen Anne Hill. John Fay closed his law office after more than twenty-five years of practice. And Dorothy, their oldest child, left home to marry.

The pioneering family left its mark on the region in their accomplishments and the places that bear their names. The Fays' property on Bainbridge Island became the Fay Bainbridge State Park. In 1944 it was deeded to the State of Washington by their son, Temple Fay, who was by then a successful neurosurgeon and teacher in Philadelphia. When two of Alice Fay's siblings followed her to

Seattle, they too made prominent contributions to the shaping of the city. Her sister Caroline Ober, a woman apparently as independent as Alice, taught Spanish at the University of Washington for thirty years. Before her move to Seattle, Professor Ober had mastered the Spanish language while serving as vice director of the state normal schools in Argentina from 1889–1893. Ralph H. Ober, Alice's brother and Anne's great-uncle, came west as a civil engineer in 1892 and played a major role in designing Seattle's Aurora Bridge, as well as watersheds in the Cedar and Skagit Rivers and a Columbia River basin irrigation survey. Ober Park on Vashon Island carries the Ober family name.

Dorothy Fay, Anne's mother, grew up in this individualist and strong-willed family. Emulating her parents' example, and perhaps because as the eldest she was often given important responsibilities, she had a strong desire to excel. She graduated with top grades from high school in three years. She then went to the East Coast for further education, an experience that would powerfully shape her goals for her children. She spent a year at Baldwin, a preparatory school near Philadelphia, and then entered Vassar College, where she would become a lifelong devoted alumna. Upon her graduation and return to Seattle, Dorothy Fay became the first woman to teach in the English Department at the University of Washington, when a family friend, Professor Frederick Padelford, asked her to help with his course load. It was here that she also got to know an elegant and eligible architect who was teaching at the university, Carl Frelinghuysen Gould.

Carl Gould was a New Yorker who had come west. Earlier opportunities in New York and San Francisco had eluded him, and a career was still not within his grasp when he arrived in Seattle.[5] The young city, still raw and rough, proved fertile ground: Gould's education and rearing enabled him to fit comfortably within the city's leadership class. He brought impressive credentials. He had graduated from Harvard College and spent five years studying at the École Nationale et Spéciale des Beaux-Arts in Paris, which was at the time the pinnacle of architectural preparation. His privileged, patrician upbringing had provided him a fine appreciation of the arts, a gracefully refined comportment, opportunities for extended European travel, and skills in such sports as horsemanship, fencing, and sailing.

Gould's family had nearly as long a history on North American shores as the Fays'. The Goulds were among an elite of old New York families, with homes in the city and rural Tarrytown. They owned extensive real estate through his mother's inheritance, including a block in midtown Manhattan and land in Harlem where her family had once had a rural summer retreat. Carl's father, Charles Judson Gould, had been a successful tea merchant, a pursuit he gave up upon

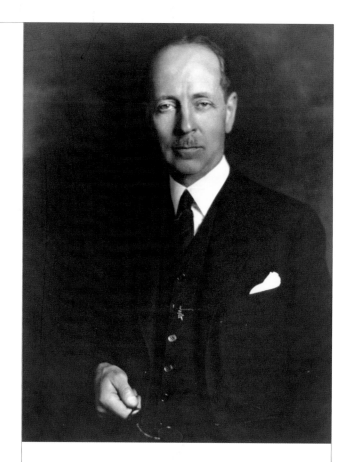

Carl F. Gould, Anne's father, in the 1930s. Gould was the principal designer in the architectural firm Bebb & Gould, and in 1914 had founded the Department of Architecture at the University of Washington.

Annie Laurie Westbrook Gould, Carl Gould's mother, for whom his daughter would be named.

Carl Gould, for Bebb & Gould, designed the operations building for the U.S. Government Locks (Hiram M. Chittenden Locks), Lake Washington Ship Canal, 1916.

Gould began his architectural practice in Seattle shortly before massive land-moving projects were to begin. Shown here is the construction of the Lake Washington Ship Canal and U.S. Government Locks (Hiram M. Chittenden Locks), Seattle, 1913.

his marriage to Annie Westbrook, who declared business unfitting to her sense of family respectability. He spent the rest of his time in the style of a Victorian gentleman, riding his horse daily in Central Park and offering his family an affable warmth that balanced his wife's controlling hand. Annie Westbrook Gould ruled the household with a strong sense of propriety and a dedication to beauty, imbuing her seven children with her love of art, architecture, and literature. She collected art—work by such contemporary American artists as Winslow Homer and George Bellows—and books, gathering a library of two thousand volumes. Carl, the eldest son, learned the lessons in full measure. As he matured, his father's congeniality blossomed in him as well.

Gould found a place for his social and professional abilities in Seattle. He arrived in 1908, just as the city was being literally reconfigured. Seattle had doubled its area by annexing six adjacent towns in 1907, and within the next few years gigantic earthmoving projects tamed its hilly terrain. Among these projects were the leveling of Denny Hill along with large sections of downtown, and the filling of the area now called the Denny Regrade. The mud flats of Elliott Bay were also filled to open more buildable land, while a major ship canal was cut to connect Lake Washington and Puget Sound. Gould worked for two architectural firms during his first years, garnering commissions that began to bring him recognition. In 1914 he formed a lasting partnership with an older, established architect, Charles Bebb, resulting in a firm they named Bebb & Gould.

Gould demonstrated his civic leadership shortly after arriving in the city. He joined the Seattle Fine Arts Society and was elected its president in 1912. He actively used the society as a forum to advocate for city design issues, about which he felt passionately. The society was dedicated not only to the traditional fine arts, but also to a wide range of visual expression that included architecture, municipal art, landscape, and interior and applied design. Its breadth of interests matched Gould's unified concept of employing all these arts in the service of civic beauty.[6] Under Gould's tenure the society was greatly

strengthened; and later in the 1920s, as its president for a second time, he again stabilized and revitalized the organization, and in doing so prepared the way for the Seattle Art Museum to follow in the 1930s.[7] In addition, he established a lifelong affiliation with the Washington State Chapter of the American Institute of Architects (AIA), eventually assuming its presidency in 1921 and from this post advocating art education and good civic design. When the Seattle City Planning Commission was established in 1924, Gould was a member and an active proponent of the city's first zoning code.

Gould's greatest influence, aside from his architectural practice, was in founding the Department of Architecture (now the College of Architecture and Urban Planning) at the University of Washington in 1914. The preceding year, he had taught a course about home design in the Home Economics Department. In anticipation of a professional program in his field, he had sought the advice of the heads of architecture departments at several East Coast universities where the Beaux-Arts curriculum was offered about how a new program might be structured. In 1914, he led the creation of the Department of Architecture within the newly established College of Fine Arts. Gould was a patient, generous teacher, who established the department standard that faculty members must be practicing architects, and headed the department for twelve years.

In 1913, Dorothy Fay also began to teach at the university. She and her friends sometimes listened to the handsome professor lecture, and she cunningly invited him to speak to her class on the relationship of art and literature. A romance soon blossomed, and on June 22, 1915, Carl Gould and Dorothy Fay were married. Carl and Dorothy Fay Gould were by many measures a finely complementary pair: both were intellectually curious, civic minded, energetic, and ambitious. Dorothy Gould loved to socialize, entertained frequently, and saw that they belonged to the right clubs and attended important events. She also made sure the newspapers knew about it when they did so. Carl Gould's career was blossoming. He was teaching on campus, running a downtown practice, and participating actively in the Seattle Fine Arts Society, the AIA, and the city planning commission. Children quickly followed their marriage and became the center of their family life: Carl, Jr., born on April 1, 1916; Anne, on November 13, 1917; and, eight years later, John Bradford Van Wyck Fay, on November 4, 1925.

Gould designed the house in which he and his wife, and soon their infant children, would live. For fifty dollars Gould had bought a lot at the south end of Bainbridge Island, near the new Country Club district where he had designed several summer homes for clients. His own property sat on the rise of a hill overlooking Puget Sound and Mount Rainier. Naming the house Topsfield, he designed a simple one-story cottage with expanses of paned windows open to the view.[8]

Dorothy Fay Gould, ca 1930. Dorothy Gould's keen social sensibility and drive promoted her husband's career.

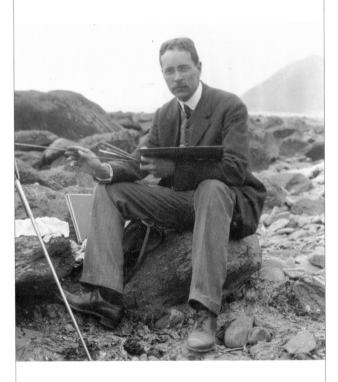

Carl Gould sketching, ca 1920. Outdoor sketching was one of Gould's favorite activities, which he encouraged in his children.

To save costs in this rural location, as well as to allow ready future expansion, he developed a precut modular system of construction, providing for components to be built in Seattle and shipped by barge to the island—an innovative method he would apply to several additional rural projects. The young family lived in the house full-time for five years until Gould designed a new family home in Seattle. Topsfield became the place to which they moved each summer, the place of holiday gatherings, and the place that would shape the memories of several generations. It would become a special retreat for Anne, whose appreciation of the island also carried with it memories of her grandparents' Bainbridge home.

Gould's architectural contributions at the University of Washington were to be among the most accomplished work of his distinguished career. In addition to Gould's leading the Department of Architecture from 1914 to 1926, Bebb & Gould served as campus architects, responsible for site planning as well as the design of buildings. Until 1926, the firm enjoyed a monopoly on university business, and, after a hiatus, the partners served as supervising architects, beginning in 1934.[9] Gould's was the major hand in the design work. On the campus that was then only twenty years old, he affirmed the overall layout, which was based on the plan of the 1909 Alaska-Yukon-Pacific Exposition on the same site, and from it created an extended axial plan. He designed the functional and symbolic heart of the campus, Suzzallo Library, directing the siting, conceptualization, structure, and detailed decorative scheme of what his biographers call "his greatest historicist structure."[10] He designed as well the Henry Art Gallery and the four buildings of the Liberal Arts Quadrangle. In total, Gould would be responsible for the design of twenty-eight buildings and would add to or supervise nearly as many more.

In the years to follow, Gould designed the plan and major buildings on the campus of Western Washington University (then Washington State Normal School), Lakeside School, the Marine Biological Building on San Juan Island, and numerous private residences and commercial buildings. With the coming of the Great Depression, business slowed painfully. Yet in spite of the economic climate during the 1930s, Gould designed buildings that broke new ground with a sensitively modulated modernism, most notably the U.S. Marine Hospital[11] and the Seattle Art Museum.

Because of his extensive Beaux-Arts training, Gould brought to all of his work a fluid understanding of historical styles, a comprehensive view of a project from site to decorative scheme, and the skills to work confidently in all of these areas. His selection of historical precedents was not mechanical but thoughtfully considered in light of function, symbolism, locale, and climate. Some of his most exemplary projects are the result of his incorporation of contemporary

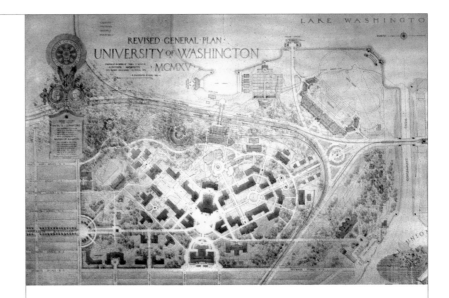

Bebb & Gould, revised general plan of University of Washington, 1915. Carl Gould took the basic schema of the Alaska-Yukon-Pacific Exposition of 1909, developed by Charles John Olmsted and Frederick Law Olmsted, Jr., and from it created an extended axial plan for the University of Washington campus.

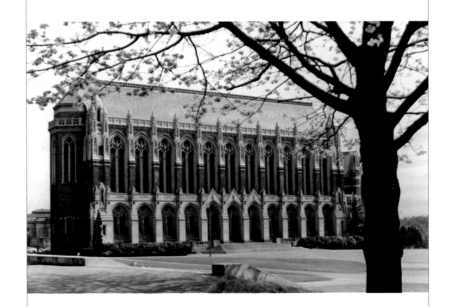

Carl F. Gould, Bebb & Gould, University of Washington Library (later named Suzzallo Library), 1924. Gould designed the library to be the symbolic heart of the campus and was responsible for its complete conception, from siting to selection of the Gothic metaphor to design of decorative detail.

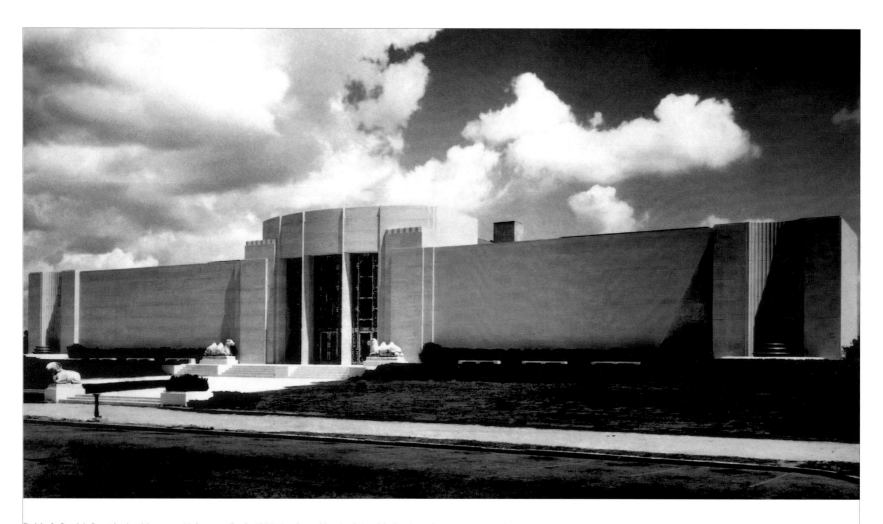

Bebb & Gould, Seattle Art Museum, Volunteer Park, 1933. Designed by Carl Gould, the Seattle Art Museum elegantly demonstrated his adaptation of modernism in the current Deco style.

building materials and practices. By the time of his death in 1939 at age sixty-five, his respect for tradition would be eclipsed by international modernism in contemporary architectural practice. More than a half century later, however, his biographers would see Gould's achievements with renewed appreciation of his sophisticated selection of historical references and their adaptation to modern materials.

Dorothy Gould, Anne's mother, reflected the value her parents gave to education in the pursuit of her own intellectual interests as well as in her strong encouragement of her children's education. Following her first teaching experience at the University of Washington, she maintained connections there for many years, lecturing occasionally in history and botany as well as English. In the early years of her marriage, even with babies at home, she covered her husband's classes in the Department of Architecture when he was traveling or when his professional practice required his presence downtown.[12] Like many women of her generation, her intellectual as well as social energies found outlet through the activities of many clubs, varying from the Colonial Dames of America, whose Seattle chapter she helped found, to the Vassar Club and Pen Women of America. She was aggressively supportive of her husband's career, deeply proud of her family lineage, and ambitious for her children in the same measure.

At age forty-five, in 1935 Dorothy Gould enrolled at the university for a master's degree in English. Her thesis was a survey of early literature about the Pacific Northwest found in private Seattle collections, collections (including her father's library) to which she had access through family connections. The thesis, while written

for the Department of English, is said to be the first on an aspect of Northwest regional history. Her research led to the publication of a book a year after graduation, an anthology entitled *Beyond the Shining Mountains*. As she described her work in the preface, "These 36 adventures were chosen from hitherto unpublished documents, from first editions of rare books, and from original sources among old places and persons. . . . "[13]

Widowed at age forty-nine, she lived another thirty-seven years as a single woman. After a decade of prolonged grieving, she reestablished an active schedule of travel and engagement. She became known for her knowledge of regional history and lectured with humor. In the 1950s she appeared regularly on local television. She was also a knowledgeable speaker and writer for the Garden Club of America, which published her subsequent small book on botanist David Douglas, for whom the Douglas fir is named. She made extended trips to the East Coast, where she stayed in relatives' homes or at the Vassar Club in New York, and took delight again in the cultural and educational opportunities the region offered. She once exclaimed after seeing a number of plays in New York, "I'm so full of culture I'm like a bread pudding that's all raisins!"[14] It was an unabashed exuberance by which many would remember her.

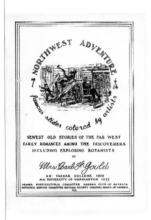

Dorothy Gould was a knowledgeable speaker who spiced her lectures with humor. This flyer advertised one of her slide lectures on regional history, "Northwest Adventure," ca 1938.

These were the people who were Anne's most intimate influences. Her heritage included her grandmother, Alice Fay, who ventured west to the Nevada frontier as a single woman; her grandfather, John Fay, who ran for Congress as a progressive reformer; her father, Carl Gould, who brought elegant design to a raw city; and her mother, Dorothy Fay Gould, who was the first woman in her field to teach at the university. Their values and actions shaped Anne's perceptions and ideals. She would build upon these values, honoring them in many significant ways, veering from them in others, but growing increasingly confident as she aged in the meaning and value of her legacy.

Dorothy Gould, 1935. Dorothy Gould began studies for a master's degree in English at the University of Washington.

Anne and Carl Gould, Jr., ages about
seven and nine, 1924.

the formative years

Nine-year-old Anne drew a picture of a circus, one that must have been filled with animation, rhythm, and color.

Her teacher, Mark Tobey, looked admiringly at her work and offered encouragement that she would remember all her life. The young artist, who was teaching a children's class at the Cornish School decades before he would achieve international renown, instructed his students to capture the energy of nature. The children's mothers, however, were displeased that their sons and daughters were not being taught to draw realistically. Anne's lessons ended abruptly when her mother withdrew her from the class. It was her first awareness of the tension between the impulse of creativity and the propriety of appearance within her family, and it was to be the first of several truncated educational paths as she bent to her mother's will. But her drawing experience with Tobey, however brief, also hinted at the visual sensibility she would develop, the trace of her father's legacy.

Topsfield, mid-1930s.

Born in 1917, her parents' second child and only daughter, Anne was reared with the decorum that marked families of her parents' position and generation. At the same time, she experienced a creative home environment ignited by the energy of two independently thinking parents. Her brother, Carl Jr., a year and a half older, was a playmate and a teasing rival, and in adolescence was sometimes an obligatory escort at their mother's command. During childhood Anne spent less time with her brother John, who was eight years younger, but as a young adult she would provide him a big sister's caring support. Her childhood was defined by the 1920s, in the United States a decade of prosperity and modernization, yet as she was approaching adolescence the country sank into the Great Depression. Although her parents never achieved the financial means they had known in their youths, they maintained the style and social affiliations that both of them valued. The Depression meant considerable financial strain for Anne's family, for it brought the demise not only of most of her father's commissions but also eventually ended the hope of any inheritance from either side of the family as investments were lost or reduced to insignificance. Yet despite these economic vagaries Anne and her brothers received the

best possible educational opportunities, special classes in the arts and sports, and the social training to move with ease among a privileged class.

During Anne's earliest years the family lived on Bainbridge Island at Topsfield, the house her father had built before his marriage. Her parents expanded the modular house as children arrived, first Carl Jr., then Anne nineteen months later (and two months premature). With two babies at home and two energetic and ambitious parents, the household activity was intense, and at times frenetic. Gould worked at "a pace that would have exhausted many men."[1] His commute itself was time-consuming, for he rode daily by ferry and trolley (they had no car for several years) to his dual positions at the University of Washington and the downtown office of Bebb & Gould. Dorothy Gould occasionally taught her husband's classes at the university or graded exams so that he could attend other business. Both parents were committed to Seattle cultural affairs, with full schedules of meetings and events in the city. By the time Anne turned three, the family moved to a house in Seattle that Carl Gould designed for them. It was a modest home in the Capitol Hill neighborhood, located between his work at the university and downtown. Topsfield, which had never been weatherized for year-round use, became the family's summer retreat.

At home in Seattle or on Bainbridge, Anne and her brothers learned the childhood lessons of values, manners, and style that would guide their course. The household was maintained in fairly formal style, in keeping with her father's standards and under her mother's watchful eye. Her mother insisted upon proper manners and formal protocol. "Of course, we weren't like other children," Anne recalled of the admonitions that continued into her adulthood. "We had to wear more white gloves; we had to do more curtsies, more standing up when elders entered the room, we had to do more thank you notes [while] the other kids were outside playing."[2] The Goulds entertained frequently to cultivate business and social relationships. Dorothy Gould was known for her exuberant sociability, and whether hosting at home or at one of the clubs to which the Goulds belonged, she planned parties with relish and flair. It was an enthusiasm Anne would one day match with zeal.

In spite of the social obligations of her parents, there were memorable family occasions spiked with color and bursts of unconventionality. "We always lived in the two worlds of social and artistic," remarked Anne.[3] "Anything creative was their motto!" her brother John added, noting that with little taste for household routine, Dorothy Gould encouraged the children in any creative or intellectual interest they expressed.[4] Evenings when they gathered together at dinner, a meal prepared by the housekeeper, Carl Gould himself made the salad at the table in the French manner. The family

Anne during elementary school years. Undated.

sat around a dining table from which Dorothy had had the center cut out to hold a goldfish bowl, a sight that astonished Anne's friends on their first visits to the house. Occasionally her father led the family on sketching trips to the mountains or the shore, and at home afterward they would place their sketches on the fireplace mantle for a critique of the day's work. Most memorable of all to Anne was the seasonal marker as each summer approached: the family packed trunks with seasonal clothing and household goods, prepared the city house for summer rental, and moved to Bainbridge for the season.

"There was a kind of flavor—you can see it in a Renoir painting—a kind of style that was expected of you," reminisced Anne of languid childhood summers at Topsfield. "Getting down to meet the boat and your father every evening, you'd be all dressed up in a nice clean dress after having been swimming."[5] A small passenger ferry that stopped along Bainbridge's shoreline left Carl Gould, along with other commuting fathers, at the Country Club dock, and each evening his children changed into dinner clothes and ran across the meadow to meet him. Anne's cousin Sylvia Case Jones remembered these meetings on her frequent visits: "When we . . . welcomed Uncle Carl at the boat each evening, we were to go up and shake his hand, look him in the eye, and say, 'Good evening, Uncle Carl.' "[6] Before afternoon swimming, Anne and her brothers would have spent the morning doing chores, and, as the only girl, Anne drew the household tasks, straightening cushions and rugs and sweeping the porch "a zillion times."[7] There were neighborhood rituals, such as tea at the Country Club each Saturday afternoon, when the men would return from golf to change into white flannel pants and straw hats. Her father occasionally took the family sailing, and when her brother Carl was old enough to manage his own boat, Anne begged him to take her along. Going to Bainbridge also meant week-long visits to her grandparents' summer home at the far side of the island, where her Grandmother Fay sat long afternoons on the beach reading to her, teaching her the names of the wildlife, and at night, pointing out the constellations by name. Birthdays and holidays were times of special celebrations for the entire family.

Anne was endowed with a rich legacy of culture, education, creativity, and social position. But heritage also includes biology, and in Anne's father's life was a pattern that seemed to foreshadow her own adult experience. The year before Anne's birth, her father had experienced one of the episodes of exhaustion that were periodically to interrupt his life. Suffering from severe headaches and weight loss, he was hospitalized in Portland. It was the second time Gould had sought such treatment, having a few years before spent fifteen months in a sanatorium while he was working in New York. From Oregon Gould wrote his wife, "I do know, if there is something that can be corrected, I will be a different person. The one or two times I remember feeling really well gave me an inkling of what one might be able to do if one was not constantly shut down by depression and headache."[8] Noting the onset of these episodes when Gould was a student in Paris, his biographers wrote, "Such bouts of poor health . . . would recur throughout his adult life. Because the first of these illnesses coincided with his radical change in work habits, it may have been induced by exhaustion. Gould's illnesses usually followed stretches of almost demonic labor and probably had some psychosomatic component."[9] When these swings are considered in light of what is known today about manic-depressive illness, or bipolar disorder, and the creative surges often found during elevated manic phases, it is possible that he suffered from the associated depression. Gould remained hospitalized in Portland for two months before returning to his young family.

As Anne grew older, the creativity she shared with her father fostered a strong bond between them. It was a bond undoubtedly strengthened by the special relationship that an only girl in the family can have with her father. When he traveled or she began spending times away from home, his letters continually encouraged her creative activities and the development of her imaginative capacity. He wrote of his own creative endeavors, describing the pleasure of a sketching trip or a design problem, and usually extended an invitation to participate. "I hope when you return we can do some lively sketching together," he offered.[10] "I am designing stain glass and selecting glass for the colors," he wrote of a 1934 addition to Suzzallo Library. "If you were here I could try you out on one. . . . I may have to take you into my office."[11] On a trip that year, he sent a picture postcard of railroad tracks:

> *Don't you think it's fun to wonder what goes on just beyond
> the vanishing point, just over the top of the world and beyond. Keep
> wondering all of your life long & if you do it's fun to live. Wander
> around in the woods and along the shore and look at the stars, and
> you can do that right at home and find the world just as great as
> Chicago or New York.* [12]

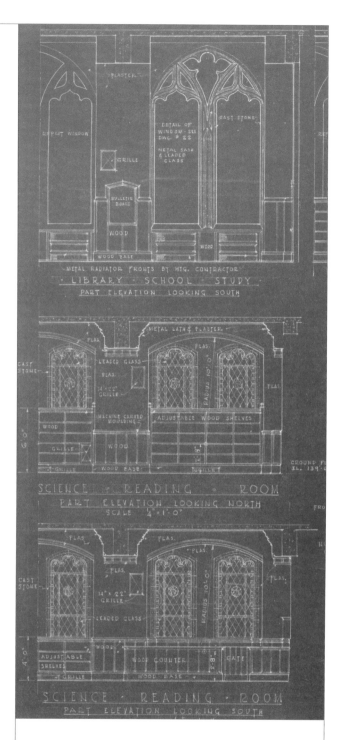

Carl F. Gould, Bebb & Gould. Part elevation, Science Reading Room, 1934 addition to Suzzallo Library. He wrote Anne about his work on the stained glass windows, "We are using Indian symbols for whales and bears and seals of the early explorers. Each one is a very complicated problem in design. If you were here, I could try you out on one."

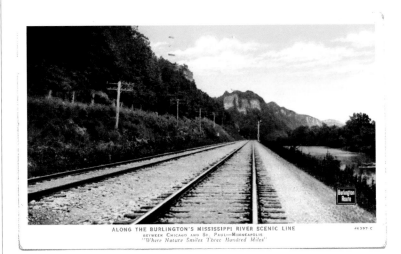

One of Gould's most eloquent encouragements to his daughter was stimulated by a picture postcard, "Along the Burlington's Mississippi River Scenic Line," in 1934.

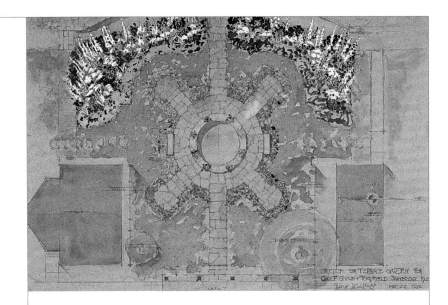

At Topsfield in the 1930s, Carl Gould designed and built a parterre garden, a design of partitioned garden beds separated by walkways. Dorothy Gould had requested the garden after a visit to Colonial Williamsburg.

Anne would value this creative nourishment lifelong.

During the 1930s, the years of Anne's adolescence and young adulthood, the family's creative strain seemed to grow stronger as business slackened during the Depression years. Gould resumed the sketching trips he had foregone when business consumed his time, and worked long evening hours building a parterre garden at their Bainbridge house. He wrote Anne of these activities and described the good company he found in the local watercolor society, along with his excitement about studying sculpture with Alexander Archipenko, who was a visiting artist at the university. At the same time that Anne received direct creative encouragement from her father, her mother also set a strong example of both creative and academic achievement by returning to school to earn a master's degree and publishing her book, *Beyond the Shining Mountains*.

The trajectory of Anne's education was guided by her parents' goals and values, their ambitions for their children, and their emphasis on creativity and individuality. Anne entered kindergarten at a neighborhood public school, and in first grade moved to St. Nicholas, a traditional private school for girls. In fifth grade she transferred to a newly launched progressive program, the Helen Bush School (known today as Bush School).

The Helen Bush School had begun in 1924 in the home of Helen Taylor Bush. It had been in existence only three years when Anne joined the fifth grade class. "We had Shakespeare in the garage," Anne remembered, "and we had one room downstairs where Mrs. Bush taught mathematics, and Mrs. Hodge taught English."[13] By the time Anne reached her teens, the school had moved to a dedicated building and expanded to cover nursery school to high school grades. Most of the faculty were not professional teachers but rather educated women with a vested interest in their own children's education. Mrs. Bush was an ardent proponent of John Dewey's philosophy of education, which embraced the new field of psychology and the changing needs of a democratic society, in contrast to traditional rote learning. From its inception, the school fostered individualized and experiential learning, the cultivation of creative abilities, and the development of active citizenship. "Education is an active process, not a passive one" stated its 1936 catalog. "This school subscribes to the philosophy of 'learning by doing.'"[14] Programs at the city's

The completed parterre garden, 1930s.

cultural institutions were regularly incorporated into the curriculum. As the school grew, professional artists were among the teachers—painters, musicians, and dancers who created a strong arts program for which the school became known. "We took her out [of] . . . the narrow type education," Dorothy Gould described later, "and put her [into] Helen Bush School, which is [a] very fine school of [the] new type, . . . with special emphasis on literature, drawing, dance, etc., but mostly on [the] flowering of each child's own talents." Anne did well there, her mother continued, noting her concentration, "good logical mind," and artistic ability.[15] "We were encouraged to be ourselves, and to think for ourselves and not just parrot what the other person says," Anne recalled. "I'm very grateful for that."[16]

The Goulds' choice of such a school for their daughter, in contrast to the household emphasis on propriety, suggests the inquisitive and holistic aspects of their own intellectual orientation. They also provided their children additional opportunities outside of school for creative and experiential learning. At age seven, Anne, along with her brother Carl, began Saturday classes at the Cornish School, a private school for the arts (now Cornish College of the Arts). Founded in 1914, Cornish pioneered a progressive, interdisciplinary program of art study that combined traditional and contemporary art forms, including ballet, modern dance, puppetry, theater, classical music, and visual arts. The faculty were professional artists drawn to Seattle from across the nation and internationally, outstanding artists in their

fields, and they made Cornish well known throughout the country. Anne enrolled in 1924, at a time when the school flourished in the quality and influence of its faculty and program. In the next few years she took piano, dance, eurhythmics (a study of movement), and, briefly, the art class taught by Mark Tobey.

Anne was about to turn twelve when the stock market crashed in 1929. Her father's firm, which had lost its singular hold on University of Washington business in the state politics of 1926, lost clients in successive waves as the crash turned into acute economic depression. The family moved to Bainbridge full-time twice during the Depression in order to rent their house in the city. As Anne approached college in 1935, her father's architectural prospects seemed to revive when government-funded work became available and Bebb & Gould were reinstated as supervisory architects for all new construction on the university campus. But the upturn was not to last; just two years later in 1937 business was so poor that the firm garnered only two jobs.[17] "We are skidding close to the wires financially," Gould wrote his daughter in early 1938. "The future of archit. profession is at this time a much unfathomable quality."[18] Although he designed some outstanding buildings during the 1930s, Gould struggled throughout the decade to provide for his family in their accustomed manner.

And yet the opportunities given Anne, along with her brothers, seem hardly diminished. As a young teenager she attended Four Winds summer camp on Orcas Island, one of the San Juan Islands near the Canadian border, where her father designed buildings for the camp in exchange for tuition. In her later teens she would have her first work experience as a counselor at the camp. There were opportunities to learn horseback riding when she accompanied her father to his riding club, and as she entered young adolescence,

classes with her friends in ballroom dancing. Anne's mother joined other mothers in giving frequent parties for their daughters, teaching them social protocol when they were young, and, as the girls entered adulthood, creating occasions to introduce them to the town's eligible young men. "The mothers were all great hostesses," Anne remembered. "One summer when I was about fifteen . . . I went to a party every day for the whole summer."[19]

Anne was in the eleventh grade when she began a sequence of transfers during the course of her education. As she began her junior year, her parents moved her from Helen Bush School back to the more structured St. Nicholas School to test her competitiveness for college. Her mother was eager that Anne attend Vassar College, which for her had been a seminal experience. In spring of that year, Dorothy Gould wrote several East Coast women's schools inquiring about the possibility of Anne's admission. Anne's creative ability was already evident, but her test scores did not qualify her for Vassar, nor did St. Nicholas allow her enough credits to graduate.[20] The St. Nicholas headmistress wrote Anne's mother, "I think that the combination of Farmington and Sarah Lawrence, as you suggested, might be the very thing for her with her artistic inclination."[21]

During what would have been her senior year, Anne boarded the train for the East to attend Miss Porter's School in Farmington, Massachusetts. Some of her Gould cousins had gone to Miss Porter's, which was then a "finishing school," specifically not college preparatory, and intended to complete a young woman's education.[22] She enjoyed the experience of the disciplined routine and classes, which were heavily weighted in art and design. She did well academically and was excited to win a place in the theater group, which was special recognition usually reserved for a student's second year.

At Christmastime there was no thought of her coming home for the holidays, and her parents arranged a detailed itinerary of visits to Gould relatives. Her father's sister Muriel Gould York was the person closest to Anne's family, the aunt to whom Anne and her mother looked for advice on current fashion, and on whom the parents counted to watch over their daughter. Knowing these relatives were more exactingly formal than her own family (the "starchy" East Coast Goulds, they would be called), her father encouraged her to visit with an open mind and a detached interest in "human nature."[23] Her mother wrote more sternly, "I shall expect you to remember (1) *you are a Gould and must live up to the very best ideas* of behaviour partly because in all sorts of queer ways old family friends will remark 'so that is Carl Gould's daughter' . . . (2) because all western girls are as you know under criticism and I hope you will so conduct yourself that people will remember you as that 'lovely girl from way out west.' "[24]

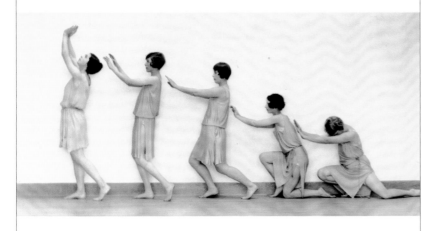

A eurythmics performance at the Cornish School, Seattle, 1926.

During Anne's first year away at school, and in future school years, both parents wrote her with a frequency and at a length hard to imagine today. Her mother's letters, pages of handwritten or typed narrative, came nearly daily, filled with accounts of activities and friends, parental advice, and proposed plans for Anne. Her father's letters, especially when she was in college, are replete with guidance and instruction—moral, financial, educational, and creative. He required strict and immediate accounting of the allowances sent her, and in inspirational passages he urged her to find ways for creative expression. "From a straight business procedure," he admonished her at Farmington, "you should have immediately written *acknowledging receipt* of [a check] and saying whether you deposited to your account in a bank or spent it. . . . Sit down *now* and send me a letter as I've outlined."[25] Years later Anne remembered her mother's constant exhortations to conduct herself properly and apply herself studiously. Yet it was her father's disciplined practices as well as his urge for creative thinking that dominated the guidance her parents gave her.

Anne stayed at Miss Porter's only one year. During spring vacation she had interviewed at Vassar, but still didn't believe she would qualify. With her parents she debated the merits of Sarah Lawrence (her preference), Bennington (too remote, in her view), and another year at Farmington, although she would lack a few credits to graduate, and she didn't want Miss Porter's to be the end of her formal education. Anne, then age seventeen, seemed uncertain about the next steps of her education. In a letter dated April 3, written in her abbreviated script, her mother proposed a host of possibilities without hint of financial constraints:

> *What do you think for next year*
> *(1) Return F{armington} and try graduate*
> *(2) Go to Paris with Mrs. Ferguson and then come out (here)*
> *{a formal debut was planned}*
> *(3) Try Sarah L (Bennington is not good I hear)*
> *(4) Try V.C. (Vassar) exams in June*
> *(5) Go to U.W. a yr, then Fontainebleau*
> *Dad plans to take us all to Europe 1936 so C Jr can sketch and study and you too if you like art or such, or gardens. (He thinks his new U.W. bldg. can be left next summer and fall.) Then Lomthorpe {spelling unclear} and Cambridge Landscape School?*
> *You are old enough to do your own thinking and choosing. Your father wants you to tell him what you want to do in the next 6 years. 25 is old enough to get married. Maybe you will prefer be maiden lady and do something {word unclear}?*
> *Love, Mom*[26]

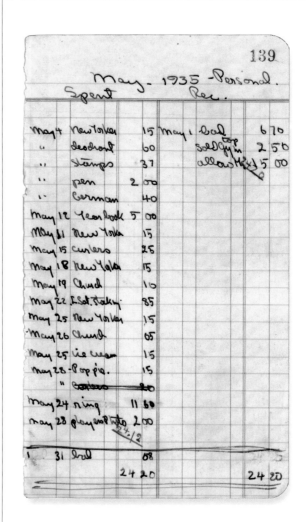

Anne's father required strict accounting of her allowances while she was away at school. Page from Anne's personal account book during her year at Miss Porter's School, May 1935.

Anne and classmates at the School of Architecture, University of Washington.

The School of Architecture curriculum included a course in industrial design. Anne recorded one project, "Gas Station Mr. Warner's class, spring '37," in her scrapbook.

Both parents regularly expressed their desire that she find a viable profession to support herself, and both seemed to regard landscape architecture as an appealing option. Her parents' experiences during the Depression, as well as their awareness of the demands and shifting relationships of modern society, often prompted their advice to her.[27] At age seventeen, however, Anne complained to her mother:

> I certainly don't see how you expect for me to map out my life till I'm 25. I think that is very silly for I don't really know. I've got a vague idea but things change from yr to yr and I have no more of a desire to become a landscape gardener than a plumber. One thing I do know though is that I do want some more of an education . . .[28]

Anne's higher education was to be characterized by stops and starts, a pattern that resulted perhaps from her mother's overarching goals and the differing opinions of her parents, but also from Anne's youthful efforts to establish independence and her increasing desire for creative expression. Although Anne left Miss Porter's with a sound academic record, as she would do also in architecture studies, she matched neither her mother's expectations nor her record of straight A's. Anne felt her mother expected perfection of her children and exaggerated their abilities and achievements. In retrospect, Anne reflected, one way she found to avoid judgment was to avoid completion.[29] Whether her path was thwarted by conflicting family expectations or her own indecision, Anne's lack of diplomas from either high school or college would remain a point of personal dissatisfaction and unease,[30] leaving her with a nagging sense of doubt in spite of what became a life of exceptional achievements.

Upon leaving Miss Porter's, Anne took the college entrance exams, for she had not formally graduated from high school. She returned home to decide her next step during the summer. The big event of the season, however, was a two-day party on Bainbridge, which culminated in Anne's debut on a warm Saturday evening in July. Her mother's love of parties was evident in the lively Friday overnight house party for Anne's and Carl's friends. The day of her debut began with an afternoon tea for family friends, which was followed by dinner in the garden around a large fire and dancing into the evening. Despite the national economic situation in 1935, it was a summer filled with parties, debuts, and betrothals for the young women of Anne's crowd, a telling statement of family position during the Depression.

In the fall of 1935, Anne entered the University of Washington in the School of Architecture, where her brother Carl had enrolled the year before. She was the only woman in her class. It was the department her father had founded in 1914 and led until 1926. When Anne entered the program, the curriculum was still modeled

upon Beaux-Arts methods, although the impact of modernism would soon be felt by American universities, primarily through the influence of Bauhaus émigrés Walter Gropius at Harvard and Mies van der Rohe in Chicago. Her class was among the last in which students still learned classical forms before the modernism of the European avant-garde redirected the curriculum. University of Washington students of the 1930s included some who would shape modern Seattle, both in terms of building design and urban philosophy. Among them were Victor Steinbrueck, who was to lead the fight to save the Public Market; Paul Hayden Kirk, whose masterfully proportioned buildings epitomize the ideals of midcentury modernism; and classmates Robert Shields, Robert Tucker, and Roland Terry, whose designs helped create the sense of a Northwest aesthetic. Although Anne would remain at the university only two years, the study of architecture would shape her thought and actions throughout her life.

In 1935 the School of Architecture was dominated by two men of complementary skills and temperaments, Lancelot Gowen and Lionel Pries. Both had been recruited by Gould, although Pries joined the school after Gould's departure.[31] Gowen was well-grounded in architectural practice and a good lecturer, but his modest demeanor paled alongside Pries. Pries led by his knowledgeable and sophisticated taste, his fluency in delineation, and his commanding presence.[32] He was a captivating and demanding teacher whose attention focused on the most talented students and, in Anne's view, was the only one enthusiastically responsive to students' creativity.[33] He was also a practicing artist who regularly exhibited his paintings, a discerning collector, and notable among the city's cultural leadership for having served in 1932–33 as director of the Art Institute of Seattle (successor to the Fine Arts Society and the immediate predecessor of the Seattle Art Museum).

Anne thrived in architecture studies. The curriculum at that time began with intensive training in drawing and design, and included the painstaking preparation and specific uses of materials: paper, pencils, sepia, India ink, and charcoal.[34] Along with the requisite credits in liberal arts, there were watercolor, sketching, and sculpture courses in the School of Art, some techniques that would have been familiar to Anne from the family sketching trips led by her father. She had a youthful familiarity with the process of design through her father's practice, but no training in technical drawing. Although only a few students would have entered school with such preparation, Anne keenly felt the lack and depended on her classmates for help. One of her classmates recalled, "We all helped Anne Gould."[35] She must have won such aid as much by her charm as by need, for it was often her social life that interfered with the drawing assignments. The deadlines, in accordance with Beaux-Arts instruction, were

absolute. "The work had to be done and in the drawer or you were out," she recalled of one occasion. "I think there were about five people helping me paint the trees, do the shadows, finish the painting. Lance Gowen, the teacher, came in just as I was signing my name!"[36]

In sophomore year the class was introduced to disciplined practice of the *esquisse* ("sketch"). Students were given a design problem, and within eight hours were required to produce a drawing of a proposed solution, which they then had to develop fully over the next several weeks without varying significantly from the initial drawing. For most of the year, final presentations were in the form of *analytiques*, drawings that required layer upon layer of watercolor wash to render shades, shadows, and highlights. Another exercise was the *esquisse-esquisse*, a sketch problem to be completed from drawing to presentation in just eight hours; the assignments to Anne's class ranged from "a lantern" and "a tiller handle" to "a waiting shelter for trackless trolleys" and "a marble baptismal font."[37] These practices were intended to teach organized thinking, concrete solutions, and speed of presentation.

Although architecture was demanding, social life beckoned temptingly for the attractive young woman of eighteen. On campus, along with two good Seattle friends, she eagerly joined the sorority Kappa Kappa Gamma. She lived in the sorority house, where she enjoyed the lively companionship of women friends and the daily bridge games after lunch. But the male-dominated Department of Architecture had its own social magnetism. Youthfully indulgent pranks countered the tension of studies: water balloons rigged over doorways, small fires lit in sinks or under the desks of students who had fallen asleep, all with a sense of playfulness that within a few years would change forever when a generation of young men went to war. The pranks reached a peak at the end of Anne's sophomore year when the department was scheduled to move to another location and the old building in which they had studied was set to be demolished. "Everything was being dismantled. It was the end of spring quarter. Everything was going. I can remember Anne Gould (who is now Anne Hauberg) taking a drawing board about so big, and she sailed that like a Frisbee, right out into Fifteenth [Avenue]," laughed a classmate in recollection.[38] Anne too remembers with delight the feeling of abandon in her act.

The environment fostered strong, supportive bonds among students, friendships that were to be lifelong; Anne found such a friend in Roland Terry, who would play a significant role in her future. She earned good grades, but once again her perception of her mother's drive for perfection undermined her confidence in her achievement. "I never knew I was talented," she recalled, "I didn't even know how to sharpen a pencil."[39] Years later Terry would call

Anne and her father at her debut,
Topsfield, 1935.

Anne and her mother at the American School of Fine Arts at Fontainebleau, where Dorothy Gould took a course in fresco, and Anne, one in design.

her the most talented in the class.[40]

While Anne was studying at the university, she and her brother had another exceptional educational opportunity. Carl Gould had served as the technical advisor to the Oregon State Capitol Commission, and, despite severely strained finances, he used the fee he received for a family trip to Europe in the summer of 1936. During the hard years of the Depression, this was an undertaking indicative of her parents'—and particularly her father's—creative drive and risk-taking. Anne, her parents, and her older brother, Carl (John stayed behind in summer camp) sailed for France to attend the summer program of the American School of Fine Arts at Fontainebleau. Housed in the Palace of Fontainebleau, the school had been founded in 1923 to afford American students an opportunity to experience traditional French instruction without the years-long residency required by the École des Beaux-Arts in Paris. The Goulds all enrolled in classes, each of them in one of the four programs the school offered: Anne in design, her brother in architecture, her

mother in fresco painting, and her father in sculpture. Together the family experienced village life and the French culture her father loved so well. Anne remembered eagerly awaiting the afternoon bus that would take them to a village to sketch or paint. They took time to travel, touring much of England before classes began and after the summer session traveling to Belgium, Holland, Germany, and Scandinavia, where they sought out modernist architecture, the last time they could have done so before Hitler began his sweeping invasions of Europe. In September they sailed home aboard the *Queen Mary*. Coming between Anne's freshman and sophomore years in architecture, the trip provided her with a rich sense of historic context that helped shape her understanding and vision of place. Within a few short years, the family would look back with longing to

Carl Gould, sketch of the Gould family in Paris, 1936.

After a summer at Fontainebleau and travel in northern Europe, the Gould family (Anne, her father, mother, and brother Carl) returned to the United States on the *Queen Mary*, 1936.

Anne Gould
INTERIOR DESIGNER
The complete furnishing
of homes and offices...

Skinner Building
Seattle

Anne announced her interior design business with a mailer and business cards, 1940.

this time when financial and health concerns seemed distant. It had been an idyllic interlude.

Anne had completed two years at the University of Washington when her educational path was diverted. Her mother now urged insistently that Anne attend Vassar. Both parents wanted their children to attend school in the East, to experience the cultural and intellectual life as well as the education. Carl, Jr., entered Yale, where he graduated two years later. Anne's brother John, age twelve, left for Groton, the prestigious preparatory school in Massachusetts, and would go on to graduate from Princeton. And so in the fall of 1937, Anne, nearly twenty, packed her trunks with winter clothes and once again took the train east, this time to enter Vassar as a freshman. She was two years older than her classmates. Vassar gave her little credit for her two years of study in architecture (although Carl received full credit at Yale). While Anne might have entered an older class, the college president suggested to Dorothy Gould that since "the cliques" would have formed, Anne would fit more readily into the entering class.[41] It was an inauspicious beginning to an unhappy year.

In the 1930s Vassar offered little opportunity for creative expression, and Anne chafed under its traditional academic regimen. Even in art she was required to begin at the level of fundamentals. For several years she had resisted the idea of attending Vassar; at Christmas that year she began to break from her parents' control. During her year at Miss Porter's, her parents had planned in detail her holiday schedule of visits to Gould relatives. This year she ignored her mother's appeals for information about her plans and spent the vacation serving tables at a resort in Lake Placid, New York, a role her mother would have thought unbecoming. Afterward she described her lively social life to her parents, "The 2nd night I had 6 dates and they seemed to keep up at about that rate—really good on the ego. . . . Go skiing, tobogganing, or skating every afternoon and a movie or beering or more skating and skiing."[42] The next semester had not begun, however, when Anne wired her parents, "Want to go to art school New York this semester."[43] Her parents required that she complete the year, but as her unhappiness at Vassar grew, her grades plummeted. She did not qualify to return to Vassar, nor could she have been persuaded, and her parents agreed with her that she should return to design.

In September 1938, Anne entered the Cambridge School of Architecture and Design in Cambridge, Massachusetts. The school was a professional program for women, and was affiliated with Smith College; it drew its faculty from Harvard's School of Architecture, where Bauhaus influence prevailed. Admission required an undergraduate degree or, alternatively, prior focused study in the field. Offering bachelor's and master's degrees in architecture, landscape architecture, and "interior architecture," the Cambridge

School provided Anne the opportunity to choose among these design fields. As she settled in Cambridge, her mother reminded her of the family's roots in the town—her father's student years at Harvard, a semester her Grandmother Fay had happily spent at Radcliffe College, and the Fay family legacy at Radcliffe, where their ancestral home, in which Grandfather Fay had grown up, was now the college's main building.[44]

Anne relished once again being in a creative environment. One of her teachers was charged with designing the garden at New York's Museum of Modern Art, whose new building by Philip L. Goodwin and Edward Durrell Stone had opened only that year. Anne was excited that her class had the opportunity to work on studies for the project. Another of her assignments was the design of a roadside restaurant, and here she sought her father's advice. His reply encapsulated the interplay of analytical and conceptual powers he had developed over a lifetime:

> *The only way to approach a solution of any problem is of course to visualize all the factors involved—site, topography, blow of the wind, climate, views, a closed or open plan, solemn or gay, its proper approaches, its interior horizontal and vertical circulation, whether funds are restricted or not, materials suitable or obtainable, {word unclear} of construction etc. and then resolve the whole with ingenuity and with aesthetic concept. Such is the only way that creative work of permanent value is done. I used to find that when I would get most of these practical factors clearly in mind, that I could juggle with them in my visual mind and at odd moments solutions would come, sometimes at a concert, or on a lonesome walk or when shaving, observing natural forms or in a great snow storm.*[45]

His letter, however, had been written from a bed in Swedish Hospital. Within a week of Anne's departure for Cambridge, her father was diagnosed with a kidney infection. With increasing anxiety, her mother's letters conveyed the news of his discomfort, delayed release, decline, and, finally, his unlikely recovery. Anne's studies were again thwarted. She came home in late December for what proved the last days of her father's life. Carl Gould died on January 4, 1939, with Anne and her mother at his side. At age twenty-one, Anne lost the person who was her creative beacon, her guide in life who inspired curiosity and adventure, the loving parent whose adoration she returned in full measure, the father who encouraged her to "look beyond the vanishing point."

Devastated by her husband's death, Dorothy Gould left household and financial matters for Anne to manage in Seattle. Anne's brothers returned East to school on scholarship support, Carl to Yale and John to Groton. The household was still sizable,

Anne made these specification drawings of a bookcase for her client John H. Hauberg, who was working in Everett, Washington, ca 1940.

Engagement photograph of Anne Gould and John Hauberg, 1941.

including Anne's grandmother and Aunt Jean Fay, her mother's youngest sister, and in the continuing Depression economy Anne learned the discipline of planning household budgets. To escape her grief, in late winter Dorothy left for an extended stay on the East Coast to visit Gould relatives and Vassar alumnae friends, but not before initiating a bitter dispute with Charles Bebb, the elder partner of Bebb & Gould, about Gould's share of the firm's income. In March, following the eastern trip, Dorothy left with her mother, Anne's Grandmother Fay, on a cruise to Central America. From afar, Dorothy sent Anne instructions on dealings with Bebb, taxes, and the estate, and urged her as well to continue school.

Anne, however, was ready for the independent social life of an outgoing, attractive young woman. Since adolescence she had enjoyed men's company, and wherever she attended school had ample opportunities to date. Now in the late 1930s, before wartime and the draft struck the young men of her generation, she was a popular member of her social set in Seattle. She became involved in a romance and her mother feared might marry impulsively. From her distance aboard the cruise ship, but with alarm, Dorothy Gould wrote her daughter, "Please don't get your self talked about—rules of social behavior have grown up as a *protection* and [are] only lightly cast aside by those who are ignorant." Anxious not only that Anne would marry prematurely but also that she would do so without the proper protocols, her mother continued, "You *promised* never to elope and now I hold you to that for it would be a very cruel blow to me and to your father's life-long training." In the same letter, one of several such warnings and pleas, she urged Anne to continue school at either the University of Washington or the Cambridge School, saying "I *do* think you will be disappointed if you don't finish your year at Boston."[46] In the end, the romance cooled, but the relationship between mother and daughter as a contest of wills had been laid bare.

Anne decided not to return to school—either in Seattle or Cambridge—and instead started an interior design business with a girlhood friend, Janet McDonald (who became Janet McDonald Paulson upon marriage). Her mother had hoped that Anne, together with Carl, Jr., would continue her father's architectural practice, either with a share of the firm or as an independent legacy. Dorothy Gould anticipated Anne as the creative force, Carl in the management role. Barely before Carl Gould's death, she went so far as to announce in the Seattle newspaper, "Girl Architect Has Designs on a Career." "Miss Anne Gould, the charming architect daughter of her well-known architect father, Carl F. Gould, was busy yesterday sketching a rough draft—of her future," read the illustrated article; "[S]he was stepping into her father's place at the firm offices of Bebb and Gould in the Hoge Building during his illness. It was for that purpose that she came home from Smith College the first of

this week."[47] When, a year later, Anne and Carl were named junior members of the Washington Chapter of the American Institute of Architects, their mother's words echo through the carefully constructed newspaper account of her children's achievements.[48] But Anne and her brother would not be swayed by a proposition for which neither of them felt suited. Instead, Anne and Janet McDonald found office space in the Skinner Building, on downtown Fifth Avenue, where Anne decorated their office with a mirror on one wall, bamboo on the others, and modernist furniture of her own design. They secured several jobs: the women's lounge at the Washington Athletic Club, the remodel of a department store, the interiors of a house by architect Lister Holmes that would be lost to a landslide within days of completion, and the apartment of a young man, John Hauberg, who was working at a sawmill in Everett.

Anne had met John Hauberg while she was at Vassar and he at Princeton, when a Seattle friend also attending Princeton casually introduced them. John was a timber heir, grandson of the co-founder of Weyerhaeuser, F. C. A. Denkmann, and grandnephew of Denkmann's brother-in-law, Frederick Weyerhaeuser.[49] Reared in Rock Island, Illinois, where the Weyerhaeuser Timber Company began, he had come to the Northwest to learn the business through the ranks. In 1938 he had worked in logging camps near Chehalis, Washington, and in 1939 began work at the company's Everett mill. The gregarious young man, who had reveled in Princeton's social life, spent his weekends in Seattle and returned weekdays to Everett, thirty miles to the north. Anne and Janet McDonald were pleased with their selection of a leather chair and a red rug for their client.

Anne and John were friends in the same social circle in Seattle and saw one another frequently at parties and events. They began attending the symphony together and enjoyed skiing in the nearby Cascade mountains. Around the winter holidays of 1940–41, the friendship changed tone. John wrote his parents in tempting anticipation that his social life had taken a promising turn and they might expect news.

The news soon came. By February Anne and John pledged to marry. They would wed in June, but first there were family introductions to be made. Apparently unclear about John's family connections, and in an action evocative now of another era, Dorothy Gould traveled to Rock Island to meet John's parents before giving her support to the union. Upon meeting the senior Haubergs in their grand home, she approved.

chapter 3

a golden future

Anne married John Hauberg on Monday evening, June 9, 1941.

Before they celebrated their first anniversary, the United States would be at war. With World War II providing the challenging backdrop to romance and the beginning of marriage, Anne and John began a family, remodeled their first home, and experienced the profound pleasures and losses that would mold their lives together.

June 1941 was still a time of relative calm in the United States. Anne and John's wedding covered the front page of the newspaper's society section, which was topped by the headline, "Pictures Chronicle Season's Fashionable Wedding."[1] Anne and her mother arranged the wedding together, and despite Dorothy Gould's worries about the limited budget they were pleased with the plans. For help with the flowers, Anne turned to her friend George Nakashima, then an architecture student supporting himself by working in floral design, but who would one day be an acclaimed furniture maker.[2] The wedding made a picture-book story: two strikingly handsome young people, both gracefully poised and socially at ease, the blonde debutante beauty and the tall, dark-haired lumber heir. They were married in the Florence Henry Memorial Chapel in The Highlands and afterward danced at a reception for three hundred guests at the Sunset Club.

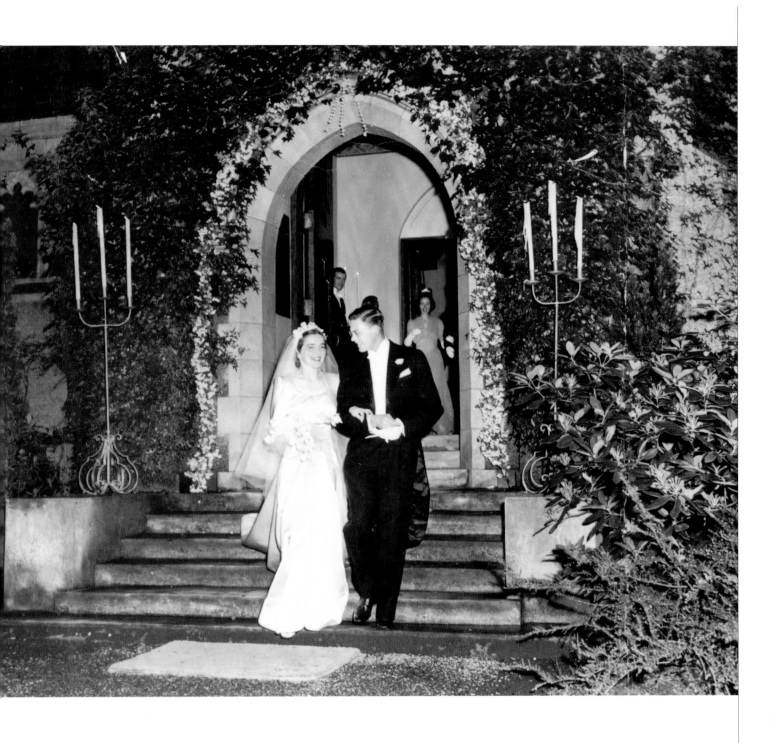

Anne and John were married at the Florence Henry Memorial Chapel, The Highlands, Seattle, on June 9, 1941.

Anne's mother and John's father, however, alone represented the parents. The other two parents would have been keenly missed. Three months before the wedding, John's mother, Sue Denkmann Hauberg, had suffered a severe stroke that left her bedridden at home in Rock Island. Two years had passed since the death of Anne's father. Although Carl Gould was not there, the young man waiting for Anne to come down the aisle matched him in height and would later mirror his civic stature.

The couple spent a month-long honeymoon at the Royal Hawaiian Hotel on Waikiki beach. In later years they returned often to Hawaii to vacation with their family. But in 1941, the choice of Hawaii was an eerie foreshadowing of global events that would overtake them and their generation. The hotel treated them to a yachting party that toured Pearl Harbor, where they saw at close range the large buildup of the American Pacific fleet. The tourist beaches were subdued because of talk of war, but they enjoyed the sunshine, warm water, and the freedom from crowds. They romanced, explored the islands, and returned home with no idea of the destruction that lay ahead. Not six months later, on December 7, 1941, Japanese planes struck the harbor, killing 2,403 and destroying fifteen ships and nearly four hundred planes. The next day President Franklin D. Roosevelt declared the United States at war.

Upon their return to Seattle, Anne packed up to join John in Klamath Falls, Oregon, a rough Weyerhaeuser mill town where he had been transferred in April of that year. It was the first of a string of small towns where they would live with few if any cultural amenities. A month after she arrived in Klamath Falls, they moved again following his transfer to a sawmill in Coeur d'Alene, Idaho. "Anne was terrified this was to be her life," John remembered.[3] The third move that year, this time to John's home of Rock Island, Illinois, was more promising. Since his mother's stroke, his father had expressed increasing loneliness. In March, before the wedding, John Hauberg, Sr., had written his son about the family summer home on a sizable property near the Mississippi River, and suggested that Anne's skills in architecture could bring the house back to life: "We have been talking about our woods house for about a year, saying it is a rare piece of property, and that we would like to doll it up, and really put it to some good use. Now with your prospects [of marriage], we will be tickled to death to have you move in, and make use of Anne's training, and make it a show place."[4] It was a remarkable statement of confidence in the young woman he did not yet know, and at a time when few women entered professional fields, but his confidence was to be rewarded. John arranged a transfer to Weyerhaeuser's Rock Island Lumber Company, and in November 1941 Anne and John moved to the midwestern town and into the Great House, John's parents' home.

The Great House, home of John's parents, John H. and Sue Denkmann Hauberg, in Rock Island, Illinois, ca 1947. The house was designed by Robert C. Spencer, Jr., of Chicago, and built 1909–11. Shortly after their marriage, Anne and John moved to Rock Island and the Great House.

The Hauberg family summer cottage, the House in the Woods, in Port Byron, Illinois, as it stood ca 1941. Anne and John undertook extensive remodeling to make it their home.

The Great House was the work of John's mother, Sue Denkmann Hauberg, who was the family link to the Weyerhaeuser enterprise. Her father, F. C. A. Denkmann, had teamed up with his brother-in-law, Frederick Weyerhaeuser, to revive a failing sawmill on the Mississippi. Their business had prospered. Sue Denkmann was committed to social service and as a young woman had worked at the Hull House in Chicago, a progressive social agency founded by Jane Addams to serve new immigrants. When F. C. A. Denkmann lured his daughter back to Rock Island with the offer to build her a new home, she built the largest house in the city to accommodate herself and several women friends also committed to social service. Before the house was finished, she had met and married John Henry Hauberg, a self-made man who had grown up on a farm and worked his way through law school, and so they adapted the house to themselves. The house was designed by Robert C. Spencer, Jr., a Chicago architect versed in the Prairie School style of Frank Lloyd Wright, and its grounds were laid out by Jens Jensen, renowned for his cultivation of native plants and habitat. Inside the house was a grand Aeolian organ, which could play such music as Beethoven and Verdi from punched-paper rolls and whose largest pipes extended from the basement to the attic. While John Hauberg, Sr., lived comfortably there, the house was always understood to be his wife's. This was the house in which John had grown up, and to which Anne and he now moved to share with his parents.[5]

Anne found Rock Island a far more amenable cultural environment than the western mill towns. Rock Island dated its history from 1835, when waterways were the main transportation thoroughfares that enabled the movement of people and goods. Settlers streamed west across the Appalachians and down the Ohio River valley to the Mississippi, where the Great Plains lay open with hundreds of miles of grassland and unimaginably rich soil. The towns along the Mississippi thrived on river commerce. When the railroad came just twenty years later, Rock Island became the site of the first bridge to cross the river. The Weyerhaeuser firm itself arose in this river-town era. In modern times, the town became part of a three-city complex known regionally as the Tri-Cities, together with Moline, Illinois, and Davenport, Iowa.[6] At the time of Anne and John's move there in 1941, Rock Island was dense with industry—not a pretty town, but a thriving one.

Anne met many friends through John's and his family's deep connections in the city. After the frontier experience of living in mill towns, they found an active community life as they socialized with friends and families John had known since youth. John wrote his new mother-in-law, "We are very busy . . . in our little social group. One can hardly call this place dull—because just when it seems the town has gone to sleep, hell breaks loose in some enormous

cocktail party. . . . Annie knows almost everybody in town by now, since we have been the guests of honor at many parties."[7] They were warmly embraced by the extended Hauberg family and joined in the traditional gatherings held on all holidays. As it did in Seattle, an older protocol still reigned there, obliging one to call regularly upon friends and family, and to stop at the home for a brief visit or to leave a calling card. Anne and John were invited into prominent civic organizations, and to their pleasure they found excellent music in the area.

The Great House was comfortable but not their own. As soon as they arrived in Rock Island, Anne and John began plans to remodel the Haubergs' cottage, which the family called simply the "House in the Woods." Located near Port Byron, then a one-hour drive north of Rock Island, the house stood within a large wooded property on a hill rising above the Mississippi, where wildflowers grew in abundance and birds migrated seasonally along the river, the central North American flyway. It was a frame house built for summer use only, with a massive fieldstone fireplace and the screen porch common to midwestern homes before the era of air-conditioning. John and his sister, Catherine, had enjoyed it as children, and not much in the house had since changed.

Anne delved immediately into the planning. She laid out the new design and hired an architect to do the drawings, for she felt the lack of not having completed architecture training. She took charge of the project from conceptualization to construction. On December 18, 1941, just a month after their move to Rock Island, the first load of lumber arrived on the site. The initial part of the project was the exterior work needed to fit the house for year-round living in the severe plains climate. The old porches came down, as did several walls to allow the reconfiguration of interior spaces. The remodeled house would include a living room, a library, master and guest rooms, a nursery, and—where the a back porch had stood—an artist's studio for Anne. Anne designed a new fireplace and chimney, built of midwestern limestone; these formed a prominent architectural feature on the west wall. A deck wrapped around two sides of the house outside the living room, where the hill sloped downward in the direction of the river and the view to the west.

In addition to their excitement about remodeling a house, they were also excited about starting a family. They were overjoyed when Anne learned she was pregnant. As the months progressed, however, Anne's mother was anxious for her daughter's health and the distance she would have to travel to Rock Island for the birth. "I worry most about losing Annie," she wrote John confidentially. "She was a premature baby and her inside digestive etc. tract is not as strong as some. She really needs the very best care. . . . I wish you could find it in your future to go to Washington D.C. or New York

Anne in the Mercury, ca 1942.

John and fellow soldiers at Officer Candidate School, Fort Sill, Oklahoma, 1943 (standing, third from left).

or Johns-Hopkins—someplace where there is a baby expert."[8] All the work Anne had done on the house now seemed to exact a steep toll, for on April 23 she was hospitalized. That evening she delivered a stillborn daughter. "We were supposed to be modern women. I built the house, drove a truck over rough country roads," Anne recalled. "There was a philosophy that you could do everything while pregnant."[9] The lumberyard where John worked made a tiny coffin for the baby. Anne came back to the Great House to recover, and a month later resumed work.

As Anne turned again to the construction project, she and John celebrated their first anniversary. In July they moved from John's family home to the Great House to the House in the Woods amid the remodeling. They were eager to move in, for as the national war effort intensified, gas rationing was to take effect and they needed to qualify for extra rations for the commute to Rock Island. John was in Rock Island daily for work, Anne less often, although social events and weekly dinners with John's father brought her there frequently. Several days before Thanksgiving that year she and John remained in the Great House. She was pregnant but not well, and in early December she was hospitalized. A day later she suffered a miscarriage. John's father noted briefly, "This is her second such."[10]

In 1942 World War II raged in Europe, Africa, and Asia. Anne and John found fewer friends for companionship in Rock Island as more and more young men enlisted or were drafted in the United States armed services, and John's draft call was impending. Two weeks after Anne's return from the hospital in December, he enlisted in the army. On March 1, 1943, he reported at Camp Grant, near Dixon, Illinois, for examinations, and a few days later learned of his acceptance to the Volunteer Officers Candidate program. In early June he was sent to Camp Roberts, near Monterey, California, for training in field artillery.

Anne stayed in Port Byron and Rock Island carrying on the remodel of the House in the Woods. Having begun by taking charge of the design and construction, she was to bring the project to completion on her own. Work on the interior consumed a year altogether. Anne designed most of the rooms with built-in furniture: an ample bench spreading beneath the living room windows, a desk and bookshelves in the library, a dresser and closets with meticulously matched wood grain in the master bedroom. Stainless steel lined the surfaces of a closet-size bar. Everywhere else she used a rich palette of woods, fitting, she thought, because John was in the lumber business, with vast forest lands in both the southern and northern

United States. For the living room she chose wide boards of sugar pine and ponderosa, and oak for the ceiling; for the kitchen, curly birch; for the dining room, butternut; and in the library water-sealed cypress. She experimented with stains and white lead to lighten the wood-paneled walls, and then gave them a soft, warm patina with a coat of wax. She used color boldly—yellow for ceilings in the studio and laundry, green ceilings in the guest rooms and nursery, dark green in the powder room. She wrote John of her experiments with the finishes:

> *The house is completely torn up. They {the painters} have a coat of shellac in the powder room which makes it look beautiful. It has a red tone. They have most all the ceilings fixed to paint and now the head painter is preparing canvas for the nursery ceiling. I thought it would be worth trying for one room, especially as it has a bad joint in the middle. He has one sample of a living room finish which I think is very good but has a little muddy look due to a white lead filler.*

> *Helberg is coming up tomorrow to see if he can think of anything better. Due to the type of seal we used, the soft wood spots when a stain in put on and yet the white lead keeps it from doing this. . . . Also the white lead lightens an oil stain which is necessarily dark. A water stain is lighter but tricky to put on and the surface has to be sanded an extra time. We have decided to bleach the nursery and the studio.[11]*

The confident aesthetic she brought to the house is evident in a letter a week later:

> *The living room is now waxed and is very pleasing. Eric Oakleaf {a painter} also put the same stain (almost) on the walls in the studio and nursery—as both were bleached and a soft wood and quite contrasting in colors. The stains did a lot for giving the wood depth and richness and pulling the whole effect together. The nursery is just about the same color and intensity as the original new boards—very nice, especially with the green closets, bed, and ceiling.[12]*

Exterior of the remodeled House in the Woods, 1942.

During John's absence, Anne wrote him about some of the new ideas in housing and design she found stimulating. She was excited by an article on housing by the Austrian-émigré architect Richard Neutra. She found it promising that such popular publications as *Small Homes Guide* addressed the "house of tomorrow." With a fertile imagination, she gleaned ideas everywhere that led to original ones of her own. In her first letter to John after he left for military service, she sketched a favorite among her recent ideas: parallel rubber strips embedded in an interior wall, a concept inspired as she waited for her car to be lubricated. The rubber, like a tire, was to be of the type that seals after a puncture. "The base mold would be curved for cleaning purposes and carry the electric cord; the other two would be for hanging pictures. They of course could be decorative looking and the base mold could be cut in one plane to make a wire connection."[13] The Port Byron house did incorporate many contemporary design concepts, but not this one.

Anne managed the team of carpenters, painters, and other tradespeople to bring the house to completion by late June. The head carpenter was a skilled old-world craftsman, and the painters sometimes numbered eight at a time. The house itself was evidence of her own design ability, aesthetic sensibilities, and determination to reach a goal that she had targeted.

The nursery in the remodeled House in the Woods tangibly signaled Anne's and John's desire for a family. Both of them hoped for a large family, as many as six children. Both of them had grown up surrounded by numerous relatives, and both delighted in the extended family gatherings that were part of the daily and seasonal rhythm of life. The Goulds had enjoyed an active life among Fay relatives and Seattle society, as well as the more relaxed pace of summers on Bainbridge, where visits of friends and family might extend for days. The Haubergs in Rock Island lived among generations of brothers and sisters, aunts, uncles, and cousins, who supported each other closely and shared every holiday. Opening their home to a wide circle of friends and their children for dinners, picnics, tennis, swimming, birthday celebrations, and parties of all kinds would become a pattern of Anne and John's lives. As young newlyweds, they eagerly looked ahead to filling the nursery. Children, however, would not come easily; Anne had already lost two pregnancies, one at full term. Now as the house moved toward completion in 1943, she was pregnant again. Having actively managed the construction throughout her earlier pregnancies, she was exceptionally cautious during the first weeks.

Another family matter also preoccupied Anne. Her younger brother, John, was to graduate in June from Groton, and she wanted badly to attend the ceremony in Massachusetts. With her mother still grieving her father's death, Anne felt responsible for supporting her

The abstract and cubist gallery at Peggy Guggenheim's Art of This Century, New York City, 1943, part of the inaugural exhibition designed by Frederick Kiesler. At right is Wassily Kandinsky's *White Cross*, which represented the kind of work shown in depth at the Museum of Non-Objective Painting.

brother through this important passage. When she received medical consent to travel, she enthusiastically planned a two-week trip to the graduation and New York City. She took her brother along to see New York sights and call upon Gould relatives.

Anne's trip to New York was filled with friends and the wealth of experiences the city offered, including theater, dining, and Fifth Avenue shopping. Yet what she found most notable was access to contemporary art and craft, to which she gave lively attention. She visited America House, a retail store for contemporary American crafts begun by Aileen Osborn Webb, and was especially excited by Peggy Guggenheim's new gallery, Art of This Century. In Paris between 1939 and 1941, until the Nazi occupation, Guggenheim had bought art from the best-known advanced artists of the day, and upon moving to New York she opened a gallery with an exhibition of the collection. The opening exhibition, designed by émigré Viennese architect Frederick Kiesler, featured surrealist paintings in a room whose gumwood walls curved onto the floor; in another room abstract and cubist paintings hung on strings at right angles to a flowing wall of ultramarine curtains. It was an extraordinary environment that signaled the gallery's avant-garde stance. Anne also sought out the stores of Georg Jensen for Danish silver design and Orrefors for Swedish glass, where, ever curious, she struck up conversations with salespeople to learn more about the craft of their products. She visited the Museum of Modern Art, recalling how, as a student, she had worked on its landscape design when the International Style building opened four years before. But all this was overshadowed by her exhilaration at visiting the new Museum of Non-Objective Painting. Billing itself as "The Art of Tomorrow," the Museum of Non-Objective Painting opened in 1939 under the patronage of art collector Solomon R. Guggenheim and the artistic direction of Hilla Rebay.[14] The art that interested Rebay, and in turn Guggenheim, was predominantly geometric abstraction; this was work that did not represent recognizable physical objects but instead emphasized relationships of color, form, and rhythmic composition.[15] It was intended to invoke the nonmaterial world and the spirituality in which Rebay believed art originated. Guggenheim's collection was replete with the work of such artists as Kandinsky, Moholy-Nagy, and Rudolph Bauer. "I was stimulated no end and am sending you some reproductions," Anne wrote John. "It was well presented—soft rugs, soft benches, soft Beethoven music. Upstairs was a man, Mr. [Rolph] Scarlett, employed to explain this art—so I spent 2 enlightening hours."[16] She delved into the subject with the genuine interest and unselfconscious curiosity that were to characterize her interactions with artists throughout future years.

Anne returned home to Rock Island on June 22 just as the final details were put on the House in the Woods. Although the home

Anne in the Illinois woods along the Mississippi, spring 1943.

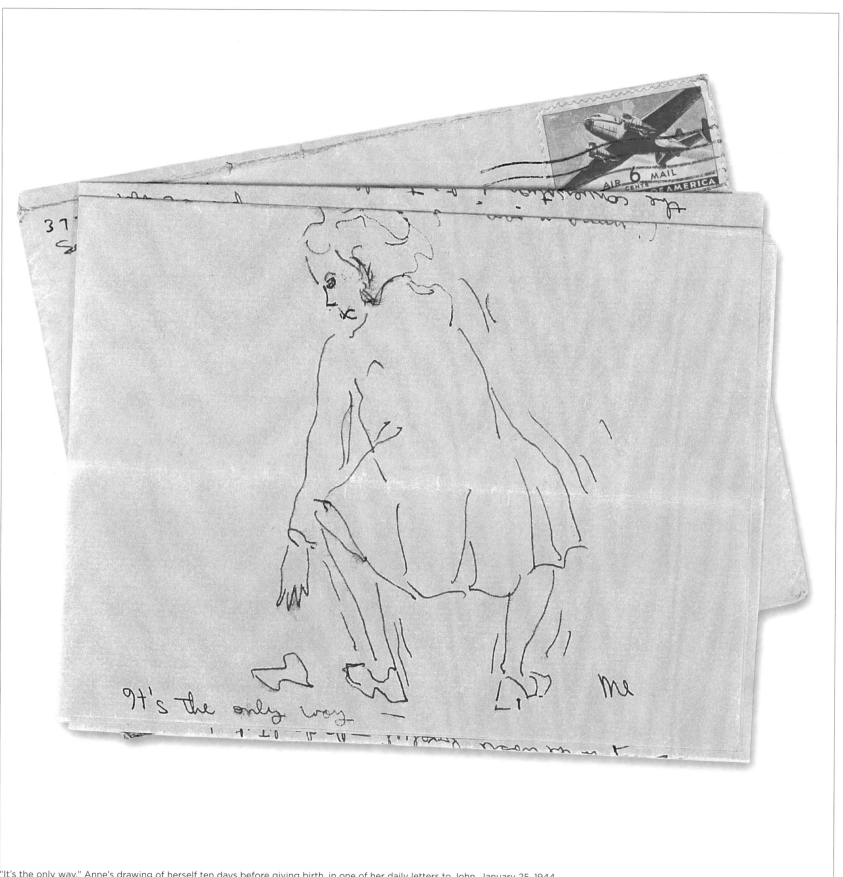

"It's the only way." Anne's drawing of herself ten days before giving birth, in one of her daily letters to John, January 25, 1944.

they had prepared for themselves now stood ready, John was in military training at Camp Roberts, and Anne left for California to join him. As events unfolded, the young couple would never live in the finished house. She rented a room near the base where he could spend leave times with her because military training regulations prohibited their living together. In November 1943, they learned of his selection for Officer Candidate School and pending transfer to Fort Sill, Oklahoma, for additional training. By now beginning the last term of her pregnancy, Anne this time returned to Seattle.

Anne could find no place to rent in wartime Seattle. Their family home had been sold upon her father's death, and Anne now lived for a month at the Olympic Hotel before finding a room in the home of a family friend. As early as 1940, even before the United States' declaration of war, the region's war-related industries, notably aircraft and shipbuilding, had ramped up production to supply equipment to European allies already at war.[17] Boeing in Seattle, like the Kaiser shipyards in the Portland area, advertised nationally for workers. Thousands of people left parts of the rural Northwest or came by train across country to take jobs. From 1940 to 1944 Seattle's population grew from approximately 368,000 to 530,000, a forty-four percent increase. Along with the unprecedented population growth came the increasing pace of production. As wartime production reached its height, the Boeing plant in Seattle turned out sixteen B-17s every twenty-four hours, and its Renton plant produced B-29 bombers in five days, at the rate of six a day. Also by 1943, increasing numbers of women joined the production lines as more and more men were drafted into active service; Boeing first advertised nationally for women employees that year, and at peak production forty-six percent of its employees were women. Housing was in extreme shortage. Workers quickly consumed available rentals; some stayed in "hot beds," where they shared a bed with others on different shifts in the round-the-clock work schedule; any available space in family homes was rented out. Besides these newcomers, thousands of military servicemen stationed at the Puget Sound region's numerous bases or putting into port thronged Seattle's streets and waterfront during their leaves. Still fearful of another Japanese attack such as had happened at Pearl Harbor, Seattle and Puget Sound regularly rehearsed blackouts in preparation for such an event. This was the city to which Anne returned to await the birth of her child.

Fay Westbrook Hauberg was born on February 4, 1944, the beginning of the family that Anne and John deeply desired. Like many military wives, Anne was alone. She and John had communicated at length about the possibility of his taking leave from Officer Candidate School for the birth. He was excited about the baby's arrival but also deeply anxious for Anne after her earlier losses.

Although her daily letters tell of her profound yearning and love for him, she urged him to consider the good record he was establishing at OCS and encouraged him to make the decision that was best for his advancement. She wrote of her plan to get herself to the hospital when the day came. And so she did, while John remained in Fort Sill until his graduation in April. The birth was a difficult one that required emergency medical treatment for Anne. But that did not suppress her joy in a beautiful baby daughter. She wrote John:

> *"Let me rave a bit about our darling daughter, She is feeding now with much energy. This morning she stayed good and awake and I was greatly impressed when I burped her and she kept her head up and eyes open and had a good look around. I am pretty sure it is unusual for a baby to be able to hold up its head for several weeks. I think I forgot to tell you her eyes are far apart (ah ha—intelligent girl!) and like all babies a deep lavender blue. . . . She has fine hair and a barrel chest. Her cheeks are so fat it is hard to tell the shape of her head. . . . She is cute as a bug's ear and looks like a girl—even though so husky. She suits me, darling."*[18]

John came home on leave after graduating as a second lieutenant when Fay was a robust, smiling two-month-old. The couple surely shared a sense of exhilaration in the brief reunion and their new sense of family.

Anne's recovery, however, was prolonged. She had gone into shock during the delivery, which she understood to be the result of a low blood count, and was treated with blood transfusions during her two-week hospitalization, then a customary maternity stay. For the next year and a half she experienced significant weight loss. What may initially have been a postpartum depression could possibly have extended into a lasting depressive episode. At the time, 1944–45, science had not yet discovered the existence of a genetic predisposition toward both clinical depression and bipolar disorder. It would be another thirty years before these links would be made. But from the vantage point of history, and reflecting on her father's depressions that followed intense and exhaustive periods of work, there is a strong likelihood that some form of bipolar disorder ran in Anne's family, which Anne now experienced.

Whatever the health issues were that Anne dealt with personally, wartime continued to direct both her life and John's. On D-Day, June 6, 1944, 150,000 American, British, and Canadian soldiers, backed by 6,000 ships and 13,000 aircraft, successfully took the beachhead at Normandy. President Roosevelt took action immediately afterward to reassign artillery officers to infantry to intensify military forces on the ground. John was thus transferred to a six-week retraining program at Fort Benning, Georgia. This time

Anne moved to join him, traveling with her baby and the nurse who had been with her since Fay's birth. Then, rather than being ordered overseas at a time of intense fighting in Europe, John was transferred to Camp Hood, Texas, about fifty miles from Austin, where he was assigned to train infantry troops, and she moved again. They bought a small furnished house in nearby Kileen. By the good fortune of John's stateside assignments, he and Anne escaped the family separations of unknown duration and the horrors of combat faced by soldiers on the battlefront. Nevertheless, the constant moving was draining. Yet another move followed Camp Hood. Early in 1945, Anne had taken Fay to Tucson to meet her great-grandmother, Alice Ober Fay, when she received word from John that he was ordered to Europe. Anne rushed back to Texas with the baby, managed to sell the house in four days, packed, and traveled to Boston for a farewell with John.

Again the emotionally charged pleasures of parenthood broke through the wartime uncertainty. As they waited day by day in Boston for John's orders to board ship, Fay took her first steps. "Every night it was something to celebrate because he might not be there the next day," recalled Anne. "Then we had something extra to celebrate: Fay walked for the first time! As she tottered back and forth between us it was such a thrill for us both."[19] Their week's time together was short and intense, although longer than either expected. The day after Fay's steps, John shipped out to Germany, arriving in Frankfurt-am-Main on May 7, the day of the German surrender to Allied forces. On May 8 President Harry Truman announced V-E Day, Victory in Europe. Once again Anne returned to Seattle.

War continued on the Pacific front until August 14, 1945, eight days after the devastating bombing of Hiroshima. At last, after nearly four years of separations, death, uncertainty and fear—longer and with much crueler consequences in Europe and Asia—World War II came to an end. From Washington State alone, 6,250 men and women had died in military service. Estimates of worldwide deaths, both military and civilian, reached 55 million people. John was assigned to facilitate the return of misplaced persons or nonmilitary prisoners of war—people who were left behind in Germany's retreat—to their homes throughout Eastern Europe.

While John was in Germany, Anne bought a small bungalow in Seattle near the south entrance to the University of Washington Arboretum. It was her fifteenth home since her marriage.[20] She decorated her new house modestly with an assured contemporary taste. Around the dining room table she placed blonde wood chairs with webbed seating. Hanging from the ceiling to the floor were drapes in a boldly striped pattern of circles and squares. In front of these stood a sleek Scandinavian-design rocker and a vividly patterned chaise, while in the center was the large white bearskin rug that had for years lain by the fireplace at the House in the Woods.

Having been reared in a family with a household staff, Anne now managed the house and the care of an active young daughter herself. John was to be on duty in Europe for more than a year after the war's end. She promptly enrolled in classes at the University of Washington, taking courses in American literature, French history, and sculpture, which was taught by a new art professor, Everett DuPen. She also began volunteer work, and, as Fay turned two, she entered her in Nursery School at UW—a step that would connect Anne to one of the most meaningful resources her family would need in future years. Women all over the United States, with or without the financial resources at Anne's disposal, learned new independence during the war. They took sole responsibility for rearing children and managing households when husbands and fathers were at the front. They raised victory gardens, led campaigns for scrap metal and war bonds, volunteered in medical and social services, and, although paid less than their male counterparts, filled manufacturing, professional, and service jobs.

As it did for so many of their fellow citizens, the war dramatically changed Anne and John's lives in the early years of their marriage. The strain and anxiety of a country at war were, for them, compounded by their efforts to start a family. Yet it was also a time when Anne gained strength and confidence as she coped with life without John and experienced the special love of motherhood.

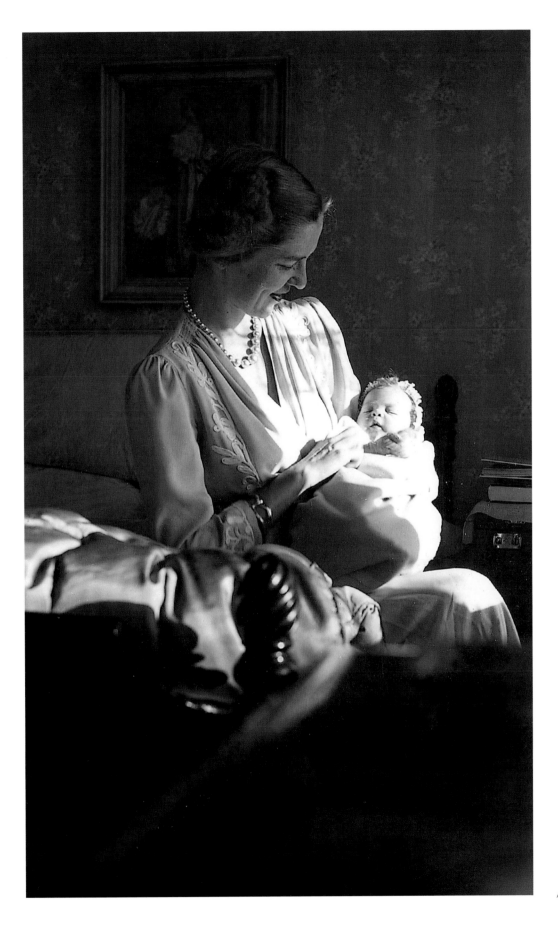

Anne holding five-week-old Fay.

Anne on the stile at Topsfield, autumn 1946.

beginning
anew
after the war

"It takes a long time to get to know your husband," Anne recalled, remembering John's return from military service. [1]

He had been overseas for fifteen months when he came home in August 1946. Fay, now a lively two-and-a-half-year-old, did not know her father. It was a time of new beginnings for all of them. As grateful as she was to have her husband safely home, Anne, along with thousands of young American women, faced the challenge of adapting to the emotionally charged shift in balance within the household and the workplace as the men returned to their accustomed roles. During John's absence Anne had structured a new life for herself with characteristic care and determination. In that interval she had been a responsive, learning parent, explored her creative abilities, and established promising new personal connections.

With John's return, Anne was now once again part of a wife-and-husband team sharing a household. The year ahead was to be one of exceptional change and adaptation for the two of them, an experience they shared with American soldiers and families everywhere as they readjusted to civilian life and one another after the long years of wartime. Anne and John also shared with these many others the pent-up desire for a growing family and a new home. They and families like them created the postwar baby boom, marking a surge in the birthrate that lasted until 1964. A parallel national boom in home construction provided a sustained boost to the national economy and spawned the far-reaching spread of the suburbs that, along with the automobile, reshaped the physical and social landscape of the United States. Unquestionably the Haubergs had the means and social standing to pursue their dreams in a style few others could attain. But the emotional motivations were the same.

The Seattle Anne and John now called home was in the throes of adapting itself from a wartime to a peacetime economy. The region's demographics along with its economic and social structures had changed irreversibly; Seattle, its population swollen by nearly half again its prewar count, now ranked among the top three cities in the country having the greatest industrial growth during the war. Both women and African Americans had entered the industrial workforce in significant numbers for the first time in history, laying the groundwork for future claims of greater rights and representation. However, the end of the war also brought massive layoffs in the region at the same time soldiers were returning home. Following a severe recession, the economy slowly began to stabilize. It would gain momentum in Seattle when Boeing launched its first commercial jet airliners, and the onset of the Cold War created a market once again for Boeing's military production. New construction, in Seattle as everywhere in the nation, helped lead the way to stabilization and growing domestic prosperity.

John returned from military service with a renewed sense of professional purpose, eager to make up for lost time. Anne's influence also instilled a new sense of direction and order to his work and daily life.[2] At Princeton, his social activities had taken priority over studying; he had failed twice and left without graduating. Now, in September of 1946, he enrolled in the University of Washington School of Forestry to study reforestation and forest management practices. Like John, many students at the university were veterans—older, matured from their years of military service, and deeply serious about study. The Servicemen's Readjustment Act of 1944, better known as the G.I. Bill, enabled thousands of veterans to seek higher education, filling colleges and universities in Washington and all over the country. This federal support had the altruistic intent of easing veterans' reentry into civilian life, while economically it

helped shield the job market from an overload of veterans seeking work. John devoted himself to his work with intensity, studying for a double major in forestry and biology. He would graduate with honors in three years. His focused studies during that period often left Anne on her own in managing daily affairs of the family.

As John studied, he looked for land where he might build a tree farm to test forest management practices. In December 1948 he made his first purchase of land, approximately 1,100 acres near Stanwood, Washington, a property east of Pilchuck Creek that was known as Pilchuck Ranch. The next year an access road was constructed to prepare for future plantings on the mountainside property. By the time John graduated in 1949, he was already established in business. His holdings on the site eventually would total 15,500 acres, more than twenty-four square miles.

Once again, as it had been the first year of their marriage, making a home for themselves became Anne and John's immediate goal. During John's overseas duty, Anne had bought a bungalow near the University Arboretum, and she did not expect John's reaction when he returned, "The minute he walked into this cute little house I had bought he said, 'It's too small.' "[3] This time they found a house to John's liking, and within only a few weeks of his return from the army they moved to 1031 McGilvra Boulevard East. In a prestigious neighborhood of ample homes along Lake Washington and located across the street from the Seattle Tennis Club, the house had more the size and presence to which John was accustomed.

It was not as much to Anne's liking. The home was Colonial on two sides, and Victorian on the others, the awkward result of an earlier renovation that offended her sense of design integrity. She agreed to live there five years, and they agreed to remodel. Anne redesigned the interiors. Outside, the Haubergs undertook a substantial earthmoving project to cut a driveway up the hill to the house and terrace the hillside around three sides of the house. They added new landscaping designed by prominent Seattle landscape architect Noble Hoggson. In the following months Anne and John filled the terraces with azaleas and rhododendrons they sometimes collected on forays to the Olympic Peninsula. Both Anne and John enjoyed working in the garden and took special delight in springtime when it came into a profusion of bloom. As the project neared completion, Anne commissioned a sculpture by Everett DuPen for the garden. This was the first of many commissions, one that awoke her love of working with artists.

In addition to the reuniting of their young family after the war, the couple found the needs of their extended family claimed their attention almost immediately. In November 1946, Anne and John moved her grandmother, Alice Ober Fay, into their new Seattle home. Alice Fay became a partial invalid when she lost a leg to poor

Interior of the Seattle bungalow that Anne bought when John was away on military duty.

John's forestry class visiting a tree nursery on the Wind River in southern Washington.

circulation, yet none of her daughters or her son was in a position to care for her. The role fell to her granddaughter. Anne was fond of her grandmother, and the family found her good company. Anne cared for her for two years until her death in November 1948. Although the Haubergs now had a housekeeper and a governess, as well as a generously sized house, the responsibilities were nonetheless significant for a young mother.

Anne and John held onto their vision of a large family. In the fall of 1946, as events swirled around her in the short time that John had been home, Anne was pregnant again. It was not to be. In April the next year, she delivered a stillborn child, her second experience of this kind. The loss was acute, the months of waiting and preparation bluntly terminated. Yet despite the loss, Anne and John maintained their hope, only to meet disappointment again when another miscarriage followed the stillborn birth. There would be additional miscarriages, but to Anne, in retrospect, they paled by comparison to the losses of two full-term pregnancies. Her determined optimism must have helped her look ahead as she took refuge in the promise

of the house remodeling project and delight in three-year-old Fay's explorations and growth.

Fay had been attending the University Nursery School since she was two. Anne had enrolled Fay there as she grappled with single-parent responsibilities during John's overseas duty. Knowing she wanted to rear her children differently from the manner her parents had followed, yet not knowing what new guiding philosophy could take its place, she sought to learn as much as she could about modern progressive practices. The school provided for parental participation, and here Anne met Eleanor Evans, the Director of Preschool and Early Childhood Development and a teacher in the Department of Psychology. In her eagerness that first year, Anne had also enrolled in a course in child development taught by Evans, a course she found more challenging than her studies in architecture.

Founded on campus in 1942, the University Nursery School was only a few years old when Anne had enrolled Fay there. It was established during wartime, at the same whose time a federal mandate was issued to provide care for the children whose parents were in the

military or essential industries. Governed by an interdisciplinary academic board, the Nursery School was an experimental school with a threefold educational mission of teaching young children, providing parental guidance, and training new teachers in the field.[4] It served university and nonuniversity families, as well as having an important community role. The school provided consultation and in-service training to the newly established childcare facilities, a need that expanded rapidly as more and more women were recruited to industrial work and, correspondingly, volunteer community groups of all kinds accepted children in their care.

For Anne, the parent education studies were especially meaningful. She had the opportunity to observe classes, meet individually with the teachers, and attend the monthly parent discussion led by Eleanor Evans. Evans had come to Seattle to teach in the Nursery School in 1944 and became Acting Director the next year. Besides her responsibilities in supervising the school's child and parent education program, she was the academic adviser to university students in the field and assumed a quite considerable advisory role to local and regional communities.[5] Anne's receptivity and dedication complemented Evans's personal interest in the arts, and the two began a valued friendship. Anne benefited from Evans's knowledge of age-appropriate behaviors and, most importantly, gained greater confidence in her own abilities as a parent.

Evans showed herself to be a social and an educational progressive. As the war ended and the Nursery School assessed how to balance its commitments to the community as well as the university, she raised questions about economic and ethnic diversity. In a memorandum to the school's advisory board in January 1946, she asked whether there should be a quota of scholarship children, perhaps supported by higher tuition for others: "Should there be a more conscious effort to get a cross section of the community?" She then tackled ethnic diversity: "Should we make an effort to include other nationalities—negroes, Japanese, etc." and asked, "Does the Board have an opinion regarding the number of Jewish children to be enrolled at one time?"[6] Her question about Japanese American children was surely a pointed one, given the war in the Pacific so recently ended, the federal internment of Japanese Americans on the West Coast, and the degree of anti-Japanese sentiment in the Northwest. Professor Stevenson Smith, head of the Department of Psychology and a founding member of the Nursery School advisory board, responded, "If we make an effort, conscious or unconscious, to get a cross section of the community it would be because such a cross section best serves the purpose of instruction and research. The inclusion of various nationalities, insofar as this becomes merely a gesture indicating democratic mindedness, would in my opinion be quite silly. If we need various nationality samples as a

Four generations: Dorothy Fay Gould, Alice Ober Fay, Fay Westbrook Hauberg, and Anne Gould Hauberg, 1946.

Anne enrolled Fay at the University of Washington's Nursery School. Eleanor Evans, who directed the school, became Anne's friend and was to prove a seminal contact for educational resources. University Nursery School flyer (detail), summer 1946.

part of a Nursery School equipment along with the sand boxes and jungle gym, then by all means let us have them."[7] Evans dutifully conformed to the conservative position on admissions, but her inclusive "democratic mindedness" is significant in light of the friendship she and Anne developed and the discussions they must have shared. It was an attitude Anne would demonstrate repeatedly in later life.

Anne's connections to art and university life through her parents' affiliations opened the door for the young couple to a widening social circle. Anne had a warm friendship with Richard Fuller, benefactor and founding director of the Seattle Art Museum. Her father had worked closely with Fuller at the Seattle Fine Arts Society, the museum's predecessor organization, where both served as presidents, and had designed the new Seattle Art Museum, which was completed in 1933. Anne and John were invited to museum openings, at a time when these were private black-tie affairs, and to Fuller's home for the more exclusive opening night dinners. Anne's active interest in art led to growing friendships with artists in the region, many of whom exhibited their work at the Seattle Art Museum. She and John attended events at the University of Washington, where, through her parents' activities, Anne was well acquainted with many people, and together the couple developed new friendships there.

With the pleasures of this social life came an equally felt sense of obligation. The legacy of Carl Gould—his professional excellence, ethical standards, and civic engagement—was very much alive in the Gould family. In addition, Dorothy Gould saw that Anne was invited to join such prestigious women's groups as the Colonial Dames, the Sunset Club, and the Seattle Garden Club, where Anne was among the youngest members. John described his impression of the pressures to excel: "The impact on Annie and me of these three, Granny Fay, 'Mrs. G.' [Dorothy Gould] and their recollections of Mr. Carl F. Gould, was profound. Annie and I were in the spotlight as soon as we came back to Seattle to live. It was much harder on Annie than it was on me. . . . [T]he social pressures on Annie were difficult to define. We gave as many parties as we were invited to, and Annie's parties were always the best."[8]

As 1948 began, Anne reflected on the year just ended. The year had been dominated by her pregnancy and recovery from the stillborn birth, but by year-end she was feeling stronger and more confident. She wrote in her scrapbook,

"'47 was valuable, in that I learned a bit about {how} organizations and groups work, broadened my friends, learned more practical experience about photography and flower arrangement, and learned a good deal about gardening. It was a year to get caught up and I definitely feel I am starting '48 a bit ahead of '47. . . . I would like to continue a clubby year and learn about the city in a general way, entertain more often . . . I'd like to take a course in photography and take a literary course, also interior decorating course. Skiiing, badminton for sports, more summer picnics, trip to California. Sailing and fishing, also continue with child study. . . ."[9]

Her energy had surged back.

By the close of little more than a year, had anyone the gift of foreknowledge, one could have seen all the major themes of Anne's life: the profound rewards and trials of family experience, a commitment to education, the shaping of homes, an understanding of art as a living process, and an energetic social and community engagement. Beginning anew after the war, she and John had solidified a strong partnership that would take them forward into the next decades together.

John, Anne, and Fay on the wall of their terraced garden, part of the Haubergs' remodeling of their large first house on McGilvra Boulevard.

the doors of education

By early 1950, the family that Anne and John desired seemed theirs.

On October 3, 1948, when Fay was four, they celebrated the birth of their second daughter, Sue Bradford Hauberg. In 1949 Anne was pregnant again and looked forward to the birth of her third child the next spring. She wrote her father-in-law in late November, "[Sue] is crawling all over and I found her in the fireplace this morning although Johnny was six feet away. . . . Tonight I was holding a bottle in one hand for Sue, turning the eggplant in the frying pan and talking on the telephone. With another baby, I'll just have to start using my toes."[1] On March 21, 1950, a baby boy, Mark Denkmann Hauberg, was born.

Anne with Fay, age four, and Sue, born
October 3, 1948.

All of the Hauberg children bore names that proudly honored their families' legacies. Fay's name, Fay Westbrook Hauberg, embraced both sides of Anne's family; Fay was transposed from Dorothy Fay Gould's family name, while Westbrook was Carl Gould's mother's maiden name, given to Anne, and in turn to Fay. Sue carried the first name of John's mother, together with Bradford, a family name from the Fays' lineage that stretched back to the governor of the Plymouth Colony. Mark's name memorialized John's family. Mark was a favored name among his father's kin, and Denkmann was his mother's maiden name.

As much as Anne and John envisioned the affectionate good times shared by a large family, all was not well with their two youngest children. Before Sue was a year old, it became apparent that she was not developing normally. She was so far behind in achieving developmental milestones that doctors declared that she would never walk or talk. When Mark was born a year and a half after Sue, it was evident at birth that he had even greater developmental impairment.

Little was known in the late 1940s and early 1950s about the range of conditions, causes, and treatments of brain-injured children.[2] "You had no help during that period," recalled Anne. "There was nobody to help you, there was no sympathy, no understanding. I was very lonely."[3] Even in 1971 John would say in a speech on mental disability, "My wife and I have absolutely no clue as to why our two children were handicapped."[4] Anne and John sought nationally for the best doctors in the field they could find, and Sue and Mark were tested to determine what opportunity each child had to grow and develop. The stress on the family was considerable. The Haubergs situation was not exceptional; they too felt like other parents of children born with disabilities, who commonly experience a succession of grief, anger, anguish, and anxiety, along with an impulse to place blame. Complicating the picture at the time was the predominance of Freudian theory among the medical profession, and particularly the prevailing interpretation of Freud's theory of personality development, which held the mother responsible for the condition of her children. Today, more than a half-century later, dramatic advances in the field of human development have taken place. With stunning frequency, the burgeoning field of genetics provides new clues to human biology and physiology. A revolution is underway in the understanding of the causes, prevention, therapies, and education of those born with disabilities. For parents and their children, perhaps the most valuable is the development of wide-ranging systems of support available to them. But none of this existed in 1950.

In the early 1950s there were few alternatives but to institutionalize children with mental disabilities. "You put them in an institution and never saw them again," Anne said of the expected choice. "It was very clear that you didn't keep the child."[5] They were "throw-away" children, as one of her friends described the mindset of the time.[6] Anne refused the idea of institutionalization. She would not submit her children to the indignity, the impersonal and endless routine, and the hopelessness that it implied to her. She held out the hope that in time new kinds of care and treatment would be developed to benefit her children. For several long years she fiercely protected them, resisting the doctors who urged that Sue and Mark be placed in an institution where they would receive care considered appropriate to their conditions. She also resisted her husband, who initially seemed inclined to follow the doctors' recommendations.[7] She refused to give up her children, and she refused to give up hope.

From the time Sue was born, she had shown greater potential than her younger brother. When she was two and a half years old, her parents took her to Anne's maternal uncle, Dr. Temple Fay, a distinguished neurologist, neurosurgeon, and psychiatrist in Philadelphia. Dr. Fay had taught neurosurgery at Temple University until 1943, when he shifted his work to the field of rehabilitation. He was an innovator and, like many of the Fays, a courageous and sometimes controversial individualist. In the 1930s he had pioneered the use of hypothermia during brain and heart surgery, a procedure that was initially dismissed but eventually became and has remained established practice. His work in the 1950s focused on repatterning brain processes in brain-injured people, a process in which he explored methods of stimulating other parts of the brain to take over the functions of the injured area.[8] Dr. Fay diagnosed Sue's condition as hydrocephalus, or water on the brain, which he said inhibited her thought processes, and prescribed a dietary regimen to control her intake of fluids. Until his death in 1963, he would continue to counsel Anne and John on Sue's progress and offer advice through her vulnerable times of transition, as when she entered adolescence or during her transfer between schools.

Even with household and childcare help at home, the major load fell to Anne. John was deeply involved in starting the tree-farm business, which regularly kept him out of town two nights a week. His business responsibilities as a member of the Weyerhaeuser board periodically meant traveling two or three weeks at a time, and it seemed always on Fay's birthday, which coincided with the Weyerhaeuser Company's annual meeting. He was already engaged in cultural affairs, as well. He had joined the board of the struggling Seattle Symphony in 1949, and, to help stabilize the organization, in 1950 assumed the role of its executive vice-president and business manager for a year and a half. He served on the boards of the Seattle Art Museum and the Helen Bush School. Together Anne and John maintained the active social course they had set early in marriage, and found time to travel to such favorite cities as New York and

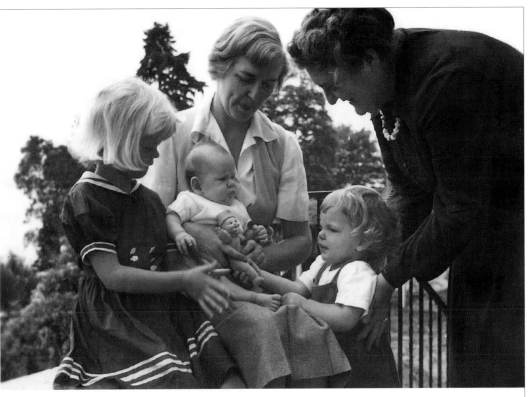

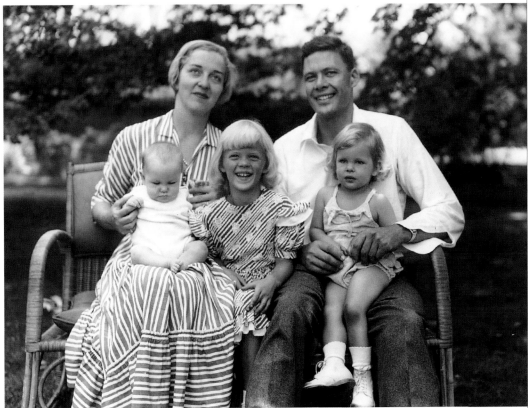

Photos clockwise from top left: Sue, 1955. Anne with Fay, Mark, born March 21, 1950, Sue and her mother, Dorothy Gould, 1950. Anne and John with their three children, Mark, Fay, and Sue. Ann Ritz with Mark, 1954. Mark, 1953.

San Francisco. They even hoped to spend a year in Europe with the children, where John could study European forest-management practices and Anne could study architecture.[9] It was a plan that was never realized.

Mark's needs were great, to the point that they were proving more than the family could manage. Although Anne had been determined not to institutionalize her child, by the time Mark was three and still not walking or talking, she recognized that he required more dedicated help than they could provide. Anne followed one lead after another until she found a family who could provide the support her son needed. They were Hart and Ann Ritz, a couple with no children of their own, who took Mark into their home to care for him. As Mark neared his fourth birthday, Anne wrote to her mother, "Mr. and Mrs. Ritz both love Markie and we couldn't have found a better place for him now."[10] John added in his own letter to Dorothy Gould, "Truly this arrangement is almost heaven-sent since I have not seen Anne look so well in many months and Mark is absolutely thriving in his own little way."[11] Several weeks later he could write to Anne's aunt, Jean Fay, "They are a very fine, steady and happy couple able to give Mark the routine and the quiet that he needs in which to develop. I think we are quite fortunate in having such a place for him. He is coming along much better and how long he stays with the Ritzs before coming back to us depends on a good many things."[12]

While the Haubergs struggled to understand and cope with their children's challenges, John put on an optimistic front in letters to family and friends that are as telling in what they omit as what they say. In a 1951 letter to his aunt in Illinois, he wrote in an upbeat voice, "All of our tribe are busy and well. Mark still does not walk but since Suby [the family's nickname for Sue] did not walk until she was twenty-six months old, we are not yet disturbed. I guess maybe we will have to admit that the Haubergs get off to a slow start."

"Fay is finding life very complicated," his letter continued, "and is rushing around taking dancing lessons, riding lessons and is about to start on ice skating lessons not to mention group piano lessons at school. All of this tied in with chores around the house, birthday parties, and other such hard labor really keeps her busy."[13] Fay attended the Helen Bush School, where Anne had gone in her youth, and her parents were grateful to see her flourishing. In addition to school she took lessons in arts and sports of several kinds, where she displayed her early athletic ability. "She is a little blond bombshell," John wrote his uncle.[14]

Because no educational alternatives to institutions were then available, a psychiatrist who was caring for Sue recommended that she be placed in a normal school situation even though she was not yet talking. And so, as Sue neared the age of three, she began preschool at the Helen Bush School, where Fay was then in second

grade. In mainstreaming today, when a child with disabilities is placed in a regular classroom, the child is typically taught ways to cope with difficult social situations. Such preparation for children and their families was nonexistent at the time, and Sue became the target of her classmates' bullying. It was a painful experience for her, one that Anne saw as not only fruitless but also harmful.

In the face of unacceptable options, Anne was determined to seek the best possible education for Sue. She called upon her friend Eleanor Evans, head of the preschool that Fay had attended, the Nursery School at the University of Washington. She asked if there were someone among the student teachers who might be appropriate to teach Sue, who then was nearing five years old. Indeed there was. Evans introduced Anne to Myrene Kennedy McAninch as an outstanding student who was especially good with children. McAninch seemed uniquely qualified for her new role. The studies in early childhood development that she had completed in the Department of Psychology represented her second degree, for she had already earned a degree in English literature. Moreover she also had a background in music and art and a facility for drawing. Her experience in the arts would be especially helpful in her teaching Sue, and it struck a responsive chord with Anne as well. In a report a number of years later, McAninch described her first meeting with Sue:

> SueB {Suby}, as she was called, was almost five years old. She weighed approximately 36 pounds, evidenced virtually no language other than the syllables "ne-ne," which she repeated for hours while moving her hands back and forth before her eyes. She demonstrated the motor skills of a child of 12 to 18 months. But something happened during our first meeting.
>
> I sat in front of SueB, took her hands in mine, and began to sing "patty-cake." Suddenly SueB stopped repeating "ne-ne ne-ne" and looked up at me. I gave her a big smile and gathered her into my arms. I began singing cradle songs to her while rocking her gently. As SueB relaxed, Anne knew that I was indeed the person to work with her daughter. I recognized that behind the blankness of the "ne-ne-ne" was a little person I wanted to get to know, if I could find a key to unlock the door.[15]

McAninch began working five days a week at the Haubergs' home. Her approach was to restructure the patterns of Sue's actions and behavior, sequentially re-teaching her such basics as crawling, walking, and running. It was a process similar to the methods that Dr. Temple Fay was developing, in which a healthy part of the brain was repatterned to assume the functions of the injured area. The Hauberg household, however, was a busy one. Anne and John continued their tireless schedule of engagements outside the home,

with both of them participating in civic and cultural activities. Fay was a lively, energetic nine-year-old, and there were also the comings and goings of the people who took care of the house and the garden. After several months, McAninch concluded that there were too many disruptions to sustain an effective learning environment for Sue. She arranged with the Haubergs to take Sue to her own home during the week and return her to the family for the weekends. At the time, McAninch lived with her mother and grandmother. It was a household, in McAninch's description, comprised of three generations of independent women who believed women could achieve whatever goals they set for themselves.[16] The arrangement to take Sue home was a full-time commitment for McAninch, who was then only twenty-two, and it proved to provide the nurturing environment necessary for Sue to break out of the isolation that had developed during the first five years of her life.

McAninch worked with Sue individually for seven years. Reading as widely as she could in the area of learning disabilities, McAninch developed an individualized program of techniques and materials for Sue's instruction. The arts played a significant role in her teaching; Sue responded expressively to music and enjoyed drawing with crayons. Working with her, McAninch drew horses to help her understand animals. Sue began to develop language and the large motor skills to run, climb, and play. She also developed the socialization skills that made it possible for her to interact with other children, and with time she learned to read, write, and do basic arithmetic. McAninch developed materials in pace with Sue's progress, for there were none of the kind available, and a clinical psychologist, Arthur Dahl, tested the child's learning. Not only did Sue become part of McAninch's family as years passed, but McAninch also became part of Sue's family, joining in holidays and occasionally traveling with her on Hauberg family trips.

Even in the first few months in McAninch's care, the changes in Sue's socialization and skills were evident in John's correspondence to family members. "Suby still does not talk," he wrote Anne's brother and sister-in-law, "but she knows every damn thing you say. It must be that Gould dutch in her."[17] "Suby is a real siren," he told his father, "and works us for everything she wants. . . . She likes nothing better than to help clear the dishes off the table, help sweep, providing somebody else is sweeping too and when I am out raking and sweeping up the yard, she is always right by my side. She still carries on a terrific conversation in an unknown tongue but is beginning to try to imitate our language more and more."[18]

In the winter of 1954, Anne and John and their children began the first of what became annual holiday vacations to Castle Hot Springs in Arizona. The casual, low-key ambiance of the private guest ranch proved a needed respite from the stresses and pace of

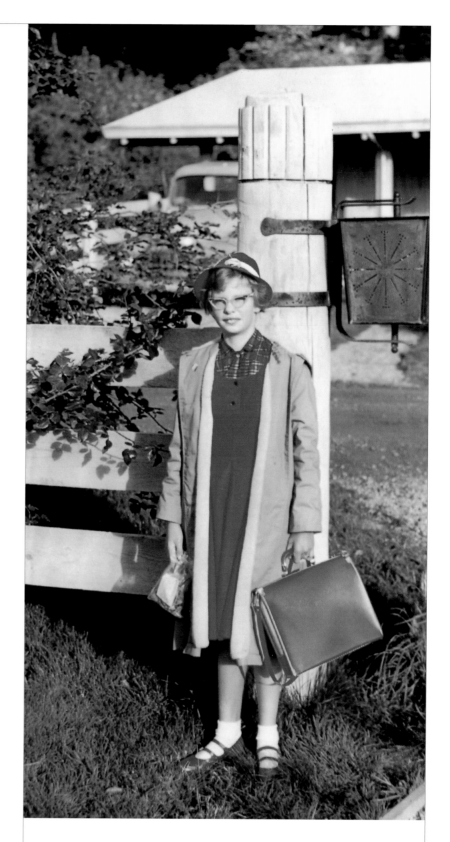

Sue in new red school clothes, leaving home on Bainbridge for the first day of the Pilot School, 1960.

their daily lives. The ranch offered Fay, by then an experienced horseback rider, an exciting new environment for one of her favorite sports. For six-year-old Sue, the ranch offered a gift that no one could have anticipated. Here she first learned to ride, beginning what became a lifelong pursuit at which she was to excel. Anne and Sue then remained in Arizona while John flew back to Seattle with Fay as school began. Anne wrote her mother,

> *Suby and I are still in Castle Hot Springs. . . . {T}hese 3 weeks here have done her so much good I'm greatly inclined to stay to Fay's birthday. . . . Our day goes like this. Breakfast at 8:30. Mr. Rex seats Suby . . . She helps herself to jam. She says 'I want cocoa' and 'Hi' to anyone. . . . Then Suby visits the office and the gift shop and then goes by herself to the stables (past the orange grove and cutting garden). There Earl (in charge of 75 horses) . . . kids Suby; there's also Louis and Lee, both nice cowboys. About then they put Suby on a horse (a very small western saddle) and lead Suby up the road and back down the creek . . . and we wave to each other. She sits up there with much confidence."*[19]

Many years later her father could exclaim of her newfound interest, "Sue was hooked for life!"[20]

With Sue's growing development in forthcoming years, Anne believed that other children with brain injury or disability might learn from the methods McAninch had developed. She knew there were few existing educational resources and wanted others to benefit as Sue had. She wanted to help families who had struggled as she had to pursue solutions to the complex of challenges they and their children faced. Following discussions with the University of Washington, the Haubergs purchased two small houses on the south edge of campus near the present-day Medical School and provided the funds to launch a program to implement new research and teaching methods. The houses became the home of the Pilot School for Neurologically Impaired Children, known simply as the Pilot School. Its purpose was to provide the children with the behavioral and academic education they needed, as well as to train university graduate students in the School of Education in how to work with such children.

From the beginning, the Pilot School was an interdisciplinary research endeavor, drawing together a number of departments whose studies pertained to atypical child development. Initially involving only the departments of psychology and medicine, it quickly expanded to include speech and language counseling, music, art, physical therapy, and recreational therapies. Its director was Dr. Charles Strother; academically it was placed under the authority of the Dean of the Graduate School, Joseph McCarthy. The three-part

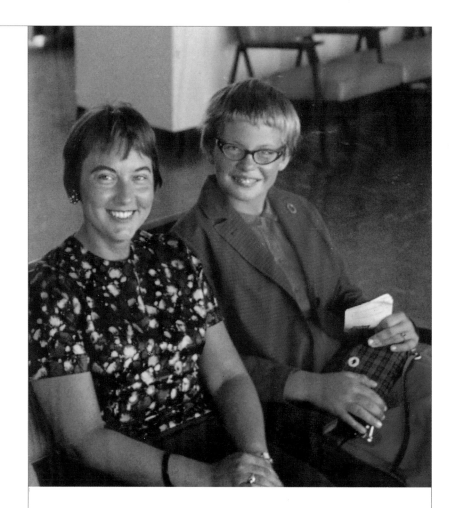

Myrene McAninch accompanied Sue to the airport as she began the Devereux Ranch School in Santa Barbara, September 1962. McAninch taught Sue individually from 1953 to 1960, and beginning in 1960 was the first teacher at the Pilot School for Neurologically Impaired Children, University of Washington.

thrust of the program—services provided to the children, teacher training, and interdisciplinary research—was remarkably like the model of the University Nursery School that had nourished Anne as a young parent.

The Pilot School opened in 1960 with only Sue and two other children under McAninch's instruction; after the retrofitting of the houses was completed, the class filled to ten students, ranging in age from five to twelve.[21] The students were chosen to represent a range of types of learning disabilities and to achieve a balance of girls and boys. Within the school's first year a preschool class was added, and subsequently another older class with a different cluster of problems, this one dealing with emotional rather than cognitive disabilities. Under Strother's leadership, the teachers developed individualized programs to meet each child's needs until the child was secure enough to enter the group class. By the end of three years, the Pilot School had a long waiting list; many more families than could be accommodated sought admission for their children.

The new environment was initially a challenge for Sue, who until then had no experience among a peer group and clung possessively to McAninch. The school, however, offered her an opportunity to grow socially and academically. By the end of the first term the effect of the change is evident in her father's letter. "She is very pleased at having been in school for the first time," he wrote to a family friend. "She goes to a school for kids just like herself out at the University of Washington. It is only a small class but she is certainly happy to have some playmates and she is making great progress. She is a Girl Scout and is looking forward to getting her own horse some time this winter or spring."[22] Sue was among the most advanced of her classmates at the Pilot School. After two years, when McAninch prepared to leave the Pilot School to complete her own studies, Sue and her family faced a decision about Sue's educational future. In 1962 she graduated from sixth grade with honors and prepared for the next step, the Devereux Ranch School in Santa Barbara.[23]

The Pilot School, which arose from Anne's vision of an education for her daughter as well as to provide an opportunity to share its fruits, continues today as the university's Experimental Education Unit. Commonly known as the EEU, it retains the same three-part mission on which the Pilot School was founded: services to children and families, professional training, and research. The EEU now focuses solely on early childhood, serving children from as early as a few weeks of age to seven years who present a wide range of abilities. It also includes typically developing children among its students, and supports active family involvement. Among the top-ranked programs in the country today for its range of services and professional training, it is unique in operating as a self-contained school led by its own principal, giving it a strong focus on the child within the academic context.

After the opening of the Pilot School in 1960, John called Dean Joseph McCarthy, its academic head, to ask what more could be done for brain-injured children and their families. The Haubergs' timing was auspicious. In 1960 an interagency committee of the State of Washington recommended the establishment of a research and training center to meet the needs of agencies serving families of children with disabilities, while at the same time academicians and clinicians at UW had been discussing the need to coordinate their work in the field. John made a major financial gift to the university to launch a capital campaign for a multiple-facility, interdisciplinary research and training program. The intent was to combine and coordinate the university's numerous research and clinical departments which, until that point, had worked separately on issues having to do with the prevention and treatment of mental disabilities, having little or no interdepartmental exchange. A laboratory school—the Pilot School—would have its own building, alongside a clinical unit for child evaluation and professional training, and behaviorial and medical research facilities. Support for this goal was greatly boosted by the recent election of President John F. Kennedy, whose family included a sister with mental disabilities. The new administration promoted congressional enactment of legislation to provide support to states in constructing just such facilities. John took the lead role in securing Washington State matching funds to qualify for the federal assistance, and in raising additional private funds statewide.

As the campaign began, the president's sister, Eunice Kennedy Shriver, representing the Kennedy Foundation, spoke before the Citizens' Committee charged with fundraising. The experience she described was one that mirrored the Haubergs':

> *Thirty years ago, when my own family was struggling to help my sister Rosemary, we were confronted with an almost solid front of hopelessness and despair. . . .*
>
> *This was the situation when my father . . . said to us, "Care and education are important. But how can we prevent mental retardation? How can we get at the source of things?" . . .*
>
> *We soon learned that scientists cared little about mental retardation; that the general public knew nothing of the subject and confused it with mental illness; that most doctors regarded retardation as a hopeless affliction; and that no one was working exclusively or even mainly on mental retardation.*
>
> *Not one medical school, not one psychology department, not one sociology department, not one research center offered a program of training or research in mental retardation.[24]*

The Child Development and Mental Retardation Center (CDMRC, later renamed the Center on Human Development and Disability) at the University of Washington, designed by architect Arnold G. Gangnes. The building complex opened in 1969.

Shriver went on to describe the revolutions just beginning in research, maternal and child care, and education. This was the hope for which Anne had held out and that now spurred John's leadership.

In 1969 the new building complex opened; it was called the Child Development and Mental Retardation Center and was known for years by the initials CDMRC. Today it has been renamed and is the Center on Human Development and Disability. The CDMRC was the first and most comprehensive program of its kind in the United States. The buildings, which included a dedicated building for the Experimental Education Unit, were designed by Arnold G. Gangnes. The school's entry and the hallways featured decorative brick elements designed by artist Norman Warsinki—images of animals, fish, and insects that would serve, both visually and tactilely, as guides to the children. It was Anne who insisted on good architectural design and an inviting environment for the school. "We talked about a building that people would want to enter," she recalled of the process that produced a single-story building with a welcoming entry and wide hallways. While some wanted a tall building for its power to impress, Anne knew that it was meant—and should be built—for children and their families.[25]

The press coverage of the CDMRC credits John alone, acknowledging his significant leadership in fundraising, but also reflecting men's dominance in public roles at the time. There was no question, however, that the combined projects were a result of Anne and John's passionate commitment together. Describing their effort, their daughter Fay recalled, "They were a team back then. He was the one who could go out there and get the dream accomplished in a practical way. She was good at talking to people about the idea, that this was really something we must do for these children. She could articulate the passion, and she'd nail people! Just nail them to the wall! . . . Dad was the front person."[26] Originally conceived as a four-building complex, the school and the research center—two buildings next to the University's Medical School—make up the center today.

Anne and John's commitment to educating children with learning disabilities greatly helped Sue, but their youngest child, Mark, was more severely impaired. In seeking to help him, they learned of a medical procedure, recommended by Dr. Temple Fay, Anne's uncle who had been such an important source of support and guidance to them. It was a technique Dr. Fay had used frequently, an x-ray of the brain known as a pneumo-encephalogram. In the

Eunice Kennedy Shriver visited the Pilot School on the UW campus during her trip to Seattle to support the fundraising campaign for the Child Development and Mental Retardation Center, April 4, 1963.

What began as the Pilot School flourishes today as the Experimental Education Unit, a national leader in its field for its services to children and families, teacher education, and research.

summer of Mark's fourth year, on August 11, 1954, Mark was admitted to Seattle's Providence Hospital. He died of complications from the invasive procedure. The neurosurgeon Donald E. Stafford, M.D., wrote, "I believe that everything possible, from the medical standpoint, was done to help Mark, but apparently the brain condition was such that he was unable to survive the additional effects of the encephalogram."[27] Anne and John were devastated. They received a compassionate letter from the Ritzes, who had cared for Mark in their home. Referring to the "sweet, beautiful child," they wrote John, "We are so grateful to you and Anne for letting us share the happiness that Markie brought into our lives."[28]

Following a service at St. Barnabas Church on Bainbridge Island, Mark was buried in Rock Island at the Hauberg family plot in Chippianock Cemetery. His great-uncle Louis Hauberg noted at the ceremony that he was the last male child bearing the family name.

As she recovered from the loss of her son in the months and years ahead, Anne clung to her belief in the possible. Possibility for her meant seeking opportunity where there seemed little hope, supporting creative innovation when the outcome was unknown, and sharing the gifts that resulted. The experiences of her daughter Sue validated her belief. Anne's chief regret in life was her own inconsistent and incomplete schooling. Yet for someone who doubted her schooling, education became "the key," in her words, to all for which she aimed.[29] For Anne and John together, the losses they experienced in their own family nevertheless gave birth to a school and research center that brought possibility to many more children. Anne would be drawn time and again to educational missions, until education became a guiding principle of her life.

JOHN HAUBERG RESIDENCE
Terry and Moore Architects Jan 31-'54

Roland Terry, of the firm Terry & Moore, designed the Haubergs' new
contemporary home at 1101 McGilvra Boulevard East. Drawing, January 31, 1954.

designing
for life and art

For the Haubergs, the year 1954 began in hope, was tragically interrupted, and then emerged to renewal.

They were to build two new homes within a period of three years. While building a new house can be stressful under the best of circumstances, it was during the designing of the first house that they lost their son, Mark. As Anne and John grieved, these homes seemed to offer them another sense of the future, proving to be constructive endeavors of the most profound kind. The relative certainty of projects that could be planned and completed as desired, the clarity of decisions that were material and financial rather than achingly personal and unknown, must have provided a grounded sense of satisfaction in contrast to the uncontrollable events of their lives. Within three years, they completed not only a house in the city but also a house on Bainbridge Island.

Such building projects were among the things Anne and John most eagerly shared throughout their marriage. They represented the gathering of a vision of how they wanted to shape their lives within a space, the close working relationship with the architect who gave form to the dream, the innumerable practical and aesthetic decisions as the form became concrete, the thrill of experiencing the new space, and the reconstructed relationship to the site it created. These were spaces to shelter private dreams and signal social standing and hospitality. There was a deep satisfaction in realizing a dream in so tangible and personal a way. For Anne, design and construction brought the intellectual challenge and sensory pleasure of creating a richly layered environment for human activity. For John, there was both the goal and its handsome achievement. Already they had remodeled two homes for themselves. Now within a short time span they were to undertake two major construction projects alongside the demands of their young family and their increasing commitments to the cultural and civic life of the city.

The first house, which they were to call the "town house," was begun in 1954. It was the result of a long-standing promise between Anne and John that their home at 1031 McGilvra Boulevard East would be only temporary. They had bought the house at 1031 immediately upon John's return from the army. Anne had always disliked it; to her, not only was it was too large, but its exterior had two contrasting styles, while inside it was a mélange of many rooms that lacked a graceful, functional flow from one room to another. Even after it was remodeled to better match their needs it could never give the kind of visceral satisfaction that good design provides. Anne had told John she would live there five years. As five turned into eight, in early spring 1954, they bought the property next door at 1101 McGilvra with the intent to build a house to her liking.

They began planning construction without delay. Anne confidently made two seemingly risk-taking decisions—although she did not see them as risks. With a clear vision of her own, she unhesitatingly chose a young architect who had not yet designed a project of the Haubergs' scope. He was Roland Terry, her friend since their student years together at the University of Washington. Then, in the neighborhood of ample and well-groomed traditional homes, she planned a house of daring contemporary design. "Unlike some women," she recounted several years later, "I not only knew how to read a blueprint but also knew exactly what I wanted. We all gave ourselves quite a challenge. The lot was narrow, sloping, and ugly. I wanted a tall, multilevel, vertical house with an open room plan at a time when everyone else was building low, sprawling houses."[1] While the open concept was Anne's, she gave complete credit to Terry for the plan.

Roland Terry had distinguished himself as the prized student in his architecture class at the University of Washington.[2] In the years ahead, he would be known for his distinctive skills in envisioning a unified conception of site, landscape, structure, and interior design.[3] He, as well as Anne, had studied architecture at a time in the school when the Beaux-Arts tradition was giving way to modernism, a transitional period when modernism might still incorporate elements of traditional design in seeking a contemporary, regional expression.[4] He was influenced particularly by two teachers, Lionel Pries, professor of architecture, and Hope L. Foote, head of interior design, a famously rigorous program within the Department of Art. Both Pries and Foote had lively interdisciplinary interests, and both worked between the terrains of old and new, as well as regional and global. After graduation, Terry more than once lived abroad, and he brought from these older places a taste for the cultivated landscape, along with the particularized regional and vernacular adaptations of site, materials, and style. He developed a fine appreciation of the natural elements of the Northwest, its muted light and abundance of wood. His decorative sensibility, a counterpoint to the purity of form of high modernism, might alone have distinguished his work. But that was to come in the future. He had had few chances to demonstrate such talent when he received Anne's invitation.

In the spring of 1954 Terry began work on the house under the firm name Terry and Moore, which represented his business partnership with Philip A. Moore. He and Anne established a productive working relationship built upon their mutual respect as well as their shared language of architecture. His opportunity came with significant challenge. The site was just sixty feet wide, seemingly offering scant area for the expansive program the Haubergs desired. They had a number of needs: bedrooms and play areas for their young family, then numbering three children between the ages of four and ten; a separate master suite; a kitchen and dining room to serve both daily family use and frequent entertaining; a living room and adjacent "public" spaces to accommodate sizable numbers of guests.

The house Terry designed is a tall cube broken by expansive planes of windows, a structure that lifts above the street on the steep, narrow lot. The front entry interior reaches the full three-story height of the house, where overhead two walls of windows open the view from upstairs to Lake Washington and beyond. Up a broad stairway, the living room extends two storeys, with one wall of floor-to-ceiling windows. The window wall looks onto the intimate and cultivated nature of a patio garden, in contrast to the territorial view at the entry. To one side of the living room, a balcony creates the master bedroom above and a study below, simultaneously defining functional areas and dramatically enhancing the experience of open

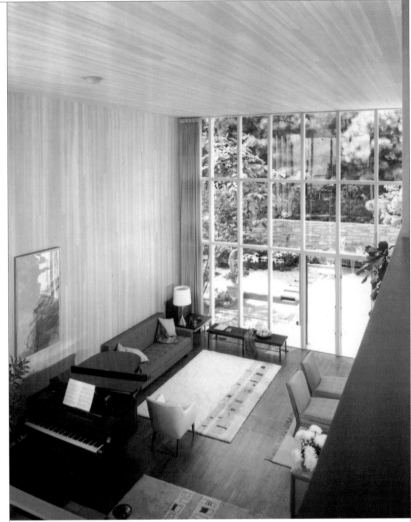

Stairwell above the main entry of 1101 McGilvra Boulevard East, with a view toward Lake Washington and the Cascade Mountains.

Living room looking onto the patio. The furniture was designed by Roland Terry and Warren Hill, the carpets designed by Hill.

space. Although the plan is vertical, the space feels laterally open as well; because of Terry's sensitivity to the qualities of light and his inventive pattern of flow, it encompasses a succession of spaces that flow diagonally back and forth across the width of the building. In all of the rooms, hemlock sheaths the walls and ceilings, its pattern and tactility lending visual warmth and drama.[5] The exterior is vertically laid fir.

As the next spring approached, the house neared completion and the family moved in, although the custom furniture Anne planned was not yet ready. Yet even in its incomplete state the house proved its suitability, as Anne found when she impulsively decided to take advantage of the open space for a party. Barely six weeks after the family's move, and with only a day's planning, she organized a Mardi Gras party. The social columnist for the local paper wrote,

In about as much time as it takes to tell it, Mrs. John H. Hauberg, Jr., planned one of the happiest parties that's been given here in a long time—a Mardi Gras dance last night in the Haubergs' new home. She got the idea at 11 a.m. Monday, sent telegrams to a group of friends inviting them for 9 o'clock the next night, put up good balloons for decorations, chose an eight-piece orchestra (which played on the balcony overlooking the big living room) and fans and eye

masks for the women and gold crowns and similar masks for the men. Fay, the hosts' young daughter, dressed as a clown, gave out the favors at the door. . . . "I saw no point in putting off a party until all our furniture was in," said Mrs. Hauberg. "Anyway, it's easier giving a dance when there isn't much furniture."[6]

That evening set the style of many more parties to follow. The Haubergs became known for their hosting of family and friends, as well as the organizations they supported, each event given a distinctive flavor by Anne's taste and energy, and each imbued with the home's creative environment.

Besides Terry, two more designers benefited from the opportunity presented by the McGilvra house. They were lighting designer Irene McGowan and interior designer Warren Hill, both introduced to Anne by Terry. McGowan designed lighting fixtures throughout the house, ranging from the backlit house number at sidewalk level to the chandelier hanging from the height of the entry stairwell. Having studied at the Cornish School and the University of Washington, she had risen in the business world to become the owner of a lighting company. She designed lighting exclusively for architects, becoming one of the few women active in the building industry. With projects like the Hauberg house, which was featured in national publications, McGowan pioneered the incorporation of lighting plans into architectural design.

Working together with Terry, Warren Hill designed the furnishings, nearly all of which were custom-made for the new house. Hill had graduated in interior design from the University of Washington under the mentoring of Hope Foote, who had influenced Terry as well. The program, whose award-winning student production made it among the top-ranked in the country, was distinctive for the hands-on experience in designing and constructing furniture it required along with its academic studies. Having studied with the support of the G.I. Bill, Hill was not long out of school and was teaching at Seattle's Cornish College of the Arts when Anne provided the opportunity to design furniture for their new home. Hill designed the dining room furniture and the rugs throughout the main floor. He and Terry jointly designed furniture for the living room and library. His work for the Haubergs' town house garnered national recognition, which opened further opportunities to him.[7]

In completing the development of the building and site, Terry designed the landscaping for the entire property, from the street to the steep bank behind the house. Here the predominant features are two enclosed yards that create visual and functional extensions of the interior spaces. The main outdoor area lies adjacent to the living room, and is composed of a paved patio with two pools connected by a waterfall, a walled garden set into the hillside, and trees selected

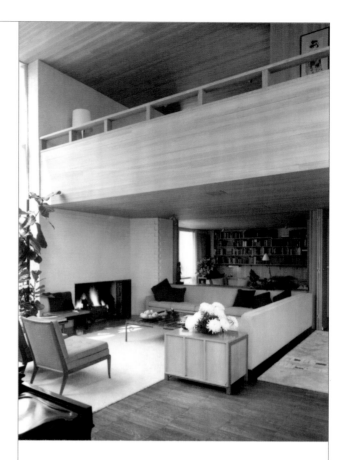

Balcony of the master bedroom, living room below.

Warren T. Hill, Sideboard, 1956 (lacquered walnut with oxidized and waxed bronze hardware). Above it hangs a painting by Mark Tobey, *Northwest Fantasy*, 1954; candlesticks by Hill.

Roland Terry, patio and garden; pebble mosaics by Guy Anderson; sculpture, *Harmonica Player*, by Everett DuPen; fountain hardware by Warren Hill.

Guy Anderson laying mosaics of beach pebbles in the patio.

to leaf and bloom in seasonal succession: Japanese maple, magnolia, and dogwood. The less formal enclosed yard lies at the entry level. In a location where the front yard or public facade would customarily be, it too, in Terry's design, is a private space that extends from the interior to create a play area for the Haubergs' children. Artist and friend Guy Anderson wrote Anne and John after a visit several years later, "A note to thank you for the most pleasant evening. I had almost forgotten how beautiful your house and garden are. . . . The general feeling of your home, and now with the plinking of water, has a most restful and reassuring atmosphere."[8] Anderson's own love of gardening would inspire Anne's ideas for her next garden.

Anne envisioned a complete environment shaped by art and design. She was acquainted with many artists in the Seattle area, and, through her father's influence, carried on his commitment to the integration of building and decoration. With John's agreement to a budget of $5,000 ($34,000 in today's dollars), she began to commission works of art that would become part of the house. She chose knowingly. From painter Guy Anderson she commissioned mosaics for the garden patio, which he made of beach pebbles that Anne and her friends collected along the Puget Sound shore. From the University of Washington sculptor Everett DuPen, whose sculpture adorned their earlier McGilvra house, she commissioned a terra cotta figure, *The Harmonica Player*, for the garden pond. Another art faculty member, ceramist Paul Bonifas, designed the bronze vessel adorning the front entry. Jane Givan Johnston, interior design instructor at Cornish, designed screens and pillows using textiles hand-woven by her husband, Bruce Johnson. Painter Paul Gustin, a Gould family friend and also Anne's godfather, produced a fourteen-paneled screen painted with the wildflowers native to Mount Rainier for the master bedroom.

In most of these commissions Anne asked the artist to stretch beyond his or her usual practice. She expressed confidence in their creative solutions, and was richly rewarded by their unique artistic productions as well as by the artists' loyalty. Although a mural for the dining room by Morris Graves was never realized, a letter from the artist, who was then living in Ireland, describes the kind of exploration both she and John willingly supported:

> *No, I have not forgotten you and the new dining room {Graves wrote}, but this letter should have been written in Istanbul where I stopped in November on the way from Tokyo to Shannon—doing so specifically to see the mosaics. I found St. Sophia a wonderful experience, but I also found that to accomplish a mosaic for your new house (which would be acceptable to us all) would take a great deal of experimenting with this dazzling two-dimensional medium. Also, fresh from Japan (where I had worked for many weeks with one of*

Guy Anderson, *Dream of the Language Wheel*, 1962, in the Haubergs' living room. Anderson thought the painting was one of his best of the time and expressed pleasure in the Haubergs' purchase. Purchased by Anne and John Hauberg, 1963.

Tokyo's best screen-makers and Kakimono-mounters, Kujurai) I was full of this knowledge which I had needed for years. . . . So, long before seeing the St. Sophia mosaics, I had been thinking in terms of the things I had learned in Japan for your mural—i.e. ink and tempera and silver leaf left untreated and exposed to air to bring about the subtle lead-greys of tarnished silver, to which could be added fresh silver treated to stay brilliant and the gold-leafs (which do not lose brilliance) and have a range of color from warm gold to light brass-yellow, —all these colors are in the range which we discussed for the possible mural.[9]

Granting such license and encouragement to artists she commissioned was to be one of Anne's most outstanding characteristics throughout the years.

Looking back on the experience, Terry reflected on the result:

The thing most unusual about this house is the Haubergs' own point of view. Rarely does one find clients interested in evolving most interior and exterior detail by means of commissioning works of art. . . . The design, I think, has stood up well through the years and proved to be a success, and restful for constantly changing art works. I have always been rather proud of how a very complex series of requirements was worked out in an interesting interior special arrangement.[10]

While a number of new houses in varying shades of contemporary design now stand among the traditional ones in the neighborhood, in 1954 the bold contemporaneity and thoughtful adaptation to site of the Hauberg house made it a beacon of progressive ideas.

Anne's impassioned embrace of art produced in the Northwest dramatically enhanced the statement of regional style the house proclaimed. From the first works of art she commissioned for it, she and John became regular purchasers and committed patrons of art from the region. Anne's early friendships with artists and her respect for and comfort in working with them sowed the seeds of her principled support. While Anne benefited from her parents' connections to the art museum and the university, she cultivated these relationships to artists in her own right when she resettled in Seattle as a young adult. In this, the construction of the new McGilvra house laid the groundwork. With the completion of their two houses, she and John began to collect in earnest. Anne led the way. John was a willing partner, and Anne was always forthright that it was his wealth that made such support possible. Together the two of them became preeminent collectors of art from the Pacific Northwest, widely respected for the generosity of their contributions. They escalated their participation, too, becoming founders of several

organizations to support and nurture artistic endeavor. Yet the spirit of support, along with the imaginative breadth with which she conceived and organized it, was distinctly Anne's. She led from two strong points: her knowledge of art, and her developing emotional bonds to the artists.

The couple began by collecting painting and sculpture by artists with whom they had personal connections. The painters were those who made up what became talked about as the "Northwest School," whose identity centered on Mark Tobey and Morris Graves and their colleagues.[11] Tobey and Graves had been well-known nationally since the early 1940s, but for Anne they were long-standing personal friends. She had taken an art class from Tobey as a child and established an adult friendship when he returned to Seattle in late 1939 after having lived in England; he would be an influence on her until his death in 1976. Through the Seattle Art Museum she befriended Graves and Guy Anderson, and she knew others, such as sculptors Everett DuPen and Paul Bonifas, through the University of Washington. The Haubergs' commitment to these artists extended beyond art purchases. To Bonifas, for example, whose bronze vessel marked the entrance to the McGilvra house, they provided sustained financial support throughout several years of illness and misfortune in the artist's family.[12]

Their collection steadily broadened as they added depth to one or another artist's representation and simultaneously widened the circle of artists represented. To Tobey's *Northwest Fantasy*, one of their first purchases for the house, they added paintings in his more characteristic calligraphic style and several drawings. They purchased the metaphoric painting by Morris Graves, *Concentrated Old Pine Top*, and in subsequent years added more of his major works as they did also with Tobey's. They acquired a collage, *Abstract Screen*, from a seminal body of work by Paul Horiuchi when it was first shown in 1961. They sought signature works of art. Guy Anderson wrote to Anne in May 1963 of a new painting that he felt was museum quality, and in August, "I am delighted that you and John like *Dream of the Language Wheel* and plan to keep it. It's the one painting that I have done recently that I have wanted to have the right home."[13] By 1965 their home displayed works by these and such others as painters Ward Corley, Kenneth Callahan, Ambrose Patterson, Richard Gilkey, and sculptor Ray Jensen. Within the next few years they added, for example, works by Portland artists Hilda and Carl Morris; major abstract expressionist paintings by William Ivey of Seattle; and a signature wood sculpture by George Tsutakawa. They visited galleries in Seattle, San Francisco, and New York where artists from the Northwest were represented and awaited with eager interest the Seattle Art Museum's Annual Exhibition of Northwest Artists, where they might also make purchases.

Library with Paul Horiuchi's *Abstract Screen*, 1961. Purchased by Anne and John Hauberg, 1961.

Paul Bonifas, ceramic bottle, undated (11 ¾ x 11 x 7 ½ in.), one of a number of ceramics by the artist that Anne and John collected. Purchased by Anne and John Hauberg, date not recorded; collection Anne Gould Hauberg.

The McGilvra house accumulated a layered richness marked by a distinctive material and aesthetic sensibility. Art and the building were all of a piece. Their home became a destination for architecture and design students, visitors from out of town, and local cultural organizations; it was twice on the Seattle Art Museum's homes tour. And just as Anne had organized a party when the house was first completed, she and John celebrated their tenth anniversary in the house, this time with one hundred fifty guests. Among them was local newspaper columnist Don Duncan, a commentator on the local scene, who wrote with wry admiration, "Skid Road personalities, do-gooders and sporting types normally generate far more enthusiasm on this typewriter than do the denizens of high society. But Anne Hauberg can out-character the Yesler crowd, out-perform the causists, and out-talk Jack Hurley." Newly convinced, Duncan described the seriousness of Anne's commitment: "What especially sets Anne apart is her strong belief that local artists are, indeed, the equal of any in the world. Along with this, she has a philosophy that she feels deeply but has difficulty expressing. Basically, it is that artist and art lover come together by some divine design, that there are in every person's life opportunities that must be seized upon or the world will be the poorer." He concluded by quoting her view about artists and excellence: " 'They are good; they know they are good; they never are satisfied with less than the best.' "[14]

However much their Northwest contributions were applauded, Anne's and John's collecting horizons were not confined to this modern regional work. During annual trips to New York and San Francisco, they collected prints by established nineteenth- and twentieth-century European artists, as they had done since they were married—prints by Pissarro, Bonnard, Picasso, Miró, and others. John began his own collecting with a gift from UW professor and anthropologist Erna Gunther in 1953. In thanks for his financial help in acquiring a collection of Native American Northwest Coast objects for the university's Burke Museum of Natural History and Culture, she gave him a ceremonial raven rattle from the acquisition. It was the first object among many that John would gather into one of the country's most significant collections of Northwest Coast art.[15] For several years beginning in the mid-1960s he bought Ancient American art from Central and South America. As he pursued his own collecting interests, John readily credited Anne with introducing him to art. While in hindsight Anne expresses regret she wasn't bolder in asking John for more financial support for purchases of Northwest modern art, their collection, in the context of their home environment, became a showcase for the region. It was an emphatic statement about her taste and loyalties.

Hardly was the new house completed when Anne and John began planning the construction of a house on Bainbridge Island, the

Master bedroom with mural by Paul Gustin (partial view, left wall), drawings by Mark Tobey (right wall). Gustin was Anne's godfather, and Tobey would be a mentor and also a recipient of her loyal patronage.

Library in 1970s with glass collection and a chair by George Nakashima. A few years after completion of the house, the Haubergs enclosed the outdoor loggia to create a library.

George Tsutakawa,
Obos No. 2, 1958
(wood, 22 ½ x 15 ½ in.).
Purchased by Anne and
John Hauberg, date not
recorded; collection Anne
Gould Hauberg.

"country house." They had fortuitously acquired the land in 1952, when Professor Milnor Roberts, a close Gould family friend from the University of Washington, had asked if the Haubergs would like to buy his and his sister's waterfront property at the southernmost tip of the island. The land was open and level, a three-hundred-foot stretch along the beach. It was in the same neighborhood as Topsfield, the summer home Anne's father had designed and where her own family now spent summers. The offer was an irresistible one.

They cleared the land in August 1956, and in October began construction, again selecting Roland Terry as the architect. On the McGilvra house Anne had been the one who worked directly with Terry; however, this time John took the lead in the planning. And while Anne imagined a small summer cottage such as her father had designed at Topsfield, Terry proposed a larger, more impressive design that he sensed would meet both John's desires and the family's needs. It did that and more, becoming a place of gathering for extended family and many friends.

The Bainbridge house is a horizontal building, responding to the open site with the same sensitivity as the town house design did through its contrasting verticality. It is again a wood structure, characterized inside and out by its posts of peeled logs and its beams with subtle decorative incisions wrapping each end. From the exterior, the marked horizontality of the structure is countered by the strong pattern of vertical siding, where rough-sawn planks as much as a foot wide are laid board-and-batten style. Extending this vertical counterpoint are narrow boards that form screens and fences to surround the garage and service areas. All are stained the gray-beige of driftwood. Setting off the roughness of natural material is the decorative detail of a hand-carved door framed by a painted fresco, both drawing attention to the entry.

Inside, the house spreads expansively in an H-shaped design, with window walls opening to protected courtyard spaces and magnificent Puget Sound views. Logs provide the supporting posts for the exposed-beam roof structure. Stone floors, fireplaces, and the dominant posts ground the building and add to its assertive use of natural materials. At the crossbar of the H, an area that separates the service and living areas, light filters through a glass-roofed dining room and central hallway. Throughout the house there is a fine balance of light with the strong structural elements.

Anne and John envisioned the house and grounds as welcoming active use by their extended family and friends. Terry's design for the approach to the house brings a subtly European touch to the informality of the setting, with a short driveway flanked on each side by a formal row of flowering trees, and alongside these the low lines of stone walls that mark the rise and fall of the ground. Near the house a small building originally served as an art studio. A tennis

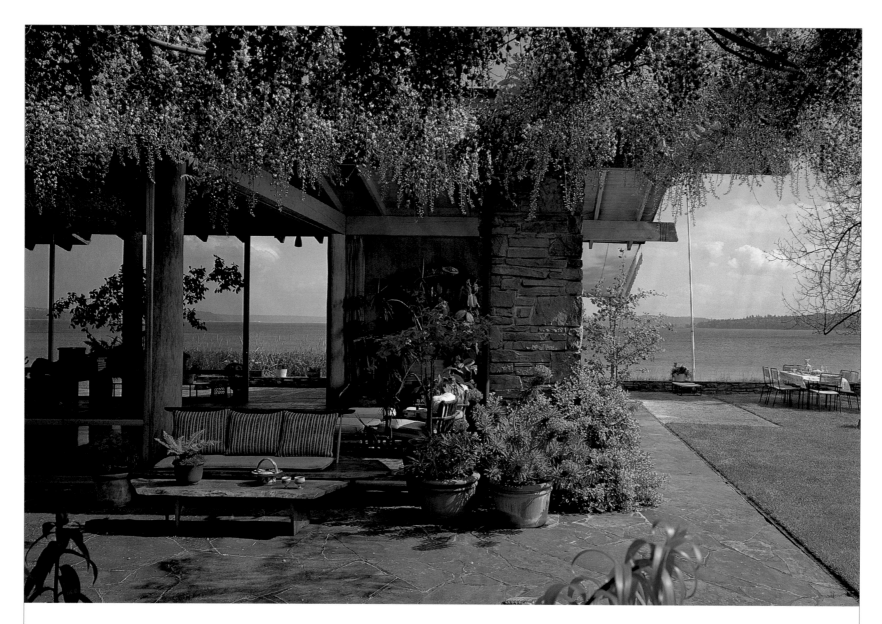

Living room wing looking south to Puget Sound.

court lies beyond the carport, and next to it are raised garden beds for vegetables and cutting flowers. On the east side of the drive they built a riding ring, and across the road a stable. A saltwater pool was planned and added several years later. The Haubergs' gregarious playfulness and vision of a communal place are evident in Anne's notes to herself during the development of the property. She listed its possibilities: "pool—how [to] develop it? croquet, tether ball, permanent ping pong table, horse shoes, badminton?"[16]

The plan for the overall extent of the property was produced by Seattle landscape designer Noble Hoggson concurrently with the construction of the house. In springtime the first year, the plan showed a putting green, tennis court, and stable; by December it added areas for shuffleboard, croquet, badminton, and tetherball—mapping out Anne's list. Hoggson planned trees of many species throughout the property: purple beech, liquidambar, pines, apples, oak, bing cherries, flowering crabapple and plum, dogwood, katsura, Russian olive. Anne worked closely with the process and, when the land was still raw, created plans for the garden beds surrounding the house, imagining poppies, daisies, and bachelor buttons in the riding field, grapevines and manzanita along the wall, groupings of

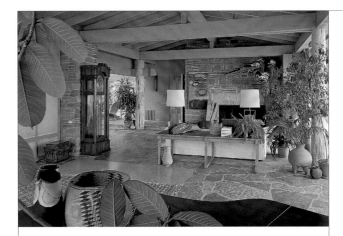

Interior of living room.

Anne eagerly planned vegetables and cutting flowers for the raised-bed garden on Bainbridge.

Roland Terry, Terry & Moore, the Haubergs' Bainbridge home, 1957. Main entry with the door, a solid plank of Alaskan cedar carved by James Wegner, and a fresco by Wes Snyder.

flowerbeds by color, and mixing in color patches of flowers alongside the vegetables. As the planting progressed over several years after completion of the house, she kept lists of plants and ideas for the garden and each spring listed the vegetables she would plant. She noted species from Guy Anderson's white garden, which appealed to her, "Clematis vitalba (30'), Traveler's Joy—small, white flowers—late summer bloom, fluffy seed heads [in the] fall . . ."[17] The love of gardening was her own, although she had strong models in the women before her. Her grandmother had helped found the Seattle Chapter of the Garden Club of America; and in her own time her mother had led the group, published several articles, and lectured frequently. Anne would take delight in the seasonal palettes of colors and the contributions that vegetables from her garden made to dinners at their Bainbridge home.

The country house, named "Summertime," became the true gathering place Anne and John imagined. Each summer they and their children moved to Bainbridge, just as Topsfield had drawn the Goulds throughout Anne's youth—and for several years, Anne and John's own family. With their magnanimous sense of hospitality, the country house became the site of celebrated parties and the favored place for neighborhood games. Anne and John may not have been able to have the large family they'd desired, but they surrounded themselves with extended family and friends and created an environment that welcomed them warmly. They held annual Fourth of July parties and End of Summer parties. Their pool and tennis court were open for neighborhood use. "You are cordially invited to come swim in our pool this wonderful summer," a letter announced to their friends. "Pool hours are from 1:00 to 7:00 p.m. Grandmothers' hour is from 10:00 a.m. to 12:00 noon."[18] A train caboose, which they won at a charity auction and transported to Bainbridge, immediately became a children's playhouse and overnight cabin (although neighbors objected to its appearance). Here, as in the city, Anne's irrepressible love of a party gave style to each event. She took a fancy to a pair of hand-painted clown shoes, which she often wore in greeting guests as they arrived from the ferry.

The town and country houses each appeared in publications, and both helped define a Northwest style of residential architecture.[19] During the 1950s and after, there was widespread interest in characterizing regional adaptations of the international modernism that took root in the United States in the 1930s and spread throughout the country after World War II. The Northwest experienced some of the greatest wartime growth in population and economic base of any region in the country, growth that subsequently fueled postwar construction. Its opportunities for new design were plentiful and free of entrenched building styles to adapt to or resist. As a number of the Northwest's young and mid-career architects

Morris Graves, *Concentrated Old Pine Top*, 1944 (tempera on paper, 57 ½ x 3 ¼ in.).
Purchased by Anne and John Hauberg, 1956.

received national recognition for their work, there was increasing discussion about the emergence of a coherent regional style.

When the American Institute of Architects held its national conference in Seattle in 1953, the professional magazine *Architectural Record* published the opinions of six Seattle architects about the question of a regional identity specific even to Puget Sound.[20] Those like Paul Thiry who argued in favor of a definable style noted the influence of the environment, the abundance of wood and wood-building traditions, and the response to vernacular forms. Five years later, one of the six architects, Victor Steinbrueck, summarized the argument in his teaching notes for the University of Washington School of Architecture. He cited the "freedom of expression encouraged by newness of country, design for mild climate and soft rainfall (32"), varied and skillful use of wood, adaptation to hilly topography, and orientation to views." He added a sixth point with a question mark, "Special personality of people (?)"[21] This list of Steinbrueck's, who was to help rally new public appreciation of Seattle's built environment through his efforts in historic preservation, could be a literal description of the Haubergs' town and country houses. The homes' sensitive capitalization of the qualities of their sites, their permeability between interior and exterior, and their expressive use of wood complemented by the ephemerality of light made them hallmarks of a contemporary Northwest style that continues its currency today.

In building their two new houses in 1954 and 1957, the Haubergs became part of a nationwide postwar boom in residential construction that reshaped the American landscape and the ideal of family life. After years of shrinking demand during the economic ravages of the Depression and the rationing of materials in the war years, by the late 1940s growing postwar stabilization established the ground for a new prosperity. Home construction surged forward and grew exponentially, fueling a sustained recovery; nationally, more than 13 million homes were built between 1948 and 1958. The lumber industry benefited directly, and for two decades forest products were delivered at record levels.[22] Augmenting this growth, products for the new homes and new households, many of them made of materials developed during wartime, became the mainstay of a new consumer capitalism that began to drive the American economy. Washing machines, vacuum cleaners, television sets, and phonographs became staples of 1950s households. Their marketing projected a popular ideal of the capable and attractive housewife—an image Anne was to fulfill with exceptional style even though decades later she would look back and wonder at the way women "were sold a bill of goods" through the expectations created for their role.[23]

Many years later, as Anne reflected on this period of building, she frequently exclaimed, "Two houses in three years nearly killed me!"

Yet it was a time she described with pride as well as passion, for those were the years when she broke out of the limited mold the 1950s set for women. In the early years of their marriage, Anne had been the one primarily responsible for the family. She had been active in social organizations but not yet able to commit the energy and focus that characterized her later activities. After Mark's death and with Sue's steady progress under Myrene McAninch's care, she began to experience some release of the overbearing anxiety that had made her experience so lonely. The ache of loss would remain lifelong, but the houses were a reaffirmation of her creative drive. She took the lead in planning the new McGilvra house, and for the first time since the birth of her children stepped into a quasi-professional role, one requiring that she not only use her architectural education, but also work within a set of project-driven goals and constraints. Her own talent now combined with her family legacy of strong, independent women and her father's creativity. She threw herself with consuming energy into the myriad decisions new construction entails, as one house followed the other. In all, her intense participation in the processes of design, landscaping, and furnishing would extend seven years.

Party invitation, undated. The Haubergs gave frequent parties, and Anne planned each with a unique flair that became the stuff of memories and stories.

Beyond their architectural and artistic attributes, both homes also demonstrated how a knowledgeable patron could contribute to the emergence of a regional identity. Anne understood the integrity of design and the integration of its parts, and developed a conviction about bringing the stamp of human creativity to all of its elements. Her knowledge of art, her affinity for handmade materials, and her belief in supporting local artists permeated both houses, giving them a palpable spirit and taste. John supported her in these convictions and learned from them. The houses they built, the art they collected to fill them, and the gatherings of friends and organizational causes they hosted in them became emblematic of Anne and John themselves. More than fifty years later the two houses remain signature expressions of modernist design, place, and a humanist empathy for the life to be lived within their spaces.

Anne with Everett DuPen's *The Cloud*, the first work of art that she commissioned.

citizen in action

On June 3, 1958, a Salmon Seafare took place at the Hauberg home on McGilvra. The neighborhood had never seen anything like it. On a temporary fireplace of concrete blocks in the driveway, salmon cooked over a fire tended by Native American tribal members.

They brought with them a painted mural in Northwest Coast style, a treasured family possession, to hang on the garage, and artist Guy Anderson sketched their portraits, which guests could buy for thirty-five dollars each. "This is probably the first time that both races will engage in salmon-baking at the same local function," noted the newspaper in advance press.[1] Inside the house, a competition raged among professional and amateur cooks for the best salmon dish. Anne had arranged the competition, which included such prominent figures as Seattle Symphony conductor Milton Katims alongside the chef from the Olympic Hotel. The winning recipes would be published in a forthcoming article in *House & Garden* magazine. "Harry from Trader Vic's brought a big salmon," she recounted. "He said it cost forty-five dollars! I didn't realize it was out of season. . . . The Indians had the fire going for twenty-four hours before they cooked anything. Salmon fillets, lots of butter. It was the best!"[2] Anne's ideas for the salmon grill, the art-making, the competition, and the connection to *House & Garden* produced a successful fundraiser. At two dollars a ticket, the event raised eight hundred dollars for the Seattle Creative Activities Center.

Children in an art class, Seattle Creative Activities Center, ca 1957–59.

The Seattle Creative Activities Center, which offered performing and visual arts to children, faced a financial crisis. Anne was a board member and among those responsible for the organization's well-being. The center was little more than a year old at the time of the Haubergs' event. Despite the extraordinary popularity of its programs, with the depletion of its founding seed money the center had a critical immediate need. Anne stepped forward with the plan for the salmon feast, an event she again approached with concentrated fervor. "I arranged it in four days. It's amazing what you can do when you're absolutely, totally, one-hundred percent focused," she related.[3] The eight hundred dollars they raised surpassed expectations and saved the center. Like all the events for which Anne was responsible, this one lasted long afterward in memory for its fun-loving, provocative style and creative mix of people. And here too, as with many of the parties that Anne and John hosted, their home was the setting for the causes they supported.

Anne's involvement with the Seattle Creative Activities Center launched a period of intense cultural and civic activity. In the next two years, a concentrated period during 1960–61, she was to take a visible role in a number of public endeavors that helped shape the city. The Creative Activities Center, which matched her belief in art and education, laid the groundwork of engagement in the 1950s; her involvement in the civic issues of the early 1960s arose from her convictions about the built environment. Once committed, she held convictions passionately. Summoning her imaginative capacity and impressive organizational skills, she threw herself zealously into the planning of activities and events. She had a flair for theatricality that she employed effectively to attract publicity and support for these causes. John warmly supported Anne's work for the Activities Center and her subsequent civic work. Both of them had grown up in families who placed high value on community service; both sets of parents set models of community engagement that Anne and John were active in emulating.

Anne had participated in volunteer activities since her return to Seattle in late 1943 shortly before Fay's birth. Her early volunteer work began in the same women's clubs to which her mother belonged. She joined a young women's organization, the Junior League, which had service as well as social goals. She began to lay her own path. It was through the Junior League that Anne discovered a dramatics program for children, an undertaking that would sow the seeds of the Seattle Creative Activities Center.

The dramatics program was begun during World War II by a pioneering woman, Ruth Gonser Lease, who was looking for a way to volunteer. During the war every American adult was urged to contribute by volunteer or paid work to wartime production and social support. Herself new to Seattle, Lease saw the distress

"This is probably the first time that both races will engage in salmon-baking at the same local function," declared the *Seattle Times*. Pictured in the paper the day before were Anne, "Mrs. Leonard J. Stone of the Yakima Tribe, and, Mr. Don Monroe of the Blackfoot Tribe, "who will be among the Indian cooks at the Salmon Seafare Tuesday in the Hauberg home."

Friends gathered at Anne's "Salmon Seafare" to support the Seattle Creative Activities Center.

of families who had recently arrived in Seattle to work in wartime industries and lived in quickly constructed projects where families of varied regional, ethnic, and racial backgrounds were thrown together in unfamiliar circumstances.[4] With considerable resourcefulness, she developed a program drawing upon the children's personal experiences. Lease was an experienced storyteller who also encouraged children to tell their own stories, and from these narratives to find a common bond that could become the basis of a dramatic performance. Lease's work was modeled on the progressive field of Creative Dramatics, whose name she adopted for her program. To Anne, the appeal of this project was immediate. "The pressure was always on to do [wartime] volunteer work. And here was [Ruth Lease] with theater, which I loved," she remarked. "All of a sudden there was something that was fun for me to do. I was so grateful to find something that would interest me, that would have something to do with the arts."[5]

Lease's program of creative dramatics was so successful and expanded so rapidly that by the end of the war its influence had reached the Seattle Public Schools, the Seattle Recreation Department, and the University of Washington. In a unique partnership with the Junior League, creative dramatics instruction became a formal program of the UW Drama Department, where it became a requirement for teacher certification. Taught by Agnes Haaga and Geraldine Siks, it grew into one of the leading such programs in the United States. In 1948 the joint Junior League/UW program introduced creative dramatics to teachers across the state in a two-day presentation held in Seattle's Volunteer Park. The event spawned a regular parks program as well as a Youth for Art Festival in conjunction with the Seattle Art Museum, the first time a children's program had been held in the museum. It began a collaboration of visual and performing arts that flourished until the program outgrew the museum's facilities in 1954, and its success reinforced Anne's interest in the connections among the arts.

Anne stayed with the program and grew with it. She was among the founding board members when the Seattle Creative Activities Center was established in a dedicated building in 1957. Lease's goal was to be free and accessible to all children of the community. It was the year of the launching of the Soviet satellite Sputnik, and in reaction to the political challenge, public schools had cut funds for the arts to redirect the curriculum to math and science.[6] The Center offered classes in both visual and performing arts to children between the ages of five and sixteen and explored the ways in which the arts intersected. "The difference between a creative arts program and formal training lies in the emphasis on the development of the whole child, rather than the production of a polished work for an exhibit or an audience," stated the center's brochure. "This emphasis on the process leads to the stimulation of creative thinking in many areas other than in one specific art."[7] "We knew that what the children learned in arts enhanced other kinds of learning in remarkable ways," reflected Dee Dickinson, the Center's first director.[8]

In many ways, the Creative Activities Center embodied values that Anne was to nurture throughout her life: the transformative character of the arts, the fundamental importance of arts in children's education, and the respect for individual expression. Less overt but imbedded in the values and practice of these programs was a conviction about accessibility across lines of ethnicity, race, and class. Although she was reared with the older generation's keen sense of class distinctions, Anne participated in an endeavor that was assertively nondiscriminatory and inclusive. Unquestionably she and John lived in privilege and entitlement. Yet her own activities began subtly to reflect the inclusive spirit that she witnessed in creative dramatics and its subsequent programs.

As Seattle expanded during the 1950s and '60s, so too did a new kind of civic awareness, and along with this awareness came a potent volunteer effort that was to attract Anne. The landscape was changing irreversibly. Development spread east, north, and south of Seattle to create sprawling new suburbs, in which some saw degradation along with development. An ambitious network of freeways covered the green in concrete and it reshaped the relationship to the land. Suburban growth threatened the health of Lake Washington, and air pollution hung in the sky from the domestic production that had developed from intensive wartime industrial growth. With the growth of population and traffic, freeways and parking lots stole land from parks and green spaces, and old buildings that bore Seattle's past were torn down to make way for new. Such losses were experienced nationwide and by no means unique to Seattle, but in a city with so short a past and so confined a space they made a particularly harsh impact. The young city had been known mostly as a military port during the war, when it was called "a cultural dustbin" by Seattle Symphony director, Sir Thomas Beecham.[9] The desire for national status on the part of the city's progressive leaders meant addressing not only the environmental problems but also the need for a vibrant, viable cultural base.

The drive to manage growth and to foster cultural as well as economic vitality took hold step by step, and with considerable setbacks in between. Countywide growth management was defeated at the polls the first time around in 1952 (the defeat was expressive of the times, with some opponents calling it "communistic" in the Cold War era when any collective effort might be suspect).[10] Marshaling the growth-management effort was attorney and civic

activist James Ellis. At the third try, in 1958, voters finally approved the creation of a regional governmental agency, the Municipality of Metropolitan Seattle (METRO), with authority to begin the cleanup of Lake Washington and to establish a countywide transit system. Proposals to build a civic center were part of another cluster of issues involving the built environment as well as the support of a rich cultural community.[11] The repeated defeat of proposals for a civic center prompted the gathering of a citizens group, this time led by John Ashby Conway, art director of the UW School of Drama, and including architect John S. Detlie. Out of this group, in 1954, came a plan for what would become a remarkably effective organization for planning and political advocacy. The new organization, Allied Arts of Seattle, became the driving force in conceptualizing and enacting a spectrum of cultural initiatives.

Allied Arts began under the direction of a temporary steering committee led by architect William J. Bain. On October 3, 1954, the committee convened the first "Congress of the Allied Arts." Serving as the governing body of the Allied Arts group, the Congress was led by architects, arts faculty members of the university, artists, and leaders of several arts organizations. It elected Detlie as the group's first president. The Congress was organized as a confederation to unite the arts in common cause and was defined by professional fields: architecture and interior design, city planning, crafts, education, landscape architecture and gardening, literature, museums and galleries, music, painting, theater arts and dance, and sculpture. Allied Arts immediately undertook both urban-planning issues and the building of cultural organizations in order to "create an environment in Seattle in which the arts can grow and produce a more beautiful and vital city, . . . more order and simplicity out of complexity and confusion."[12]

High on the agenda the first year was the creation of an arts group to advise city government. Allied Arts drafted an ordinance, worked with the city council, and within a year won the authorization of the Municipal Art Commission. Predecessor to the present-day Seattle Arts Commission, the Municipal Art Commission reported to the mayor but operated without funding or authority. Detlie, still president of Allied Arts, was its first chair; its members were among the city's prominent leaders in their fields. The commission worked quickly; less than a year later, in June 1956, it presented an ambitious comprehensive plan that reflected the goals outlined by Allied Arts. Among its list of thirty-five objectives were the designation of two percent of the city's capital funds to the arts, the presentation of an annual arts festival, the hosting of a world's fair, the launching of a permanent ballet company and repertory theater, and public funding for arts institutions. It was a powerful agenda driven by committed, dynamic people. With some

modification, all its objectives would be accomplished, and all would become part of Seattle's cultural landscape.

Anne joined the Municipal Art Commission shortly after its formation, recognizing it as an opportunity and finding that it became the springboard to much of her work in the next few years. Her cause, as theirs, was the aesthetic integrity and vitality of the urban environment. Through the commission's far-reaching and strategic deliberations, she gained a broad picture of the cultural and built environment of Seattle. She learned about the needs, the lack of funds, the conflicting forces, and the potential of concerted action to achieve change. In response she found ways within her commission role to make visible the needs, and to broadcast the commission's message. She used her home as a meeting place. When the Municipal Art Commission sought greater authority, she hosted a special meeting, attended by Mayor Gordon S. Clinton, several members of the city council, and directors of city departments. "No one at the gathering," noted a prominent news columnist, "could have missed the strategic importance of the atmosphere and setting" that the Haubergs' house offered.[13]

When resources were not available, she sparked a parallel independent effort, the Committee of 33. Anne, her fellow commission member Jacquetta Blanchett, and her friend Anne Robinson founded a women's group called the Committee of 33 in response to the dearth of public funds for city beautification. By all accounts the idea was hers. It is an organization limited to thirty-three, all members by invitation, and described by the original members as "formed by a group of congenial people who love their city and wish to enhance it in a meaningful way."[14] Popular newspaper columnist Emmett Watson called it "Annie Hauberg's brain child, . . . a cluster of well-heeled Seattle matrons who vow to make Seattle more attractive."[15]

The Committee of 33 worked alongside the Municipal Art Commission as a partner in organizing such public events as a rally, receptions, and discussions on urban design issues. They created a pooled membership fund to underwrite city beautification projects, and in 1970 were to take as their first capital project the restoration of Prefontaine Place Fountain downtown at Third Avenue and Yesler Way. The restoration represented to Anne a proud undertaking, for the fountain was designed by her father. Carl Gould, who was deeply interested in the City Beautiful movement, had proposed the fountain in 1913 as "a personal statement of his commitment to urban beauty" at a time when Seattle was debating a proposal for its first coordinated city plan.[16] Although the plan had been soundly defeated by Seattle voters, despite Gould's ardent support, the fountain had at last been built in 1925. As Anne herself increasingly focused on urban design issues, the Committee of 33's restoration of

Prefontaine Fountain was designed by Carl Gould as a personal contribution to city beautification. Drawing by John Paul Jones of Bebb & Gould, 1925. Its renovation in 1970 was the first capital project undertaken by the Committee of 33.

Rally to save Pioneer Square, 1961. "The gathering staged by Mrs. Anne Hauberg's Committee of 33 and the Municipal Art Commission was called to promote the proposed Municipal Historic Sites Commission to preserve buildings about to fall to the wrecker's hammer."

the fountain in 1970 exemplified the meaningful linking together of her heritage and current work.

Anne joined the Municipal Art Commission as pressures on historic structures in Seattle began to build. The pressure, in Seattle as well as throughout the United States, was driven by the availability of federal funds for redevelopment, as well as by the modernist belief in the new. It could be traced, ideally enough, to the postwar Housing Act of 1949, which mandated provision of "decent" housing for all "to remedy the serious housing shortage, and the elimination of sub-standard and other inadequate housing through the clearance of slums and blighted areas."[17] The act made available federal funds to communities that developed "workable programs" for such improvements. Subsequent amendments to the act incrementally shifted the emphasis from the correction of slum housing to comprehensive renewal planning, which emphasized nonresidential redevelopment and increasingly centered on the downtown business district.[18]

By the spring of 1960 in Seattle, anxieties caused by the planned destruction of several buildings in Pioneer Square had mounted among a number of citizens. The area had been the heart of Seattle's early development as it was rebuilt after the fire of 1889, but by 1960 it was in derelict condition. The triangular Seattle Hotel was scheduled for demolition for a parking garage, the Great Northern Hotel was condemned, and the path of the new interstate freeway threatened the landmark Kalmar Hotel as well as historic houses. Allied Arts and a number of architects again took a leadership role. Anne's letter to artist Mark Tobey described the discouraging picture, "As business men are loathe to invest in these old buildings, it looks as though there is not much that can be done at present. Possibly five or ten years from now, enthusiasm could be generated among business men. At present, such enthusiasm is confined to artists and ladies! (Damn it!)"[19]

At a meeting of the Municipal Art Commission, the momentum shifted. When Anne noted the lack of effective coordination among concerned groups, the chairman of the commission, Robert L. Schulman, proposed the commission assume leadership by calling a rally, hopefully to include the businessmen's Central Association (now the Downtown Development Association). In January 1961 a rally did gather on the steps of the old Mutual Life Building, and by then the group was prepared to advocate the establishment of a Municipal Historic Sites Commission. The immediate goal was to delay the sale or destruction of historic properties to make it possible to search for those interested in preserving them. "The principal movers in the campaign are Mrs. Anne Gould Hauberg's Committee of 33 and the Municipal Art Commission," reported the newspaper. "Mrs. Hauberg's group is an unofficial but energetic group of

women dedicated to 'apply pressure in the right places to get things done' . . ."[20] Anne was behind the organization of the rally, which afterward adjourned indoors to debate the proposed ordinance. The mayor and members of the city council joined the discussion. "Your speech was terrific but even better than your speech is your ability to get people out," cheered one of the panelists after the program.[21] In a neighborhood as yet untouched by tourism, and where few people of Anne's social position would have ventured, columnists played up the juxtaposition of classes: "Socialites in mink mingled with politicians, an old-time jazz band played revival music, and police patrolmen kept inhabitants of Pioneer Place [sic] at a discreet distance as time ran out for remnants of past glories."[22]

Five years later a plan to demolish most of Pioneer Square would again be advanced. Yet the new momentum had begun to stir. In 1970 the city council would declare the Pioneer Square neighborhood a historic district, one of the earliest such districts in the United States, and three years later would adopt the Landmarks Preservation Ordinance. The city's creation of the Historic Seattle Preservation and Development Authority in 1973 afforded funds for the acquisition and restoration of historic buildings. At the same time, the Committee of 33 stepped forward to fund the planting of trees and the refurbishing of the waterfront landing in the district.[23] Thirty years later fellow art commissioner Hans Lehmann reminisced, "Our noisy effort helped to spark a civic movement for the remarkable revival of the whole Pioneer Square area and the end of the wanton destruction of Seattle's architectural heritage."[24]

Anne's pace increased as she again joined a campaign against business interests. Allied Arts had identified a problem related to highways as one of its first major issues: "A Roadside Treatment Committee analyzed the matter of grim ribbons of highways, billboard alleys, cluttered street signs, obscured scenic view."[25] Allied Arts spun off a separate organization, the Washington Roadside Council, under the leadership of Jack Robertson. In 1961 the two organizations undertook a campaign for control of billboards along state highways, a campaign fiercely opposed by a powerful business coalition. Anne joined the fray, and would participate in the Roadside Council for fifteen years. Against the odds, the campaign was successful, resulting in the Highway Advertising Control Act of 1961. It was praised by State Senator Nat Washington as "one of the best organized volunteer efforts to achieve legislation, . . . an amazing success by amateurs over an extremely efficient and well financed opposition."[26]

The freeway that tore through Seattle's historic core in 1961 became Anne's central, defining issue in these years. "Once in a lifetime, something is important to you," she declared to a newspaper columnist. "We are wrecking a beautiful city with the freeway."[27]

For fifteen years city and state engineers had schemed a vast network of high-volume thoroughfares through Seattle. A 1946 map proposed a north–south freeway along approximately the same route that I-5 would carve out of the landscape, and by 1953 cars sped above Seattle's waterfront along the Alaskan Way viaduct, the city's first limited-access highway. An enormous new funding resource became available in 1956 when, in the name of defense, Congress passed the National Defense Highway Act, a bill that authorized the construction of 41,000 miles of freeways. Washington Governor Albert D. Rosselini and Seattle Mayor Gordon S. Clinton moved quickly ahead in securing the federal funds to realize construction of a north–south axis, as well as a connecting east–west corridor to serve the burgeoning suburban communities east of Lake Washington. It was one of the first freeways in the country to cut through the heart of a city. A headline in the State Department of Highway's newsletter declared, "Superhighways seen as having great effect on Washington economy."[28] Anne stepped boldly forward to side against business, despite John's prominent position in the business community. "All great cities have a downtown park," she continued in the newspaper account, "but then, all great cities have their Carnegies, Rockefellers and Fleishhackers. Our business men don't support the arts but are more apt to sit in their clubs and talk of golf and hunting."[29]

Many fiercely contested the Department of Highways' boosterism. Allied Arts deplored the lack of accountability to citizens about the design of the freeways. When Anne joined the Municipal Art Commission, she gained access to a fuller story of the debate. A 1957 report on the plan had, in fact, anticipated the devastation such a freeway would wreak in so confined a space as Seattle and addressed the issue in part by calling for generous setbacks from private property, ample landscaping, and terracing of hillsides. Anne starred the text in her copy of the booklet from the City of Seattle Planning Commission.[30] The report continued, and Anne underscored:

> *The City Planning Commission recommends that the Municipal Art Commission be given the opportunity to review with the Washington State Department of Highways matters pertaining to securing esthetic values in the Central Freeway.* The general public is expending a vast sum of money on this project, and we should expect that it not only will carry cars into and through our city swiftly, but do so on a route of beauty and majesty commensurate with the grandeur of Seattle's natural setting."[31]

When architect Paul Thiry, a member of the City Planning Commission, proposed covering the freeway cut through the city center with a European-style boulevard and park, Anne readily grasped the vision. Thiry was motivated by his abhorrence of the

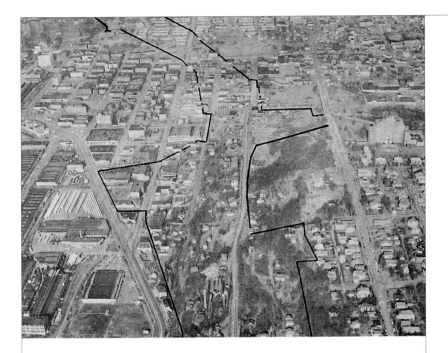

Land requirements for Interstate 5, viewed from Beacon Hill to downtown. Seattle was one of the first cities to cut a freeway through an established city center.

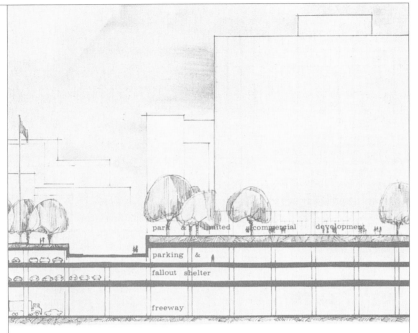

A four-tier proposal for a park to cover a ten-block-long section of I-5 through downtown. Below the park were a parking structure, a bomb shelter, and at the bottom, the freeway. It was "a bold plan" to create "a major park, which would compare with such civic assets as Union Square in San Francisco and Central Park in New York."

Alaskan Way Viaduct along the waterfront, enough to invest in engineering plans and cost projections of such a proposal.[32] Anne joined a group of people in support of Thiry's plan. When the freeway march was organized on June 1, its chairperson was Audrey Kerry, but Anne effectively captured its driving energy and spirit for the press and posterity. Called its "benefactor and sponsor,"[33] she emerged that day as its spokesperson. At the City Council's request, Thiry's proposal was turned over to City Engineer Roy W. Morse, who criticized the plan as unfeasible and dramatically reduced its scope. Increasing cost projections, tight construction schedules, and federal refusal to cover the added costs soon killed the proposal.

Fifteen years later a greatly modified Freeway Park was built over I-5, an effort that James Ellis again helped lead. Designed by Lawrence Halprin and Associates, the park bridging the freeway was the first of its kind. John described the July 4, 1976,[34] dedication with enthusiasm: "A. mentioned in Jim Ellis' speech. Park has spectacular waterworks, lots of concrete planter boxes and dividers, grass, walks, trees that will soon subdue the cement—5 acres for $14 million—but just a great thing for Seattle."[35] The newspaper covered the event with a historic photograph of the 1961 march led

by Anne.[36] Ralph Munro, then special assistant to the governor and later Washington's Secretary of State, wrote to her, "I am glad to see that the editorial writers are finally recognizing that your idea was a legitimate one and am proud that you had the foresight to speak out so early. If only so many people had listened then, Seattle would have been a far finer city today."[37] Of Anne's willingness to confront opposition and ridicule, which Munro's letter noted, her friend Virginia Wyman would look back years later and applaud her "ability to stand up in a man's world of power."[38]

An immediate outcome of the freeway protest march was the new Citizens' Planning Council. Even before the march there was talk about creating an umbrella organization that would pull together the various interest groups addressing issues of growth and the built environment. When several people asked Anne to take the lead, she wrote to the officers of Allied Arts,

I hesitate to be the stirrer of more activity, but suggestions have come from Mr. Don Yates, Mrs. Andrew Price, and Mr. Jack Robertson that there is a need for one large group which considers all aesthetic problems in relation to our city and state. Possibly the

Freeway Park dedication ceremony, July 4, 1976.

Victor Steinbrueck, drawing of the Public Market from *Market Sketchbook*, a book published in 1968 to raise civic awareness.

president of the Roadside Council, the President of the Arboretum, the President of A.I.A., and the Landscape Institute and Planning Institute, plus University representation, could be part of such a discussion."[39]

As discussions of such a group began in the spring of 1961, Anne made an eloquent appeal:

> *Beauty is good business. Let us take a walk in our city, pick our best brains, and dream and imagine together.*
>
> *Then let us gather together people who are sympathetic to art, who have discrimination, and join them in one Commission to work as one group, not several groups going in several directions as we do now. . . .*
>
> *The commission will be guided solely by what the people who live here want to live with. They will plan from the knowledge that beauty, not profit, is the best business practice for a city. The profit motive never achieved a work of art.*
>
> *We must keep prodding our city officials. They are elected to serve the people, and when they know the voter wants beauty in Seattle that is what they will give him. . . .*
>
> *We must sell visual beauty.*[40]

Anne formed a group initially named the Keep Seattle Beautiful Crusade, gathering together lawyers as well as design professionals. Modeled upon a successful Citizens' Council in Philadelphia, the organization moved quickly toward formalization and was incorporated in July 1961 as the Citizens' Planning Council. "Core of the new group," reported the newspaper, "are those who sponsored a recent protest march against an 'open-ditch' freeway in the central area." It continued, "Many people are waking up to the fact that there has been too great a tendency to plan major public projects without sufficient regard to broad environmental factors—what might be called the 'blinders' approach. . . . The need for alert citizen watchdogs will increase as area growth problems grow ever more complex."[41]

Anne started the organization but did not remain part of it for long. She soon left over a difference of opinion she no longer remembered. The Citizens' Planning Council, however, was a vital organization throughout the 1960s, spurring the creation of a number of special advocacy groups that were to effect significant change in the public agenda. First linking with the Washington Roadside Council, it took on such issues as underground utility wiring, where it achieved only limited success compared to the billboard campaign. It gave rise to such groups as Citizens Against the R. H. Thompson Freeway, which staged a years-long and ultimately successful fight against a thicket of freeway lanes proposed

through the Arboretum and a residential community; and Choose an Effective City Council, which sought out and supported progressive candidates for the political office. The council's board included such people as Daniel J. Evans and Slade Gorton, who would become Washington State governor and United States senator, respectively. In time, as these specialized groups absorbed the energy of the Citizens' Planning Council, the council itself disbanded. Today, surprisingly few people remember the council, recalling instead only the advocacy efforts to which it gave birth, but its legacy of civic action is vividly evident in Seattle's urban environment.

Throughout Anne's outspoken efforts for freeway modification, John had been supportive of her work, despite his connection to Weyerhaeuser, one of America's major corporations. But her vocal role had tested him. "The way you have been supporting Annie is nothing short of miraculous," he wrote Betty Bowen, an art advocate and civic activist closely involved in this and other civic campaigns, "and I certainly want to express my appreciation, even though this whole business has driven me practically to the nearest padded cell."[42]

Anne's continuing antibusiness stance, however, must have stretched John's tolerance. When Seattle's Public Market was threatened by redevelopment plans, he would forbid her to participate in efforts to save it. In November 1963, when the Central Association and the City Planning Commission announced a plan to raze and rebuild the area between First and Western Avenues and Union and Lenora Streets, opposition forces gathered immediately. "If you get involved in this," she quoted his saying, "You'll never be able to accomplish anything in this city again."[43] She would not take a stance publicly, but she worked passionately behind the scenes on behalf of the preservationists.

Newly elected city councilman Wing Luke led the adoption of a City Council resolution to save the historic resources of the Public Market area. Allied Arts, under the presidency of architect Ibsen Nelsen, took an organizing role. Victor Steinbrueck, professor of architecture at the University of Washington and an ardent proponent of historic preservation, led the fight and, together with attorney Robert D. Ashley, formed the activist group "Friends of the Market." Mark Tobey, who had sketched the people of the market during the formative years of his work in 1940–41, lent his support from his home in Switzerland. "The Market," he wrote, "will always be within me. It has been for me a refuge, an oasis, a most human growth, the heart and soul of Seattle."[44] Ultimately, the market would be saved by a public vote in 1971, when it became the city's second historic district. And although formally she had respected John's admonition, Anne would continue to be associated in people's minds with the effort.

Anne's activity in 1961, however, was public and unabated. She directed her additional efforts to Seattle Center, where a world's fair was planned. Allied Arts had in 1954 listed the hosting of a world's fair among its initial goals, and this project was on its agenda for the first Municipal Art Commission. It would be the first such fair since 1939, before the tumult of World War II. In November 1956, voters had passed a $7.5 million bond issue to enable the conversion of the Civic Auditorium on the north edge of downtown and to undertake the clearance of the surrounding warehouse area. The long-term plan for the area was a civic center, but first it would be a fairground. Shortly thereafter plans were launched for what became Century 21, the Seattle World's Fair of 1962.[45] Allied Arts joined with trade organizations, businesses, and government agencies to plan the ambitious event. Paul Thiry, who would propose the freeway lid, was appointed the fair's principal architect.

At the heart of the fairgrounds plan was a monumental International Fountain. In her capacity as a Municipal Art Commission member, Anne served on the committee to organize a competition for its design. It was a major commission. "The city has voted $250,000 for the fountain [over $1.3 million today] and Annie is working on a competition among artists," wrote John. "She loves to do this sort of thing and is very good at it because of her training."[46] Anne's colleagues on the committee were several of the men who led Allied Arts and the Commission; architect Lister Holmes was the professional adviser to the project. As the competition drew to a climax, in March 1961 Anne helped draw the Committee of 33 together again with the Municipal Art Commission to host a public reception for the finalists and the jurors. The design was awarded to two architects from Japan, Hideki Shimizu and Kazuyuki Matsushita, whose fountain—with colored lights, music, and water shooting rhythmically high into the air—became a favorite sight on the fair grounds. Eighteen years later, in 1979, the Committee of 33 would contribute $5,000 toward the renovation of the International Fountain.

As 1961 progressed, planning for the World's Fair was in full swing. A number of the fair buildings were designated for use afterward by arts organizations, and the plans called for complementing these buildings with significant works of art by artists in the region. A group of friends and admirers of Mark Tobey urged that the artist most famously connected with Seattle be represented by a major, permanently installed work of art. Despite his fame there was no place, they argued, where his work could always been seen and his legacy to the city properly acknowledged. The Municipal Art Commission voted its approval of the proposal, but there were no funds for such a purchase or commission. Together Anne and John quietly offered to underwrite a mural-sized painting for the future Opera House, which was being created out of the old

anne gould hauberg

Mark Tobey, *Journey of the Opera Star*, 1964, (oil and collage on canvas, 7 x 12 ft.) mural for the Seattle Center Opera House commissioned by the Haubergs. Collection City of Seattle, 1% for Art.

Civic Auditorium. They would work directly with Tobey, allowing him freedom from requirements or time constraints. Anne's focus, she told Tobey, was on the long-term benefit to the new Civic Center rather than the passing fair.[47]

Tobey was at the height of his international prominence. After nearly four decades of intermittently making his home in Seattle, he now lived in Basel, Switzerland. He had won first prize at the Venice Biennale in 1958, the first American to do so since James McNeill Whistler in 1895, and he was to be the subject of a large retrospective exhibition at the Louvre's Musée des Arts Décoratifs in 1961, the first time the French museum had granted such recognition to an American. When the exhibition opened, European critics called him "the foremost living American artist" and "perhaps the most important painter of our epoch."[48]

Anne flew to Paris with a friend, Kay Huston, for the opening of the Louvre show, with the intent to continue discussions about the mural with Tobey, who had not yet decided to undertake the project. They met for dinner in a Paris café and afterward Anne wrote excitedly to John, "The news is that Tobey will do the mural—isn't that terrific? He . . . has given the mural much thought."[49] John had written earlier proposing an annual payment schedule for this work, which appealed to the artist. A few days later as Anne and Huston traveled on to Greece, she wrote John again: "Tobey says this mural will be more important than his Louvre show. So if costly!!? Still one of the great things to do."[50] In addition to the excitement of the mural, the trip was a special one for Anne, the first time in many years she had taken a respite from the needs of her family.

Tobey worked on several compositions, none of which satisfied him, and the fair opened in April 1962 without a mural. Two years later, in 1964, he wrote John, "The work on the mural is now going well—I don't do anything else. It is 13 feet long—a combination of oil paint and collage and I believe it will certainly wake up the lobby as it should."[51] The mural was shipped that year to artist Paul Horiuchi's Seattle studio, where it was mounted and installed in the Opera House lobby. Tobey arrived shortly before its completion and added a self-portrait to the lower right corner. The mural, entitled *Journey of the Opera Star*, remains unique in his oeuvre. The collage elements—news clippings, magazine advertisements, and pieces of drawings—alone distinguish it. Its woven web of figures relates it to his signature paintings of the 1940s yet the dense composition conveys a more cacophonic rhythm on a large contemporary scale. In contrast to the monumental size of much other contemporary painting, Tobey's work was typically small; the mural is among the few large works that Tobey ever produced.[53] Throughout the process and despite the delays, Anne and John expressed their confidence in his artistic decisions and timing, a credit to their role as true patrons.

Hideki Shimizu and Kazuyuki Matsushita, winning proposal for Seattle Civic Center Fountain Competition.

The completed International Fountain, 1962.

Mark Tobey, about 1961, when he was at the height of his international recognition.

At the Haubergs' request, Roland Terry designed a freestanding wall in the Opera House to show Tobey's mural to greater advantage. Terry, drawing, 1971.

At the Opera House, however, the installation site proved inappropriate. The mural was mounted high on a lobby wall, rendering illegible the detail that required close observation. Tobey was angry; Anne and John were sympathetic. For the next six years, they corresponded regularly with him about a more favorable installation. Seattle Center director John Feary and James Chiarelli, the Opera House architect, entered the discussion. It seemed no one was satisfied. As the debate continued, the Haubergs hired Roland Terry to devise a design solution, which again they would underwrite, as they had done with the mural itself. Terry designed a freestanding black wall with a low platform to serve as an unobtrusive guardrail. The mural was finally reinstalled in 1976. Visually prominent at last, it remained in place until 2000, when it was put in storage during an extensive renovation of the Opera House. Today it hangs in the remodeled and renamed Marion Oliver McCaw Hall.

In the short span of 1960 and 1961, Anne entered the arena of civic activism to dedicate herself with unceasing energy to the improvement of the city's public spaces. As she would do in all her major endeavors, she saw a need and moved to fill it. She acted on the need with a breadth of vision that saw the meaningful connections among the past and future life of the city, and she took deeply to heart the causes to which she committed herself. She branched from one endeavor to another as their complementary purposes unfolded and multiplied. She took risks in moving away from her position of protected comfort to speak out publicly for the issues in which she believed. And she risked undermining John's support as she spoke out against business interests in favor of her convictions.

And yet the uncertainty and displacement of the Tobey mural mirrored in some ways those in the Haubergs' own lives. Despite Anne's impressive breadth of civic achievement, by the end of 1961, events that would shake her individual and familial well-being were about to emerge with unpredictable force.

Anne and John dancing at the
Sunset Club, December 1962.

anne gould hauberg

fissures and transitions

"Life goes on here at an ever increasing pace," wrote John to a friend in March 1961, "with Annie attempting to get legislation passed controlling billboard blight, and beautifying the city, and with me attempting to get Republicans elected once in a while in a century that has decided to go Democratic."[1]

Indeed, by 1961 the pace for the Haubergs was intense and at times frenzied. John had been the first of the two to enter the political realm when he became chair of the Washington State Finance Committee for the Republican Party in 1956, and served as well on the party's National Committee. By 1961, in one year alone, Anne was involved in the Municipal Art Commission; the effort to rescue of Pioneer Square and the establishment of the city-authorized Historic Sites Committee, forerunner to the Landmarks Preservation Ordinance; the Washington Roadside Council's campaign for statewide billboard-control legislation; the advocacy of a park to cover the freeway in downtown Seattle; the formation of the Citizens' Planning Council; and the realization of two major art projects for the new Seattle Civic Center and World's Fair grounds. These added to the Haubergs' continuing engagement in numerous cultural and social organizations and tremendously active social schedule.

It was a critical time, too, in the life cycle of the family. Fay was completing her years at the Helen Bush School. Outside of school she was notably accomplished in horsemanship, winning many awards including the Washington State Equitation Championship. Now in high school, she experienced an adolescent's typical swings between dependency and independence, and as she entered her senior year in September 1961, like most seniors, she looked forward to graduation and college. Sue attended the Pilot School and in June 1962 would graduate and leave home to attend the Devereux Ranch School in Santa Barbara. Both daughters would be moving from home the same year. Sue would be attending a boarding school, where the school would play a surrogate parental role, while Fay would take a more definitive step toward independence by leaving for college. For parents and children, this is typically a time of anxiety and tension as well as expectation. For parents facing their children's absence for the first time, it is also a time of loss, and the Hauberg household was no exception. The family's earlier history of loss would have made these anxieties all the more intense.

"I was so unhappy my entire high school years," Fay remembered of family life during that time.[2] Adolescence is a time of separation and individuation, when young people push against parental authority in the process of achieving this developmental task, and anger on both sides is frequently an unintended tool in the process. Few adults look back at these years without recalling their experiences of fear of rejection by their peers, embarrassment, and resentment of their parents. But to Fay, the stress within the family seemed palpable. She recalled her father's impatience with her mother's freely associative pattern of thought, and her parents' frustration when they failed to tell one another of invitations and found themselves with conflicting commitments. The type of social drinking condoned at the time, a "Lauren Bacall and Humphrey Bogart excess" which Anne and John enjoyed, most likely exacerbated emotional reactions and miscommunication.[3] Most significantly, Anne and John had experienced the overwhelming uncertainty and responsibility of caring for two disabled children, a situation that commonly tears apart many families through guilt, blame, and exhaustion. Tension often strained the household during the children's early years, an anxiety heightened by the loss of several pregnancies. In this family context, Fay sometimes felt overlooked, as the bright, capable, athletic daughter who didn't require exceptional support.

As Fay and Sue began the last semester of school before they would leave home, in late January 1962 Anne flew to New York to meet with Mark Tobey. The artist had traveled to New York from his home in Basel to prepare for a retrospective exhibition at the Museum of Modern Art. Anne intended to continue discussions with him about the Opera House mural commission. However, she fell into such a state of agitation that Tobey called John in alarm. John came to New York immediately. With the help of Dr. Fay, her uncle, Anne was taken to Philadelphia and placed in the care of his colleague, psychiatrist Dr. Joseph Hughes. Anne's diagnosis was manic-depressive illness, also known as bipolar disorder. She entered the Pennsylvania Institute for a regimen of rest and treatment. It was an awkward period for John, whose family included sturdy, self-sufficient German-American farmers and who did not know how to cope with such an illness as his wife was experiencing.[4]

Manic-depressive illness is characterized by recurrent phases of elevated excitement and depression. Individuals experience its phases differently, whether cyclically, in combination with one another, or with one predominating over the other. In its chronic state, the phases may be protracted and deep. It is an illness "that is biological in its origins yet psychological in the experience of it," notes psychologist and author Kay Redfield Jamison.[5] She writes, "The manic-depressive temperament is, in a biological sense, an alert, sensitive system that reacts swiftly and strongly. It responds to the world with a wide range of emotional, perceptual, intellectual, behavioral and energy changes."[6] Jamison herself suffers from the disorder in which she is expert and describes her own experience:

> When you're high, it's tremendous. The ideas and feelings are fast and frequent like falling stars. And you follow them until you find better and brighter ones. . . . Feelings of ease, intensity, power, well being, financial omnipotence and euphoria pervade one's marrow. But somewhere this changes. The fast ideas are far too fast and there are far too many. Every moment of confusion replaces clarity. Memory goes. . . . Everything previously moving with agreement is now against . . . {until you are} enmeshed in the blackest caves of the mind."[7]

Historically, a high incidence of writers, composers, and artists have recorded extreme mood swings, and moreover, as Jamison's own description suggests, there is a strong correlation between bipolar disorder and creativity. Now science also has demonstrated a genetic predisposition to both bipolar disorder and creativity. In light of Carl Gould's experience of cycles of feverish work and depression, there seems a strong likelihood that Anne inherited a predisposition to the condition.

Anne spent four months at the Pennsylvania Institute and then returned to Seattle. She arrived home in late May only a week before Fay's high school graduation from the Helen Bush School. "When she gets back here," John wrote to Anne's Aunt Muriel, "she will live a very quiet life for a while until she recovers her zest. But even then, I think that she will stay away from participation in civic

Fay's graduation from the Helen Bush School, 1962.

affairs."[8] Fay had spent nearly all of her senior semester without her mother, who was hospitalized when college acceptances arrived in April. Fay now prepared to attend Middlebury College in the fall, and her formal debut was scheduled for December. At the same time, Sue was completing her work at the Pilot School, where she was the most advanced student. An even greater milestone for Sue was the conclusion of her years working with Myrene McAninch in an intimate and life-changing learning relationship, and she was expecting to travel to Santa Barbara to attend Devereux Ranch School.

Nationally the next few years of the 1960s were a fulcrum of political and social change. The invigorating hope that Kennedy's presidency inspired in many, the passage of civil rights legislation in the wake of his death, and the United States' gradual immersion in a war in Vietnam were to change the direction of a generation. University campuses, including the University of Washington, became stages of protest and engines of change, as waves of free speech, black power, and antiwar protest merged into increasingly forceful demonstrations against the established order.

Fay graduated from Middlebury in 1966 with the idealism of that decade. She was inspired by the challenge that President Kennedy had issued, "Ask not what your country can do for you, ask what you can do for your country," and applied to the Peace Corps. Assigned to Africa, she was training for the Peace Corps in Los Angeles when she met fellow volunteer Nathaniel Blodgett Page. Their shared goal and friendship blossomed over the next year into a loving and committed relationship, and on June 17, 1967, they were married on Bainbridge Island and feted at the family's country home. "A sizzling, perfect day!!" John wrote in his journal. "To church at 6—a full house—where did they all come from? A happy wedding with a giggle or two. A fantastic reception. . . . All over except for a swim and kids' talk by 2:30 AM."[9] Ten days after their wedding, Fay and Nat left for Peace Corps service in Ghana, where they taught at the Government Teacher Training College in Berekum for two years.[10] They left the United States as racial tensions and the Vietnam War inflamed widespread protest, and returned to find the country riven by the war and radical social change. For the next several years, they made their home near Boston, the region where Nat had grown up.

Sue spent eight years at Devereux, starting at age fourteen. She had been frightened about the prospect, not understanding her parents' intentions and believing she was being sent away because she was not wanted. Dr. Temple Fay helped her parents guide her through the transition. Her adjustment was eased by the school's horsemanship program, part of the vocational track Devereux offered alongside an academic one. Since early childhood she had enjoyed

Sue at Devereux Ranch School, Santa Barbara, ca 1962.

Sue would become a national award-winner in Arabian horse competitions. Here, in Salem, Oregon, 1989, she is pictured winning the event for "Arabian working cow horse" with her horse Delight.

horseback riding, and now at Devereux she was assigned a horse that would be hers to care for and ride. Soon she had acquired sufficient skill so that her parents gave her a higher-performing horse of her own. Anne and John visited regularly, as they also visited Fay during her years at Middlebury, offering their daughters encouragement and support. Sue advanced steadily through her studies at Devereux, but her love of horsemanship would set her life course.

John recorded the family's excitement about Sue's graduation. In bold letters he wrote, "June 14, 1968 SANTA BARBARA—SUE GRADUATES!!! from Devereux with a San Marcos High School Diploma and a big awards plaque for horsemanship. She was so pleased, proud, and pretty. Mother and Dad, Granny Gould and

Myrene all pretty proud and pleased too."[11] Sue would spend two additional years at Devereux working with the horse program, where she assisted the younger children and helped care for the horses.

Anne continued her rest and recovery in the year following her return from Philadelphia and then gradually resumed her habit of active engagement. Her attention turned once again to art, and she took classes in painting and ballet. These were the years that John became deeply involved in raising funds to build the new Child Development and Mental Retardation Center at the University of Washington. He was on the boards of the Seattle Symphony, the Seattle Art Museum, the Helen Bush School, and Reed College, among others, as well as the Weyerhaeuser Company. He continued

to add land to the tree farm. Each year Anne and John made a trip to an international destination, and for the first time since their early marriage they were without children at home.

For Anne, this time of rest and reevaluation also opened another area of exploration. Through her years-long friendship with Mark Tobey, Anne was acquainted with the tenets of the Bahá'í faith and became increasingly drawn to it in the 1960s. Tobey had embraced this syncretic religious teaching when he was a young man, at one point even dwelling on the possibility of giving himself to its mission full-time rather than to art. During the 1960s, when Anne and Tobey were often in correspondence about the Opera House mural, their letters also frequently included mention of Bahá'í principles and Anne's growing commitment.

The Bahá'í faith originated in present-day Iran in 1844. Its teachings were written in the following decades, and by 1912 an American headquarters was established. It is among the new religious movements of the nineteenth and early twentieth centuries that have sought a synthesis of eastern and western philosophies, scientific and faith-based beliefs, and rational and nonrational thinking. The Bahá'í faith shares with some other contemporaneous movements an anticlerical intent, seen in its turn toward direct personal connection to the spiritual or divine rather than to hierarchical church authority. Anne was attracted to its call for the unity of all people across lines of race, ethnicity, religion, and nationality, its acceptance of the equality of men and women, and aspirations for universal education and world peace. She began regularly attending the formal meetings, called Feasts, and the informal gatherings, or Firesides, in members' homes. On October 17, 1969, she was formally registered as a Bahá'í. Her commitment is a sustained one. She found guidance in its code of conduct and tried to live by its principles, although she said that its prohibition of alcohol was one tenet she didn't follow. She conscientiously followed the Bahá'í mandate to spread its teachings as she talked about her belief to friends and occasionally invited people to Firesides in her home to discuss the principles of the faith.

Anne and John had experienced years of acute anxieties. Anne's illness and hospitalization followed the challenges of two disabled children and the death of one of them. Yet the couple had demonstrated great strength. They had endured, and with evident mutual love, loyalty, and support. In June 1961 they celebrated their twentieth wedding anniversary by giving a party with characteristic flair: "Annie loaded the house with flowers and invited our favorite friends—a wonderful party complete with handwriting reader," John noted under a photograph in his scrapbook.[12] Their twenty-fifth anniversary celebration, hosted by friends, was equally joyous. By John's admission, Anne had carried the greater burden of responsibility for the family. As she grew more engaged in activities outside the home, John wrote admiringly of her contributions to the organizations she supported. For his own part, during her period of greatest public activity in 1961, he occasionally sought colleagues' support on behalf of her causes.[13] Their profound satisfaction with Sue's progress and the success of the new Pilot School motivated each of them to delve further into the field of mental retardation, continually seeking information about new advances in scholarship and clinical practices. Their resilience may be one of their most meaningful gifts to their children.

Anne's annotations of a Bahá'í text. She starred its call for knowledge of arts, crafts, and sciences.

made
by
hand

"If you don't support the artists, you won't have them," Anne frequently says, quoting her father, and her support grew to be far more extensive than her father might have envisioned.[1]

She encouraged artists by purchases, commissions, social introductions, financial assistance, and hosting and organizing exhibitions of their work. She developed a distinctive taste for the material object and its craftsmanship, along with a conviction about art's quality of aliveness. This aliveness originates in the spirit and ideas an artist brings to the material; it is embodied by the object, transmitted through the object to the beholder, and can transform a space with its unique energy.[2] It is a quality, in her view, that anyone who looks with an open mind can feel intuitively. "Art is alive," in her words, "when it is memorable, and it is memorable when it has two elements: heart and intellect."[3] Aliveness, in Anne's view, is uniquely in the handmade object, and craftsmanship, the touch of the artist's hand, is an essential component.

Ruth Penington, metalsmith and jewelry maker, was professor of art at the University of Washington and active nationally in the American Crafts Council. She is shown here teaching summer classes at the Fidalgo School of Allied Arts, La Conner, Washington, 1961.

"I'm glad that I got interested in crafts before the fine arts," Anne remarked, "because craftspeople have a sincerity and a love for material that you can see."[4] Crafts had first captured her attention in the years following World War II, when her early collecting paralleled the rise of American studio crafts. She had an affinity for functional adornment—perhaps because of her architectural background, and through both her own studies and the legacy of her father's Beaux-Arts sensibility. Always alert to new events and developments, she could not help but be stimulated by the burgeoning activity in crafts as it began to surge nationally in the 1950s, growing with particular vitality on the West Coast. Even as she expanded her involvement to creating and supporting organizations on artists' behalf, her personal collecting in support of artists never wavered.

The studio crafts movement flourished in the postwar years when Anne began collecting. Drawing upon roots set down earlier in the twentieth century, it was spurred by the wartime immigration of European craftspeople, notably those associated with the Bauhaus. It was fueled by the expansion of colleges and universities as vast numbers of former soldiers returned to school under the G.I. Bill. Along with every other discipline, art departments grew to meet the demand of larger enrollments and added new programs in craft media. For some craft students who had served in the war, the choice of quality of life prevailed over established routes to professional advancement, and making things by hand represented an authentic, basic, as well as artistic, way of life. As craft media gained a foothold, the universities also helped legitimize and promulgate this work through events, exhibitions, and acquisitions. The intellectual environment of the university meanwhile stimulated students' concern with the expressive or conceptual content of their work.

Aileen Osborn Webb, an East Coast woman known publicly in her lifetime as Mrs. Vanderbilt Webb, would eventually inspire Anne's organizational efforts. A wealthy patron in New York State who was dedicated to traditional craft production, Webb established a substantial network of support for crafts that encompassed marketing, education, publication, and community-building.[5] During the Depression she had helped a rural New England community revive its craft industry, and in 1943 opened America House, a retail gallery in New York City, to present such crafts to an urban public. The same year, seeking to advance learning opportunities, Webb established the School for American Craftsmen, where European master craftsmen brought their finely honed skills to teach alongside Americans. To foster communication among craftspeople, she founded the American Craftsmen's Council (now the American Craft Council) and the magazine *Craft Horizons* (later renamed *American Craft*), which became a mainstay in the field.

Even though Webb's personal interest lay with traditional crafts, she enabled the organizations she established to embrace a larger mission as university-driven studio crafts gained momentum in the 1950s. She was a founder of the Museum of Contemporary Craft in New York, seeing it as a national venue for contemporary craft. (It was subsequently renamed the American Craft Museum and is now the Museum of Arts and Design). In 1957 when she led the council in organizing the Craftsmen's Conference near Monterey, California, participants from throughout the country were electrified by the experience of discovery and gathering together. Four years later the conference came to Seattle, where the University of Washington's Henry Gallery (now the Henry Art Gallery) mounted an exhibition of American contemporary crafts in conjunction with the event. During these years, Ruth Penington, a metalsmith and jewelry maker at the university, was an active organizer who represented the Northwest at the American Craftsmen's Council. The council began to establish a few select branch galleries outside New York, and in 1964 opened a gallery at Frederick and Nelson, a flagship Seattle department store.

There were good reasons for the council's turning its attention to Seattle. A vibrant studio crafts community was active in the area, fostered by the University of Washington, where teachers like Penington had worked in craft media well before the war.[6] In 1947, across Lake Washington in Bellevue, an enterprising businessman who wanted to attract people to the nascent suburb organized the beginnings of the Bellevue Arts and Crafts Fair, which would grow to become the region's largest crafts fair. Postwar generation students like ceramist Robert Sperry joined the university's art faculty, where they revolutionized attitudes about form and material both in classrooms and studios. Beginning in 1953, the University's Henry Gallery hosted an annual competition, the Northwest Craftsmen's Exhibition.[7]

In 1954 a group of nine university-trained artists, including Sperry, launched the Northwest Designer Craftsmen to bring together professionals in the region.[8] The Northwest Designer Craftsmen took a leadership role in the 1961 conference in Seattle, and for the Seattle World's Fair in 1962 organized an exhibition of contemporary West Coast crafts, Adventures in Art, to represent the United States.[9]

In 1964 Aileen Webb was the guest of honor at an event at the Seattle Art Museum, which was preceded by a breakfast at the Haubergs' home. "We had a breakfast for ninety people to meet a Mrs. Vanderbilt Webb, who gets people tangled up in organized crafts," John wrote Mark Tobey.[10] As craftspeople came to the museum in numbers to show Webb their work, Anne was astonished at the quality of the objects. Many of the artists were members of

Ruth Penington, necklace, 1971 (silver and ermine tails, 9 ¼ in. diameter). Collection Tacoma Art Museum, gift of Anne Gould Hauberg.

Robert Sperry, who taught ceramics at the University of Washington and helped found the Northwest Designer Craftsmen, exhibiting his work at Hall-Coleman Gallery, Seattle, 1961.

the Northwest Designer Craftsmen. "I woke up to crafts at the art museum party," she recalled. "I couldn't believe people were making such lovely things—because there was no gallery to represent them."[11] She was sitting next to two friends, Elizabeth Bayley Willis and Donald Foster. Willis, working under the auspices of the United Nations, had traveled extensively in India to advise on craft production for export, and she enjoyed as well long-standing friendships with artists Mark Tobey and Morris Graves. Foster, then working for the Ford Foundation, was to become one of Seattle's best-known gallerists. "We've got to do something here!" Anne exclaimed to her companions. Realizing there needed to be a broader base of support in the region than the Northwest Designer Craftsmen, which was comprised of the artists themselves, the three discussed the need for a group to raise awareness and support for the artists' work and to bear the organizing responsibilities, freeing the artists for productive time in their studios. At that time, Anne noted later, "There were only five places that showed craft in America.[12] She leapt forward with characteristic imaginative conviction to project an art center in Pioneer Square, the historic downtown district that she and others were attempting to preserve.[13]

Crafts became Anne's primary focus. She gathered a few friends in her home for discussion: Donald Foster and Elizabeth Willis, to whom she had first proposed the idea; Warren Hill, who had designed furniture for the Haubergs' McGilvra house; Gladys Rubinstein, an early patron of local crafts; and Anne's neighbor and arts supporter Patty Phelps. "We spent many long hours at Anne's house chewing the rag. We talked and talked," recounted Foster.[14] In 1965, they formally announced the formation of Friends of the Crafts, with goals that suggest the depth of the long fermentation of ideas. The group declared its dedication to advancing education and promoting the field, with the intent to both present exhibitions and establish a crafts museum. Its focus was twofold: regional, national, and international contemporary craft; and traditional and ethnic production. It drew strength through including both artists and patrons in its membership. Ruth Penington, the university metalsmith who was active also in the American Craftsmen's Council, served as the first president.

"Anne was a doer," renowned textile designer Jack Lenor Larsen, a longtime friend, said of her. "She didn't work her way through things. She flew over."[15] And in such style Anne began her contribution to the Friends of the Crafts. She volunteered the McGilvra house as the site for the Friends of the Crafts' exhibitions. For the first three summers of its existence, the Friends mounted public exhibitions in the Haubergs' home while the family spent the season on Bainbridge. "These are busy times," John wrote to a friend as the first season began. "Annie's outfit, the Friends of the Crafts,

George Nakashima, Bookmatched Persian Walnut Dining Table with Urushi Base (29 x 75 x 40 ½ in).; and Conoid Chairs of Suri Urushi Dark Walnut, 1970. Purchased by Anne and John Hauberg, 1970; collection Anne Gould Hauberg.

Dale Chihuly demonstrating process of blowing glass, Bellevue Arts and Crafts Fair, 1968. "The hot spot was the glassblowing furnace of award-winning Tacoma glassblower Dale Chihuly, 26, who drew perspiring crowds during the day to watch close-up demonstrations of his artistry."

are taking over our house today for the first of a series of weekly exhibitions which opens our house to the public on Thursdays, Fridays and Saturdays for the rest of the summer . . . Annie is really wound up and works until midnight every night. Our phone rings like an angry hornet from dawn until that time, and people wander in and out. I have never seen Annie so enthusiastic and excited and I think it's wonderful."[16] Jewelry maker Ramona Solberg was among those invited to show her work there: "The first time I met Anne was during the Bellevue Fair [where Solberg's work was exhibited in a booth]. Warren Hill had asked if I would let him display some jewelry at Anne Hauberg's house. So he worked up something on the wall, and there was my jewelry hanging there. Anne had a little party."[17] The exhibitions were monitored by Friends of the Crafts members, but nevertheless, from today's perspective, Anne's offer of the house seems an audaciously trusting act.

The young organization grew promisingly with all-volunteer support, and the Haubergs pledged financial support to encourage new memberships. After the first three years of exhibitions in the Haubergs' home, the program moved to a gallery space in Seattle Center. Characteristic of the group's ambition, in 1970 the summer schedule featured a Japanese folk art exhibition and rotating smaller exhibitions of work by individual artists. In June, for example, they

showed furniture by George Nakashima (who had helped Anne with her wedding flowers), textiles by Alice Parrott, and ceramics by Toshiko Takaezu and Mutsuo Yanaghara. When Nakashima would not ship a set of dining table and chairs unless its purchase were guaranteed, the Haubergs bought it in advance and so added to their collection its first pieces of handmade furniture. The Friends of the Crafts also showed Northwest Coast Native American art from local collections, including a number of exceptional objects lent by John, in an exhibition organized by Warren Hill.

In 1971 the Friends opened their own office and gallery space, housed in a former architects' office above two contemporary galleries in Pioneer Square. For the first time, the program could be run year-round, they could assemble a library for educational use, and they added a curator, Catherine Munter. The gallery was the first step in a three-part plan that looked forward to building a collection of contemporary and ethnic craft objects and opening a museum, which some envisioned would be directed by Elizabeth Willis.

The gallery's celebratory inauguration on November 19 displayed two exhibitions: the work of the Northwest Designer Craftsmen, and the other, at Anne's suggestion, an exhibition and sale of glass made recently in a glassblowing workshop. The summertime workshop, which was affectionately called the "Peanut Farm," had been

Anne unpacking objects from New Guinea, to be exhibited by Friends of the Crafts. Seattle's newspapers, here the *Seattle Times*, gave generous coverage to the launching of Friends of the Crafts. Anne wears a necklace, *Pay Day*, by Ramona Solberg.

four craftsmen

lee nordness selects

marian clayden
fritz dreisbach
william harper
teruo hara

friends of the crafts
march 8 thru april 11
tues.-sat. 12:30-5:00

members preview
march 7, 6:00-9:00
no host bar

Friends of the Crafts exhibition announcement.

organized by artists Dale Chihuly and Ruth Tamura and was the seed of an endeavor that would one day become Pilchuck Glass School. Anne was intimately acquainted with the workshop and its artists because they had camped the past summer on the tree farm John owned. No one guessed then what potential the first workshop held; the sale held hardly a hint. "The work was simply terrible!" laughed Gladys Rubinstein in recollection. "They sold everything for two or three dollars."[18]

Yet for all the promise, good work, and good will, the Friends of the Crafts could never achieve the means to sustain itself. In 1974, when John was president of the Seattle Art Museum board, there was talk of merging with the museum but the idea died. In 1975, as the Friends faced a crisis of chronically inadequate support, the board voted to close the gallery and office. The group kept alive throughout the 1970s with such activities as workshops, tours, and its publication, *By Hand*. The groundwork was laid, however, for support of the crafts by other organizations.

Despite the eclipse of the Friends of the Crafts, Anne sustained and expanded her personal commitment to studio crafts. Her activities had broadened beyond the Northwest as she became more deeply involved in the dynamic crafts community of the 1960s. During frequent trips to New York, she met artists and craftspeople through Jack Lenor Larsen, who served on the boards of both the American Craft Council and Maine's Haystack Mountain School of Crafts. After John was invited to join the board of the American Craft Council, where he served twelve years, he described their "heady days of frantic comings and goings" to New York, Washington, D.C., France, England, and Spain.[19]

Some years later, in 1978, Anne would be one of the organizers at a Seattle Art Museum event in honor of Joan Mondale, wife of then Vice President Walter Mondale and an ardent advocate of the crafts. In honor of the Mondale visit, the Seattle Art Museum mounted a four-day exhibition of crafts from the Northwest (staged only days before the opening of the monumental King Tut exhibition; see Ch. 11), which included ceramics, fiber art, jewelry and metalwork, wood, and glass. Assisted by the Committee of 33, the group of women dedicated to city beautification, the museum hosted a preview breakfast for one hundred fifty art professionals, artists, government officials, and volunteers.

The big celebration of Mondale's visit was held at the Haubergs' that night, when Anne joined with caterer Joe McDonnal to create one of her signature parties. At tables strewn with clamshells, guests dined on clam pies nestled among the shells while champagne flowed freely. Anne gave to McDonnal the same creative freedom she provided all artists, and in the same way helped further his career. On another occasion, the two of them covered the floor a foot deep

with hand-washed autumn leaves. She matched him in creative imagination and responded readily to McDonnal's ideas with "Why can't we do it!"[20]

When Aileen Webb promoted the founding of the World Crafts Council to create an international community of traditional craftspeople and contemporary studio artists, Anne followed her expanding mission with keen interest. In 1968 Anne was a delegate to the second World Crafts Council conference, held in Lima, Peru. She and John went together to Lima, and afterward joined a small group of delegates to visit Machu Picchu, as well as Cuzco and the Amazon community of Iquitos. "When I go to these conferences, I meet people from all over, whom I enjoy," she recalled.[21] She enthusiastically joined the board of the World Craft Council in 1969, when she and Ramona Solberg were named directors of the Council's American Committee representing the Northwest. The two of them attended the group's world conference in Dublin in 1970, about the time the World Crafts Council had become an affiliate of UNESCO.

Anne embodied the craft aesthetic she advocated. Craft infused her daily life—the furnishings of her home, the clothes she wore, the jewelry with which she adorned herself. She made a dramatic presence. She was tall—a legacy from her father—and displayed the zesty theatricality she had learned from her mother. She had always liked fine clothes and often embellished these with handmade articles of clothing. Her jewelry was bold, long before such personal statements were common, and nearly always artist-made. "I'll never forget it," remarked LaMar Harrington, who was working at the university's Henry Gallery when she first met Anne. "She was wearing a black filmy silk dress and a hat with a wide brim with a huge flower on it. She was such a striking woman as she walked through the door."[22] As the years progressed, Anne added more handmade adornment. A colleague of Anne's, Priscilla Beard, described how in the 1970s "she would come into the room, and she would have on the wildest glasses. I remember this purple and turquoise mohair shawl, a long coat, and a long scarf that wrapped around her shoulders, and she would be wearing her turquoise and green and blue glasses. She'd slip out of the coat, and she'd have on a handwoven top and skirt, and then incredible jewelry, heavy, chunky jewelry. She'd enter a room and the rest of the women in the room looked as if to say, 'Oh, god, I can never compete with that woman.' "[23] Of the clothing she commissioned, Anne herself remarked, "I wish I'd done it when I was thirty!"[24] But she was not a purist; she might throw an inexpensive, floridly colored boa over her coat, and would often pin to her costume the badge of a cause she was currently supporting. The fun-loving spirit and the good cause mattered most.

Anne with Joe McDonnal, who promoted "informality in a formal setting," ca late 1970s.

Warren Hill, who had designed furniture for the Hauberg's home, organized an exhibition of Northwest Coast Native American art, for the Friends of the Crafts, 1970.

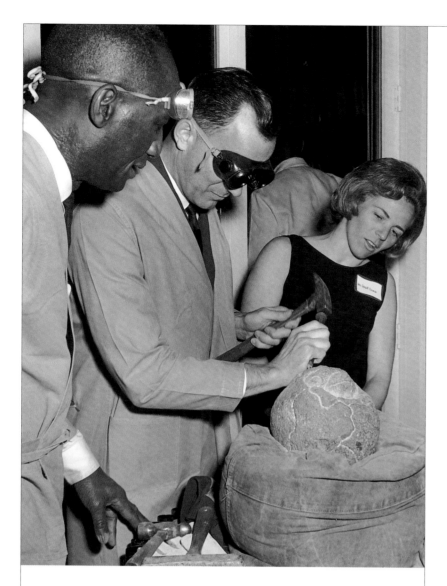

Sculptor James W. Washington, Jr., with Governor Daniel J. Evans and Nancy Evans at the Haubergs' house, 1965. Anne brought high-ranking state officials together with artists and members of the newly created Washington State Arts Commission to promote the role of art and design in the urban environment.

The craft aesthetic was evident in her home. Beginning with her first commissions of art for the McGilvra house, Anne had built a richly textured environment that capitalized on the interplay of the building, its furnishings, and artist-made objects. It was an environment that not only warmly welcomed guests but also took care to display the work of artists to advantage, and she used the house to introduce individual artists' work to her friends. Whether the artists were in "fine arts" or "crafts," she organized numerous events at the house to support them, some in which a single artist might be the honored guest, others that included artists in the social mix. She was as interested in introducing guests from other professions to the artist's point of view as she was in brokering social contacts that might benefit the artist's career. She brought her peers' attention to the sculpture of James W. Washington, Jr., by hosting an exhibition and reception at the house. In 1965 Washington was prominently featured at a party she and John hosted for high-ranking state officials and members of the new Washington State Arts Commission. Anne planned the "get-acquainted" party to bring together the two constituencies, along with several artists, in order to promote the role of art and design in public buildings. In an evening spiced with performances and art demonstrations, a newspaper photographer captured Washington as he guided Governor Daniel J. Evans in a beginner's attempt to carve stone, dramatizing the synergy Anne sought to stimulate.

Anne's knowledge of art, her love of the handmade, and her belief in supporting artists from the region brought a distinctive energy and ethos to her homes, her personal presence, and her endeavors. Her conviction about the wholeness of design, about the integrity and integration of its parts, and about bringing the stamp of human creativity to all the elements of life became the hallmark of the recognition accorded her locally and nationally. She credits her parents' friendships with artists, her father's leadership of the Seattle Fine Arts Society, and—most importantly—her father's inspirational encouragement to her personally, for guiding her toward this accomplishment. It is a position that increased its definition and focus with passing years. Throughout her life Anne was to actively commission work from artists and craftspeople, suggesting and supporting new directions or applications for their work, and would increasingly take chances on emerging talent whose work as yet was unrecognized. This was to be one of her outstanding characteristics as an art patron. Late in her life she would remark, "Now I just automatically befriend an artist or architect whose work I like. If they're appreciated, they blossom!"[25] Not only did Anne frequently quote her father, "If you don't support your artists, you won't have them"—she lived by these words.

The landscape of Pilchuck tree farm.

dreams
for the
mountain

In the summer of 1972 a hole was punched through the wall of the Friends of the Crafts gallery in Pioneer Square. The Friends had a new neighbor, the office and gallery of the nascent Pacific Northwest Art Center.

The hole became a doorway, and that suggested a close relationship between the two, as it well might, for Anne helped give birth to both. Unlike the Friends of the Crafts, however, the Pacific Northwest Art Center, to be known as PNAC, was entirely the Haubergs' undertaking. From the beginning, PNAC was conceived to be more than a small downtown gallery. It was the first seed of a cultural center that Anne envisioned in the foothills of the Cascade Mountains, to be set amid a flourishing community development next to John's mountainside tree farm.

In spring of that year John had written a letter to Imogen Cunningham, an esteemed photographer and longtime friend of Anne's family. In the letter he confirmed his and Anne's purchase of the entire body of her work, then on exhibition at the Henry Art Gallery. He also described their vision for the PNAC, which eventually would be the repository for the photographs by this artist who had spent her youth and early career in Seattle. The centerpiece of their plans, he wrote, was a "Mark Tobey Gallery of Northwest Arts and Crafts on a beautiful hilltop site on a tree farm (ours) . . ."

Our "models," {he continued} are the Kröller-Müller Museum about one and one-half hours from Amsterdam, and the Louisiana Museum, an hour north of Copenhagen. These are modest structures in rural settings (as we expect ours to be) but with fairly impressive visitors' statistics. We would like to add, however, programs of craft workshops, music, theater and dance that the models do not yet have.

A downtown office would function actively in winter, although the country gallery would remain open year-round, and John reported that a glass workshop, which was first held the preceding year, planned to return the next summer. "We look forward to a modestly expanding summertime craft school as the years go by under the sponsorship of PNAC and in cooperation with the Union of Independent Colleges of Art." (This was the agency, known as UICA, that had granted the seed money for the first glass workshop.) He concluded,

PNAC has a Board of Trustees, problems with the IRS, no stationery as yet, a dozen or so "members" in addition to the trustees, and no address other than our attorney's. You might say we are pregnant but we're having lovely affairs with the Henry Gallery, the UICA, the IRS, the National Endowment for the Arts, our architects, artists, various museums and other organizations. The birth will be an explosion.

The letter was signed, tellingly, "John H. Hauberg, President, Pacific Northwest Arts Center (Sometimes known as Mr. Anne Gould)."[1]

By June the PNAC downtown gallery was beginning to materialize. "I have got to get Annie deeply involved in this program right away or it isn't going to take place," John wrote Colin Graham, director of The Art Gallery of Greater Victoria and a friend of Tobey's.[2] The Mark Tobey Gallery on the tree farm that the Haubergs had originally proposed to the artist escalated to the stature of a museum. John reported that Tobey had signed a new will leaving "all of his effects" to PNAC, and that Virginia Wright, a preeminent collector in Seattle, would leave one of Tobey's great, late paintings, *Parnassus*, to the PNAC.[3] Anne was so enthusiastic about an arts center at the tree farm that she had persuaded the director of the National Parks Service to look at the site for its potential as a national cultural center.

Anne had ardently promoted a center dedicated to art produced in the Northwest. There was no place in the Seattle area where the work of its most renowned artists could always be seen, for local museums had no spaces permanently dedicated to such a purpose. In particular, Anne, along with a group of Tobey's friends, lamented the lack of public access to his work, which was acclaimed in Europe but was little to be seen in his adopted hometown. Additionally, her involvement with studio crafts made her keenly aware of the need to have them continually on public display in order to build appreciation and support. She was passionate about her belief in the excellence of the region's artists, their contribution to the health and vitality of the community, and the need to embrace and recognize this contribution.

Their property on the mountain seemed the perfect place for such an art center. The Cascade foothills near Stanwood, Washington, look out over the flat plain of the Skagit Valley, with Puget Sound and its islands lying beyond, and the Olympic Mountains on the horizon to the west. This was the mountainside on which John had built his tree farm, with the first purchase of land in 1948 now having grown to 13,000 acres. Adjacent to the tree farm John had bought an area known as Freeborn Hill, a southwestern slope of mixed pasture and young second-growth forest, a site that captured both his and Anne's imagination. "Annie wanted very badly to have some kind of art enterprise up there on the hill," John recounted. "It's such a beautiful spot."[4] She pictured a mountainside cultural center for visual and performing arts.

John had purchased the property with the intent to create a residential real-estate development. The site had proximity to major cities and highways and exceptionally scenic and expansive views. He dreamed of a recreational community built to the highest standards of environmental sensitivity and good design, one to compare to the most exemplary models in the United States. Such a scheme was made feasible by the scheduled extension of Interstate 5 north of Seattle to Everett, which would be complete in 1967, and by the population growth projected for the vicinity. He researched concepts for residential developments and was impressed by a book by John Ormsbee Simonds, a practicing landscape architect and member of the faculty of the Carnegie Institute of Technology. "Having read your treatise 'Landscape Architecture, the Shaping of Man's Natural Environment,' " he wrote the author, "I am very much inspired by your sensitive philosophy. Have you been able to put your ideas into

practice on any fairly large scale? I would really like to visit some of your projects in the months ahead.

"My interest is not academic. I own a 3,000-acre tract about an hour's drive north of Seattle, with a great potential in every respect, including the aesthetic."[5]

For over a decade, Anne and John imagined, planned, and built a striking variety of projects on this mountainside property. Some dreams were realized, and some were not; some got off the ground but later died; and one, Pilchuck Glass School, famously thrived. The place names varied too: Freeborn Hill was the name for the foothill slope where John bought acreage; Pilchuck was the name of a creek that ran across the property; Victoria was the name of a small local community and the section of land John purchased for development; and Tatoosh was a name from the Makah people on the Olympic Peninsula. John's Pilchuck Tree Farm was already well-established. To the tree farm, they added or planned:

· a ranch for their daughter Sue, which began with a house and a boarding stable and eventually grew to eighty acres and eight buildings;
· a cottage for themselves;
· a work and residential community for developmentally disabled youth;
· a premier vacation and residential community;
· a Mark Tobey Museum for Northwest Art and Crafts, along with a performing arts space;
· a combined not-for-profit and commercial cultural and recreational development;
· Pilchuck Glass School.

Their efforts to conceive, build, and manage these projects occupied Anne and John from the mid 1960s throughout much of the 1970s. Both of them were intensely stimulated by the mountainside site. Anne seemingly never tired of imagining the possibilities, as she broadly sowed ideas that were exploratory, connective, and fertile. "This was one of her most persistent dreams," as Jack Lenor Larsen recognized. "She was always talking with others about what the tree farm could be. She was visionary and utopian."[6]

John's plans for a real-estate development were only beginning when the Haubergs launched a project of more personal concern. With the purchase of the 3,000-acre development site, they had set aside a piece of land for use by their family, and another for a program for developmentally disabled youth. Anne and John's experience as parents of children with developmental disabilities made them acutely aware of the lack of support and programs for families like theirs. They had seen the profound benefit of specialized

education for their daughter Sue, now at Devereux. The Pilot School at the University of Washington was by this point well established, and the university's multi-departmental, interdisciplinary Child Development and Mental Retardation Center was about to start construction, with John spearheading the fundraising. Anne was always looking to Sue's future and, with her daughter in adolescence, foresaw the need to create some measure of independent living. While she and John could provide well for Sue, she was well aware that other young people with needs for special education were not so fortunate.

In 1964, shortly after the purchase of the Freeborn Hill site, local newspapers announced John's establishment of Victoria Village (called Victoria Ranch in its early years). Housed in existing farm buildings on twenty acres of land, it was to be a summertime program for teenage students with mental disabilities, conducted in cooperation with the local Snohomish County Public Schools. Victoria Village took its true form when, three years later, its primary funding was established through the Washington State Department of Vocational Rehabilitation and its program was redirected to serve young people age seventeen and older. Dr. Edgar Doll of Bellingham, a former student of Anne's uncle, Dr. Temple Fay, and his wife, both experts in special education, served as advisors, with their own work providing a model.[7] The goal of the program was to teach young people work-readiness habits and skills and, as part of the training, to provide paid work. It was open initially to boys with mental, physical, or social disability. In time it expanded to become a year-round residential program and offered training in life skills as well as practical study and work experience. New buildings, financed by the Haubergs, were built to accommodate the growth. When a new residential unit was constructed in 1970, it was designed by the architectural firm of Ralph Anderson, for, as always, Anne insisted that good design contributed to the learning environment. In 1972 the Anderson firm designed a workshop as well as dormitories for both girls and boys. By this time the staff numbered twenty-one, with a full complement of clinical and professional services.

Although the nonprofit school was funded in large part by the state, securing funds sufficient for operations was a continual challenge. It sought grants and donations to supplement its revenues. John contributed significantly to operations as well as construction, and growth continued with the addition of buildings in 1974 and 1976.

Anne saw a gamut of possibilities for Victoria Village in relationship to the real estate development John planned. "She had this all organized in her head," recalled a longtime friend of the Haubergs, Mary Cozad, of Anne's vision of coordinating the various projects on the property. "The children of Victoria Village would be

trained to have jobs in the residential development."[8] Recounted Anne's daughter Fay,

> She was always pushing them to come up with things that the kids could do to make a living. She had this idea these kids at Victoria Village could have training, {for example} to sell flowers and vegetables at a roadside stand. She was always trying to figure out some kind of vocational training that these kids could have so that they could be independent. Dad's thing was the building, the planning.[9]

As the program matured, Anne made connections to the people and resources she knew who could contribute a creative spark.

In the later years of the school, Anne headed its crafts program and brought artists to Victoria Village to lead day workshops for the students. "She knew the artists," remembered jewelry maker Ramona Solberg, "she got lots of us to go up to the tree farm, to conduct little workshops. I did one on silkscreening. . . . Their attention span wasn't very long, so [the projects] had to be short."[10] Anne's aim was that artists would design functional objects to be produced by the Victoria Village students and sold in regional stores. When an activity center opened on campus in 1976, the *Skagit Valley Herald* announced the event with an appeal to "the local shops and citizens to purchase Victoria Village products and services" in order to support it.[11]

Anne organized a Christmas tree sale that year that exemplified her ability to rally people in support of a goal. She created an imaginative plan beginning with the youth of Victoria Village, who helped dig five hundred small live Noble firs from the Haubergs' tree farm. The students assembled boxes designed by renowned furniture designer Sam Maloof and potted the trees in them; they made cookie-dough decorations, and, meaningfully, received payment for each step of the project. Anne called a work party of friends to the McGilvra house to assemble the trees, decorations, and tags identifying the project, then arranged the sale of the trees at the Seattle Public Market to benefit the crafts program at Victoria Village. "SOLD OUT!" her thank-you letter exclaimed. "Volunteers, workers, designers, craftsmen and artists—all working together made this a successful project."[12] Such a chain of connections was the kind of action that inspired her and that she inspired. "She really has a sense of synergy," remarked architect Tom Bosworth, who was to work extensively with the Haubergs. "This is an incredible gift that she has—to throw out ideas and then have people start working with them."[13]

As they did with a number of their projects during these years, Anne and John committed themselves together, and their individual

Boys and young men in residence at Victoria Village (then called Victoria Ranch), which ran a fulltime live/work program, 1969.

Anne organized the digging, boxing, and decorating of living fir trees, along with their sale in the Public Market, to benefit the Victoria Village craft program, 1976.

contributions were intimately intertwined. As president of its board, John watched over Victoria Village's management and provided major support for construction and operating shortfalls. Publicly and organizationally, Victoria Village was his project. At the same time, Anne's connective energy pulsed through it. She was determined to offer special-needs youth the means of a productive life, desirous of creating a constructive learning environment, and insistent upon superior professional architecture in even a small rural setting.

In 1970 the Haubergs built a house and riding stable for Sue and turned again to Roland Terry for the design. The new house was across the road from Victoria Village, by now in operation for six years, and which Anne and John envisioned might provide a sense of community for Sue. Sue left Devereux that year, having stayed an additional two years after graduation, and in 1971 she moved with caretakers to a new home of her own. The day she moved was a landmark of independence. "A. up early and Sue packed to leave us forever," John noted in his journal, "taking Weenie [the dachshund] but leaving Cleo and her 4 kittens."[14] The country home her parents had built provided Sue with the chance to pursue her love of horsemanship. Anne envisioned that the stable might prove a viable horse-boarding business in which Sue could participate, and for a while Victoria Village had a contract for its students to provide part of the maintenance. Two years after her move Sue received her driver's license, and the next year, a car of her own. She earned a Teacher's Aide certificate at Everett Community College and began driving weekly to the University of Washington to help young children at the Pilot School, a responsibility she undertook with special delight. Her home was always a stopping place whenever Anne and John visited the mountain.

John avidly pursued his plan for a commercial real estate development. He hired John Simonds, the author of the book he had admired on community planning, to create a master plan. Simonds lived in Pittsburgh and agreed to visit the property for several days to gain a fuller understanding of the site. But when John said to Anne, in anticipation of Simonds' visit, "Anne, I want you to have a house for him to stay up on the place,"[15] he undoubtedly had no idea of the creative flurry that was about to be launched. An adventure in modular housing began.

Anne had a keen interest in prefabricated housing, and the property had need of a place to accommodate visitors. Anne and John also wanted a cabin for their own use on the tree farm. To Anne, the situation was one ripe for a modular home; Simonds was to arrive in a month. She recalled, however, "All I could find in prefab was metal, and I didn't like the idea, with John in the wood business, of having a metal prefab."[16] She recruited architect A. O. Bumgardner to design a house in two modular sections, each the size of a truck-trailer. After trying unsuccessfully to find a contractor who could meet the deadline, she met Peter Bilder, a fabricator of structural components for residential construction, who agreed to the look over the site. "I brought Peter Bilder to the site. And he said, 'Oh, no, I can't do a house.' You have to have [permits]; you can't just go out and build it in the yard. And I said, 'Yes, you can.' Bilder's background was in something else. But he knew what he was doing, he knew how to do it. And so we got that darned house in place, furnished, in two weeks!"[17] The two modules were lifted onto a prepared foundation on the crest of a meadow hill, and Anne furnished the interior. The house was completed in time for Simonds' arrival, and for years afterward it served as the Haubergs' cabin. They named it "Instant."

But this was far from the end of Anne's adventures in prefabricated housing. Excited by the construction of Instant, and wanting to create a model that could be reproduced for the market, Anne commissioned two more houses in cooperation with Bilder. Each was one module in size, and each was produced within a week. "I had three different architects in three weeks," exclaimed Anne, recalling the three houses produced in little more than thirty days.[18]

She asked Henry Klein, an architect from the nearby town of La Conner, to design the first of these, to be sold at Seattle's annual PONCHO auction to benefits the arts (Patrons of Northwest Civic, Cultural and Charitable Organizations). This time she asked artists Guy Anderson and Phil McCracken to decorate the house.[19] A brochure described its special interior features, which included a "Mexican clay fireplace . . . the burlap wall covering, stained a soft white . . . the deep window seat . . . bay window frames . . . floors of Masonite cut into 12-inch squares that are both decorative and inexpensive." It cited the two major markets that Anne saw for modular housing: second homes, each adapted by an architect to the individual needs of the owner; and housing for low-income families, "who can purchase a shell—move into warm dry housing that they own—and finish it as time and budget permit." The brochure quoted her as saying, "I feel it is important to inject the personality of the buyer into the planning and finishing process. I hate to see a row of identical houses."[20]

She thought the third house, designed by Donald A. Winkelmann of Naramore, Bain, Brady, and Johanson (now NBBJ), was the most flexibly and practically conceived in terms of a modular residence, although she admitted its high-quality bay windows made it the most expensive.[21] The week following the PONCHO auction, a trade show of trailers and mobile homes was scheduled and the third house was designed for exhibit there, with the hope that the commercial venue might attract an investor. As she began

the second and third houses, Anne remembered thinking, "I've been really good about not spending money because I was brought up that way, and John liked that. But once in a while I should do something outrageous. I got excited about these houses and I thought, 'The hell with it, John can afford it.' "[22]

Anne's enthusiasm, however, pushed John's limits. He wrote in his journal, "A & J have a big rhubarb over another Peter Bilder 'peanut shell' for Trailer Show—a waste of money and time etc. A. adamant. Hi ho! Now she has a house for this Saturday at PONCHO and one for the following Saturday. What next?"[23] As exasperated as he might have been, in subsequent days he wrote appreciatively of her efforts. The project, however, went no further than three houses. There was one inquiry from a German company after the trailer show, but the units, priced from $4,000 to $12,000 (basic shell to finished) proved too expensive to be commercially viable. Still believing she could have found a way, Anne concluded that the houses "did OK, but we could have done much better." And yet the sheer accomplishment of the three houses underscores her unrelenting focus, and the energy she found—though sometimes frenetic—to achieve a goal. "It was fun," she recalled, "totally intense for one month."[24]

John, meanwhile, laid extensive plans for the residential development, which he named Tatoosh. In addition to recruiting landscape architect John Simonds, he hired an engineer, a site surveyor, an aerial photographer, an economist, and a golf course designer. He commissioned plans for water systems, site layout, roads, landscaping, and financial feasibility. He had roads graded, a water system installed to serve the entire projected development, and a golf course partially constructed. As the vision evolved, the development was conceived as a series of cluster villages, each with a distinctive architectural design and surrounded by open space, an arrangement that would rival such environmentally sensitive developments as Salishan in Oregon. These housing clusters would be centered around world-class golf courses, manmade lakes, tennis courts, and riding trails. The company was incorporated in 1971, and by late that year planning and permits were far enough along that John could announce a community of 6,600 homes. "What Is Tatoosh?" read his draft of the project description:

> Tatoosh is a second home, weekend and summer colony country club combining unparalleled golfing, tennis, riding, and swimming facilities in a beautiful upland countryside viewing the snow-capped peaks of the Cascades, the waters and islands of Puget Sound, and the Olympic Mountains. . . .The development of Tatoosh is a 20-year plan to create the most beautiful living and recreation area in the Northwest.[25]

The first modular house, designed by Henry Klein, being positioned on a foundation at Pilchuck Tree Farm. Comprised of two modules, the finished house became Anne and John's mountain cabin, which they named Instant.

Artists Guy Anderson and Philip McCracken furnished the interior of the PONCHO house, adding a Mexican clay fireplace and white-stained burlap-covered walls.

Donald A. Winkelmann, Naramore, Bain, Brady and Johanson (now NBBJ), designed the second modular house, which was planned for the charitable arts auction organized by PONCHO.

While John's plans expanded, Anne audited a course in Greek architecture at the University of Washington in preparation for a trip to Greece and Turkey. The class was taught by Tom Bosworth, a New Englander who had come west in 1968 to become chair of the School of Architecture. Anne approached him at the end of the course with an invitation. In Bosworth's words she said, " 'I want you to meet my husband because I think you'd like one another, and he needs your help.' He did need my help," recounted Bosworth, "and we became great friends."[26] Working as a consultant, Bosworth helped John to evaluate the advice of the many other consultants and to coordinate plans for development. "He really wanted the thing to fit the land," Bosworth said of John, "and he liked the land a lot. He had a great sense of it."[27]

Anne persisted in her dream of a cultural center. She wanted a museum where art of the region could always be seen, a center for craft production and exhibition, and a performing arts space nestled in a natural amphitheater. In the mid-1960s, Anne and John had corresponded with Tobey about their desire to establish such an art center on the tree farm. It would be similar to the Maeght Foundation in Provence, France. "I was up at the Tree Farm the other day researching a site for such a grouping of Museums (and I hope, a theatre)," John wrote Tobey. "We have a creek that runs through some timber and this could be dammed to make a very tidy pond set in the woods. The various buildings could be around this small lake and the area unified by becoming a very lovely garden. I think it is a terrific site."[28]

Henry Klein, model for the proposed Mark Tobey Museum, 1972. The museum, to include a performing arts space, was to be the center of a cultural and recreational complex planned near the Pilchuck Tree Farm.

By 1969 they were ready to press forward with these plans. John again wrote Tobey in words that echo Anne's thinking:

> Within the Center will be at least two museums, the largest and finest of which we would like to name the Mark Tobey Museum of Fine Art. Here on permanent display will be many of your works contributed by your many friends who have bought Tobeys through the years. Annie and I would like to see this museum also be the place for the Mark Tobey Archives, with a University of Washington or Seattle Public Library connection to furnish professional librarianship for such papers as you and your correspondents may wish to deposit . . .
>
> The second museum in the Center will be a building for collections of craft work in which Annie is so interested. We are hoping that both museums will be teaching museums as well as permanently displaying Northwest arts and crafts."[29]

Surrounding the center would be forty acres of gardens, ponds, and forestland. Within the next year and a half, they asked Roland Terry's help on siting the building, and they contracted museum professional James Plaut of Boston to advise on concept, design, and program. They also shared an understanding of the financial obligation they were prepared to underwrite: "In the years ahead, Annie and I will invest almost a million dollars in the Center and will support an annual budget of $100,000 and more," John promised Tobey.[30]

Anne dreamed as well of the more poetic dimensions of a cultural

center tied to both nature and the residential development. Several months after John's letter, she wrote Tobey,

> *I think it is time to put into words what I feel John and I are doing. Perhaps we will be lucky. I feel the tree farm thing will be ready to happen in 10 years. I WISH YOU COULD SEE IT. . . .*
>
> *I see choosing 3 to 5 beauty spots & having Guy {Anderson}, Phil McCracken, Leo Kenny, etc.?? {sic} do a garden and name the gardens for them. Then, connecting these gardens by paths for walking, biking, riding horses, & probably golf carts (electric). Also a swath E. & W. through the forest for walking & the trees hung with some lovely bells by a woman in Eugene, Oregon (a Mrs. Sutherland). The sites for homes would be chosen by sensitive people where site, outlook, size, etc. combine in a suitable way. . . . The main thing is to attract the right kind of educated sensitive young people. . . . I envision 3 buildings. Hopefully a museum for you and your paintings and designed, I hope, by Roland Terry. Maybe this is asking for the moon. But still we must try. . . .*
>
> *I think the surrounding area should foster creative experience— crafts, music, festivals. I see Arthur Erickson of Vancouver B.C. doing a festival building much like a building at Expo that I saw in Canada last year. . . . 3rd building—I see by Don Winkelmann—a pleasant hotel. . . . Then with these 3 architects (this is still just my idea!) a team. It is too big for 1 architect to realize the best. I think it needs to have things happen after bouncing creative things against open, able, creative minds.[31]*

Anne and John continued to press for the excellence of the program and the scholarly foundation on which it would be built, and drafted a list of objectives not only for an exhibition program but also for conference and class space, along with residential and studio facilities. By early 1972 they were ready to proceed further with the design. This time they chose Henry Klein, rather than Terry, to design the museum complex. Anne had experience working with Klein on one of the prefabricated houses, and both Anne and John were impressed by the thoroughness of his proposal for an arts center. Klein was charged with designing the full plan for a museum, craft center, and performance space.

To secure Tobey's commitment to the endeavor and his best available works of art, the Haubergs offered him a lifetime stipend, together with a pledge to buy art directly from Tobey and from his dealers. At Anne's urging, they made plans to buy a house for Tobey in preparation for his eventual return to Seattle, and Anne made arrangements for its supplemental use by the local Bahá'í group, who embraced the idea of its one day being the home of one of their most prominent members. In the next few years, museum consultant James Plaut, Colin Graham, Director of the Art Gallery of Greater Victoria, and Tobey's Seattle attorney, Arthur Barnett, would visit the artist in Basel, Switzerland, to finalize negotiations regarding his collection and estate.[32]

With the Haubergs' growing investment in an art center, John was advised to separate the commercial real estate and philanthropic components of the site. Thus, shortly after the incorporation of Tatoosh, the Pacific Northwest Art Center was formed in 1971 and in early 1972 incorporated as a nonprofit entity. This was the "pregnancy" that John had described to Imogen Cunningham. Joseph McCarthy, Dean of the Graduate School at the University of Washington, assumed presidency of the new PNAC board. Anne served as its energetic membership chair. In the following months Mimi Pierce was hired as the assistant to the president and director of the downtown gallery, where artist Tom Wilson was already active as the gallery's curator. The Haubergs provided the funding, based upon a growth strategy outlined by McCarthy and operations budgeted by Pierce.

Even though PNAC's office and gallery were its urban foothold, its vision was centered on the mountain development. The leaders of the fledgling organization hailed the design that Henry Klein presented for a Mark Tobey Museum of Northwest Arts and Crafts, and they carried the museum model to Portland, Oregon, and Vancouver, British Columbia, to stir interest among art collectors throughout the region. With construction scheduled to begin in 1975, it seemed the vision was becoming a reality. The PNAC gained additional visibility when the organization hosted the 1972 debut of a new film, *Mark Tobey Abroad*. Produced by Robert Gardner of the Film Study Center at Harvard, together with filmmaker Robert Fulton of Aspen, Colorado, the film was funded by the Haubergs.

Anne and John both wanted to create awareness and interest in their multiple plans for the tree farm. Years earlier they had celebrated the tenth anniversary of John's tree-farm business operation by inviting friends for a day's visit and tour of the properties. As the 1970s began and the expanded development plans became more tangible, they hosted several large events to draw people to the site. In July 1970—only a month after completion of the modular houses—they celebrated the twenty-first anniversary of the tree farm by hosting a gathering of well over three hundred people who came along the mountain road in a string of a hundred cars despite heavy rain. The following day, still amid heavy rain, Anne staged a colorful festival to raise funds for the Friends of the Crafts. Held in a large barn because of the weather, the day's schedule was filled with craftspeople at work, performers, and a light show. Members of the Friends of the Crafts were elated by the enthusiastic response and the crowd of 350 people, but because the number was

Anne and John, founders of the Pacific Northwest Arts Center, at the inaugural exhibition of the gallery in Pioneer Square, July 11, 1972.

Anne and artist Kenneth Callahan, Pacific Northwest Arts Center inaugural exhibition.

lower than projected, the result was a sizable financial loss. The Haubergs quietly made up the difference.

Three years later Anne organized a Founders' Day Picnic for PNAC to raise membership for the organization and awareness of the proposed art center. That memorable picnic was held in a bowl-shaped meadow, the site Anne envisioned for a theater. This time she planned a day overflowing with artists' presentations: a performance by Seattle's Madrona Dance Studio that included singers, dancers, and a brass ensemble; a glassblowing demonstration by Dale Chihuly and his colleagues from the summertime glass workshop; a clown mime; folk singing; a performance by actors from the Seattle Repertory Theater; discussions by sculptor James Washington and ecologist Jerry Gorshine; and a kite exhibition. "Wouldn't you know it would rain?!! Now to be called 'Annie's picnic weather'—BUT she pulled off a fascinating day for everybody who came—probably 200–300 people—the best," John exclaimed.[33] The rich variety of performers, the color, and the overall creative energy were the result of her enthusiastic, focused attention.

Just as the Founders' Day event brimmed with activities, ideas for development adjacent to the cultural center multiplied in abundance. Varied proposals called for a mix of commercial and not-for-profit enterprises. "Might turn Inspiration Point into an entirely commercial playland," John mused at one point.[34] The possibilities included workshops for artists alongside paid-viewing demonstrations and the sale of artists' production; the re-creation of historical rural craft production such as ironwork; demonstration of logging-related skills; a variety of recreational activities ranging from tennis and golf to a gymnastics center; an artificially heated swimming hole; campgrounds for day use and extended stays; and horse-drawn wagons to transport people in order to protect the land. Even though such proposals were advanced as hypothetical examples, they suggest the magnitude of the mountainside vision.[35]

These optimistic plans for the mountainside tree farm contrasted starkly with the events taking place in American cities as the 1960s crossed into the '70s. The summer of 1967 had seen race riots in Detroit and Newark, along with the buildup of American troops in Vietnam to 500,000. The Civil Rights Act of 1964 had spurred both heroic action and violent resistance, and in April 1968 Martin Luther King, Jr., fell to an assassin's bullets, as did Robert Kennedy the following August. On January 26, 1969, the director of Seattle's Urban League, Edwin Pratt, was murdered in front of his home. The year 1969 saw the largest protest against the Vietnam War, drawing 250,000 in Washington, D.C. On May 4, 1970, National Guardsmen killed four protesting students at Kent State College. National antiwar demonstrations followed, and on the Day of Mourning for the students, 10,000 protesters marched from the

Anne and John at the tree farm, September 1971.

Friends of the Crafts poster advertising the Festival, July 26, 1970. Drawing by John Moehring.

University of Washington to downtown Seattle. John wrote in his journal that day what many must also have felt, "Routine business seems so irrelevant."[36]

In Seattle, these national tensions were followed by a severe recession. In 1971 Boeing, then the region's economic engine, was caught between overproduction of the new commercial 747 and the cancellation of the SST program, and within the next two years the company laid off 60,000 workers. As the economy plunged, a billboard famously posted, "Will the last person leaving Seattle turn out the lights?" Finally, by late 1973, the United States began its withdrawal from Vietnam, and the "Boeing bust," as it was called, subsided—but by then the country had experienced a generational shift in societal attitudes and allegiances.

John's magnificent vision for the residential and vacation community was not to be. As early as 1970 he expressed concern about proceeding with Tatoosh.[37] By 1973, the doubts about its manageability had grown stronger, and by year-end financial projections indicated the plan in its proposed form was untenable, especially with the economy exacerbated by the gas crisis and the severe national recession that year. The directors of Pacific Denkmann, the parent company John owned, saw an unsustainable cash drain, and, acting upon their advice, in 1974 John began slowing down or closing out components of the development.

Nevertheless, even as Anne and John were planning their art center on the tree farm and preparing for PNAC's incorporation, their commitment was to yield unexpectedly rich fruits. In 1971 Dale Chihuly, a young artist from Tacoma then teaching at the Rhode Island School of Design, sought a location for a summertime outdoor workshop somewhere in Puget Sound where a small group of teachers and students could explore the nascent studio art of blown glass. They envisioned constructing the equipment themselves and working in an environment unconstrained by the classroom studio.

Contemporary studio glass dated its origins to a point as recent as 1962, when the first nonindustrial furnaces became practical for individual use and artists began experimenting with the medium. Chihuly and Ruth Tamura, from the California College of Arts and Crafts, had received a $2,000 grant from the Union of Independent Colleges of Art for this purpose. Chihuly's friend Jack Lenor Larsen, who was also a friend of Anne and John's through their support of crafts, knew of the Haubergs' development plans. He suggested that Chihuly meet the Haubergs and introduced the idea to Anne. " 'I'll talk to Johnny,' " Larsen recalled Anne replying, remembering that "She was always clear that it was his money."[38]

Anne had met Chihuly during his senior year at the University of Washington and watched his demonstrations at the Bellevue Arts and Crafts Fair, and such a proposal could not help but excite her.

"She was probably the driving force in getting Pilchuck started," recalled Chihuly.[39] And so, in the summer of 1971, the glassblowing workshop that birthed Pilchuck Glass School, named for the creek that ran across the tree farm, took place in the rain and mud of the wettest summer in memory.[40] At the end of the season, John agreed with Chihuly to pay for all expenses exceeding the grant and to fund a second year.

From its inception, the glass workshop, known by several early names, was a component of PNAC. The workshop fit readily into the vision for teaching and studio production at the mountainside cultural center. Both Anne and John were enamored with the actuality of helping to realize this dynamic venture that Chihuly had brought their way. To support it, during the second year of the workshop a small board was created, whose members were Anne, John, and three additional PNAC trustees.

At the end of the second summer, the Haubergs invited the entire workshop group to their Bainbridge home to discuss the program's possible future. Also attending was Tom Bosworth, whom Anne had introduced to John as a consultant for Tatoosh. Afterward John asked Bosworth to design a simple shelter for glassblowing, a hotshop housing workbenches, tools, and furnaces that reached 2500 degrees, to be ready the next summer. Bosworth designed a structure evoking the tent origins of the first summer's hand-built shelter as well as regional vernacular forms, both rural and Northwest Coast Native American. The building would become the icon of Pilchuck Glass School. By 1973 Chihuly could describe Pilchuck as the "best glass-blowing facility in the country."[41]

The status of PNAC was about to change, however. When the idea for a Northwest art center on Freeborn Hill first arose, the Haubergs had approached Richard Fuller, president and director of the Seattle Art Museum, to ensure there would be no conflict of interest, and to gain his endorsement. Now Fuller, in failing health after leading the museum for forty years, was to retire. In 1973 John assumed leadership of the museum board and led the search for a new professional director. With this sharing of common leadership, PNAC's board voted in 1974 to fold its organization into the museum, where it would have administrative support. PNAC thus joined the Seattle Art Museum's cluster of special interest councils, and the Pacific Northwest Art Center became the Pacific Northwest Art Council. As the proposed Mark Tobey Museum and Pilchuck (then the Pilchuck Glass Center) operated as components of PNAC, each now each faced a change of status within the Seattle Art Museum sphere. Should the Tobey Museum be in the country, or should it now occupy a permanent space in town, perhaps at Seattle Center?

In 1976, by contrast, Pilchuck established its own nonprofit

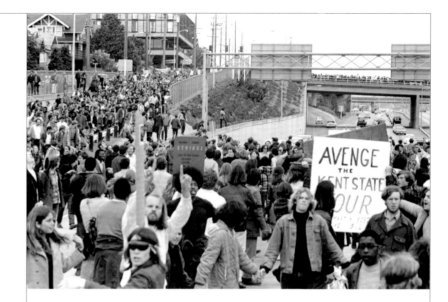

Marchers in Seattle poured onto I-5 to protest the killing of four students at Kent State University and the invasion of Cambodia, May 5, 1970.

The hotshop tent, the first glass workshop at Pilchuck, summer 1971.

Dale Chihuly, who promoted a freely experimental artistic environment, floating blown glass on the pond at Pilchuck, summer 1971.

status and began operating independently. John's financial commitments continued; he underwrote capital investments as well as providing major support for operations. Between 1973 and 1993 Bosworth designed twelve buildings and building additions, as well as numerous smaller structures on campus. In 1980, however, John began a systematic reduction of operating support, while continuing his capital investment, and called for an expanded board to assume greater financial and leadership responsibility. "John assured the future of Pilchuck when he announced he would phase back his

leadership role and his contribution to the operating budget by five thousand dollars a year" declared Patricia Baillargeon, a member of Pilchuck's first board.[42]

In the early years of Pilchuck, Anne was a regular visitor. She made the one-hundred-mile round-trip from Seattle to support Chihuly, the international artists who were present, and the talented young artists she seemed to excel at recognizing. John was less visible on campus at that time; the hippy style of young artists in the 1970s away for a summer adventure was not an attitude with which he

was at first comfortable. As years passed, however, he grew at ease on campus and savored visits there, where his respect for Chihuly became powerfully evident. In 2001, as he celebrated his eightieth-fifth birthday and Pilchuck its thirtieth, he would describe Pilchuck as his greatest achievement.[43] In 1996, the school's twenty-fifth anniversary, Anne, for her part, would be crowned by its artists the "Queen of Everything." "Nothing compares to her support of Pilchuck. It would never have happened without Annie," remarked Chihuly, and added quickly about John, "Or at least, had it not started there [on Haubergs' property], we wouldn't have gotten the financial assistance to continue."[44]

Pilchuck Glass School, together with Sue's ranch, was the only component of all of the dreams for the mountain to survive. For twenty-eight years, Sue's ranch provided her a place to live independently together with caretakers, until she moved to the city in 1998 to be closer to her family. In 1974, despite three years of stipends, Tobey withdrew his support for a museum in the country, conclusively ending the Haubergs' plans for a cultural center. The same year fraud was discovered at Victoria Village, revealing its financial weakness. The school had always struggled financially, and now its ongoing losses were found to have been hidden by the director; it continued operations but became increasingly unsustainable, and the property was soon sold. Tatoosh effectively ended in 1974 and came to a final conclusion in 1981, when the subsidiary company was absorbed by Pacific Denkmann. PNAC closed the doors of its downtown gallery, although the council continued to operate within the Seattle Art Museum until 2001, when it merged with the museum's Contemporary Art Council. The modular house Instant remains, though transformed by additions and renamed Tatoosh. Pilchuck Glass School, however, thrives as an international leader in its field and has opened the way to the recognition of glass in the art world.

Like the profile of a mountain, Anne and John's aspirations rose to great, sometimes breathtaking, peaks and then descended. For more than a decade the possibilities of the tree-farm properties lured them, and as they looked toward the tree farm, the two of them marshaled tremendous drive, a wealth of skills and resources, and complementary interests. And like mountain travelers, Anne and John often traveled on parallel but separate paths, driven by their styles of working as well as their interests and affiliations. Even after the descent, Anne could not stop dreaming about what might have happened in that inspiringly beautiful place.

The hotshop, designed by Tom Bosworth, that became Pilchuck's icon, 1973.

the
landslide

A landslide begins with a nearly unnoticeable crumbling of pebbles and sand.

Grains of sand and small rocks roll intermittently down the slope without apparent cause. From time to time unseen forces send quivers through the foundation of earth, and the dusting of rubble accumulates. Water, the sustenance of all that grows in the earth, gathers in the fissure of the rock or saturates the soil. If the hillside is clay, it may undermine and collapse from within, and if it is rock, it may break apart from the top. Either way, a hillside suddenly gives way with astonishing speed. What has seemed solid and enduring has changed form. It is no longer the way it was, and nothing can be done to restore its wholeness.

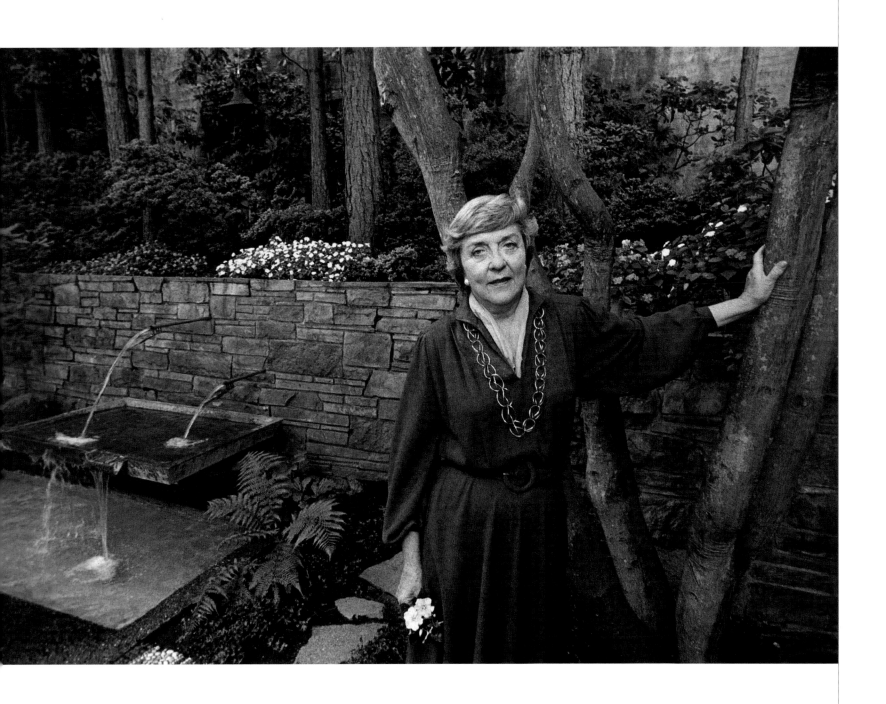

Anne as a single woman, in the patio of 1101 McGilvra Boulevard East. She wears a favorite necklace by sculptor Claire Falkenstein. The photograph is one of a series, *Seattle Faces*, by Anne Noggle, 1982.

For the Haubergs the mid-1970s were a time in which the ground of their lives together was not as secure as it seemed. For many years each had moved independently in pursuing community interests and commitments. Supporting each other's intellectual and emotional engagement in an organization or issue had been a sign of mutual respect and at the same time a statement of confidence in their partnership. Yet as the pace of involvement stepped up, the two of them increasingly seemed to move on parallel but separate paths. There were activities they greatly enjoyed together, particularly their building projects and their many travels, yet in the daily engagement with their activities each seemed to acquire a separate momentum.

The year 1975 began with spotlight recognition for Anne. She had placed the winning bid at the annual auction for PONCHO, an organization dedicated to raising money for the arts (the one to which she had donated a modular house). Her bid gained her an opportunity to name four guests to be interviewed on Seattle's public television station about their work or special projects. In February "Anne's Four" aired on KCTS. Her choices tell of her own breadth of interest and inquiry. They were U.S. Congressman Joel Pritchard, who had begun a program to involve teens and seniors in government; artist Ramona Solberg, a jewelry-maker and an influential teacher at the University of Washington School of Art; Art Skolnik, the first City Conservator, responsible for preserving historic buildings; and her husband, John, in his role as board president of the Seattle Art Museum, speaking about the relationship of the museum and the community. The show was warmly received, and many expressed hope that the program would be continued.

Other significant events for Anne unfolded that year. She planned an exhibition of portraits by Mark Tobey, to open at the PNAC gallery at year's end. In June, she was again in the spotlight when Mayor Wes Uhlman named her to the Seattle Arts Commission, an agency then just four years old and already taking national leadership in setting aside a percentage of capital funds for public art. She would serve two terms, during which she helped develop the 1% for Art program (the realization of an early Allied Arts goal, although modified from the originally proposed 2%), initiated tours of public art sites, and spurred the development of an art program for people with disabilities. By fall, Emmett Watson, a popular columnist for one of Seattle's major newspapers, named her one of the city's "ten most fascinating people" in a front-page story.[1]

Watson's article is notable for its characterization of Anne's contributions and public standing at the time. Watson cites her art, education, and civic achievements, describing her as "a woman of such diverse, humane (and often maddening) talents." Even in complimenting her, he reflects on the complex reaction Anne could rouse among those working with her. He cites as well their appreciation of her role in art and education. Watson wrote,

> "Annie has this great capacity to see things in art," {said the Haubergs' friend Patty Phelps}, "but she CAN explain it, she can educate other people."
>
> Education, via Annie Hauberg, can come at sometimes stunning and unexpected moments. Says one Seattle businessman: "Annie tends to arrive at my doorstep with a basketful of material and maybe eight books and wants to talk about them all at once." Ideas, concepts and plans seem to spill out of her like an uncapped gusher. She is an inveterate note-taker.
>
> "She picks up every item that intrigues her," says one woman friend, Jaquetta Blanchette, "and the thoughts go into notebooks, then emerge months or years later to spark or highlight another Annie project." . . .
>
> What sets her apart, one must conclude, is her encompassing drive, ability and intelligence. . . . Said another, "she sees the ultimate significant fact."[2]

While Anne reaped this recognition, John was absorbed in his responsibilities as president of the board of the Seattle Art Museum during its transition to professional leadership. He had overseen the hiring of Willis F. Woods from the Detroit Art Institute to become the museum's director, and in March 1975 Charles Cowles became the first curator of modern art. The museum expanded into additional gallery and office space in Seattle Center, and in the next few years would begin to plan a large facility that was more centrally located than the graceful 1933 building in Volunteer Park designed by Carl Gould. John's responsibilities compounded. In 1976 he was ready to begin construction of several major buildings at Pilchuck, where the hotshop for blown-glass production, built in 1973, was the school's iconic center. There, the next round of construction included the lodge, a flat-glass studio, a bathhouse, and the first permanent housing. He was deeply involved in determining the fate of two major projects under his own direction, the still-hoped-for Tatoosh residential development, and Victoria Village, the residential program for developmentally disabled youth. He was on numerous boards and declined invitations from more. It was "a disastrous overload," he wrote in retrospect.[3]

Complicating Anne and John's schedules was their routine of living in the Bainbridge country house nearly six months of the year, moving there from early May until late October or November. Even during this extended summer season, their pace did not relent. Daily they traveled back and forth on ferries and the freeway for meetings in the city, usually combined with visits north to Tatoosh,

Sue's ranch, Victoria Village, and Pilchuck Glass School, while their evenings in the city were full of social and cultural events. On Bainbridge, their neighborhood was equally convivial, their schedule filled by social gatherings often centered around the Haubergs' tennis court and pool. Anne was so wrapped up in activities in town and at the tree farm that she was rarely home.

During John's presidency of the board of the Seattle Art Museum, an issue concerning Mark Tobey drove a wedge between Anne and John. Together they had supported Tobey's career, commissioned a mural from the artist for Seattle Center, and planned a museum in his name. Now in 1975 the new museum director, Willis Woods, proposed making a signature acquisition for the museum, a nineteenth-century painting titled *Peaceable Kingdom*, by Edward Hicks. The museum had few funds for such an acquisition but had assets in its collection, which included a number of paintings by Tobey that some labeled "second and third tier."[4] Earlier that year the Committee on the Collection of the museum's Board of Trustees had reviewed the Tobey holdings, among other works of art in the collection, to evaluate the range of quality. At a meeting of the committee in early June, Woods presented a proposal to trade several Tobey paintings and acquire the Hicks work, and described the negotiations underway with a New York gallery. If the matter were to be approved, it would be forwarded for board consent. John supported the director's artistic leadership, perhaps feeling free of obligation to Tobey after the artist's rejection of the proposed Mark Tobey Museum.

The next morning the *Seattle Post-Intelligencer* carried a prominently positioned story about the proposed trade.[5] Many people blamed Anne for leaking the story; they knew of her close friendship with Tobey and her access to confidential information, although she herself was not a board member and disclaimed responsibility. The source of the story—there were two corroborating sources—remains unknown to this day to all but art critic R. M. Campbell and the individuals. John, however, was among those who blamed Anne. He was furious at the action that most likely appeared to him to be a betrayal on many fronts: to his position as board president, to his civic leadership, and to him personally. Within the course of a week Woods relinquished the Hicks and withdrew the proposal.[6] The rift between Anne and John lasted longer. The Tobey incident, although short, was destructive. It exposed a fault line that had opened between the two of them, and it was one that would eventually also divide their mutual friends of long standing.

The week following the Tobey incident, Anne left for a second stay at the Pennsylvania Institute in Philadelphia. This time she must have recognized that the pace of activity, compounded by the intensity of furor and blame at the Seattle Art Museum, had reached a breaking point, and this time she initiated the call herself. She had kept in touch over the years with Dr. Joseph Hughes, who had cared for her in 1962, and she now returned for help with an episode of the manic depressive illness that stalked her. After talking on the telephone with her from Seattle, John noted to himself that ideas poured interminably through "her teeming mind." She was "still going [a] hundred miles an hour and no sign of relaxing," and she felt an acute sense of obligation to the events in which she was involved.[7] John wrote several lengthy accounts to Dr. Hughes describing his and Anne's innumerable activities, the Tobey debacle, and the stability of their marriage. His actions, however, suggest his distraction. He visited Anne one weekend out of her month in Philadelphia.[8] And, rather than wait for her return, he hosted his own sixtieth birthday celebration with a large Japanese-theme party on Bainbridge. Their two paths remained separate.

After a month Anne returned home. On Bainbridge she took pleasure in bringing her special gifts of order to the house and gardens. During her absence, Fay and Nat had arrived from Boston for a month-long visit, bringing their new baby Carey. It was Anne and John's first grandchild, a milestone in their lives. She resumed her engagements in town and visits to artist friends at the Pilchuck glass workshop. In mid-August she joined John and a few friends on a trip to Alaska to explore Northwest Coast Native American sites, the source of John's prized collection. In September she traveled to Deer Isle, Maine, to attend Haystack Mountain School of the Crafts, the summertime arts school that had inspired Chihuly's rural glass program. She spent three weeks there taking a ceramics class and gloried in the experience. These connections to art and artists must have been healing, but the number and quick succession of activities also suggest that her pace had not slowed substantially.

The parallel lives that reflected their independence and were an integral part of their marriage became harder to join. The preceding summer John had begun a romance with their Bainbridge next-door neighbor, Ann Brinkley. Together with her husband, Jim, the couple were frequently the Haubergs' tennis partners and companions at cocktails and dinners. While extramarital affairs are as old as literary accounts of them, surely the new social morés of the 1960s and '70s eased the sense of their permissibility to someone of John's rearing and position. In the small, exclusive, and very social neighborhood of the Bainbridge Country Club where Anne and John lived, the shifting ground was evident, although the crowd, Haubergs included, partied hard, as they had always done. In December of that year Anne had another relapse, this time presenting as a depression; however, this time she remained at home. As Anne lay in bed, John wrote in his journal, "Tension of so many SAM activities (mainly PNAC Thursday) and her sense of involvement. Every little detail

that is 'wrong' bothers Annie tremendously . . ."[9]

The pace of their lives and distinctive individual trajectories continued over the next two years. In 1976, with the deaths of her mother and Mark Tobey, Anne lost two of the people most significant in her life. She had watched over her mother's care after a recent broken hip, moving her to a convalescent home on Bainbridge so that her mother could participate in summertime family activities. Anne may have felt conflicted about their relationship, but now her mother's death meant a time of emotional accounting. John too had strong bonds to "Mrs. G.," having supported both her and her sister Jean financially for many years and earned their profound gratitude.

John remained intensely involved in the Seattle Art Museum. In his role as president he became one of the museum's chief advocates for moving the museum from its neighborhood park setting to a downtown site. The museum had outgrown the building designed by Carl Gould, yet city restrictions on park use and neighborhood resistance inhibited expansion of the existing facility; John and others argued that a downtown site would have greater visibility and accessibility. To Anne, however, the thought of giving up her father's building was hard to countenance. Although she spoke up for continued negotiation of the park issues, she did not take a public position against the move. Her unease would erupt on a related matter several years later, however, when construction of a new museum building was underway downtown. Even as these plans were discussed, Tobey's death drew John, representing the Seattle Art Museum, into a prolonged contestation of the artist's estate.[10]

Under John's presidency, the museum also undertook what would prove a watershed event when it won a place on the national tour of Egyptian art from the tomb of King Tut. As preparations for the exhibition were underway in early 1978, John and Anne joined a Princeton Art Museum–led trip to Egypt to see firsthand the context from which King Tut's art had come. It would be the last time they traveled together. The King Tut exhibition, which opened in June of that year, was an undertaking that was to transform the museum's staffing, public relations, attendance, and income, and project the organization to a next level of maturity.[11] By the time of the exhibition's closing in November, nearly 1.3 million people had visited. Success of this magnitude was evidence of John's focused leadership, maintained in spite of evidence that the marriage was failing.

In September 1978 the ground gave way as the marriage crumbled. John left to live alone on Bainbridge and declared his intention to marry Ann Brinkley. Whatever disbelief and outrage Anne felt, there was now no way she could reverse events. She asked for a year's grace period in keeping with the Bahá'í teaching that called for reflection and reconsideration. John agreed to her

Anne, her mother, and brothers John and Carl, photographed by Mary Randlett in 1970.

Haystack Mountain School of Crafts, Deer Isle, Maine, where Anne took a class in ceramics in 1975.

Anne with her granddaughter, Carey Page, at Haystack Mountain School of Crafts, 1975.

request. When the divorce was finalized a year later, he immediately remarried.

The year-long interval of separation was marked by turmoil and resolution, both private and public. The day of John's announcement of his intent to divorce, Gemma Morgan, Anne's assistant, and Tom Wilson, who had served as the curator at the PNAC downtown gallery, were at her side. Anne was resolved to remain engaged in the activities about which she cared most and asked Wilson to escort her to the events on her calendar. That evening she talked to Dr. Hughes in Philadelphia. Once again she initiated her own visit to the Pennsylvania Institute, remaining there a month. Afterward she traveled again to Haystack in Maine and to Penland School of Crafts in North Carolina, where she sought personal renewal in the artist communities. After an extended absence, she returned to Seattle with some sense of equanimity.

Although she had taken this time away, she may not have given herself enough room to absorb the shock of the loss before she resumed her activities in Seattle's art world. Hardly four months after John's leaving her, she sparked an incident that even her friends had trouble understanding.[12] On January 9, 1979, respected gallerist Diane Gilson opened an exhibition of Matisse drawings, an event that represented the culmination of considerable effort to bring such work to Seattle. Anne questioned the authenticity and pricing of the drawings. Her vocal opinions, Gilson claimed, cost the gallery lost sales. Anne believed she was right in speaking her mind. Gilson filed a libel suit, which was settled out of court nearly two and a half years later. Wherever blame lay, the *Seattle Times* maintained its implicit support of Anne in a nearly full-page article on the settlement that highlighted her legacy and accomplishments.[13] The incident remained in friends' memories as a painful aberration, a tremor, indicative perhaps that the emotional adjustment was still under way.

Yet her resilience was notable. As her lifelong friend Anne Parry described Anne at this time,

> *Annie was superb. There showed her strength of character. I think a lot of people thought Annie would just collapse under this. But Annie did not give up, she did not collapse. She kept going places. She might have had a broken heart, but because she had such outside interests, they really kept her going because she wasn't going to withdraw from all of them. . . . She was so superb when all that happened. Her inner strength, her wonder, got her through it.*[14]

life on her own

On the morning of October 24, 1979, for the first time in more than thirty-eight years, Anne awoke as a single woman.

She was approaching her sixty-second birthday. Given the year's separation, she had already borne a good share of the anger and grief, the sense of betrayal, and the realignment of friendships that divorce in such circumstances brings. In the years ahead she would call upon her father's counsel to look ahead with a constructive view of life. He had written to her the first year she was away at school, "I hope you take some nice long walks in the New England country among the autumn red and orange foliage and take big breaths of the frosty air and think of what's going on way over the long horizon. Always keep your horizon big and don't be satisfied with little things and immediate and easy things."[1] And several days later, "Somehow things come out in the long run. . . . Life is always that way—ups and downs—and if you know that's going to be so, you will know how to wait till things come out all right, as they most always do."[2] Time and again his positive philosophy would replay in her words and actions. "I find life extremely exciting," she would say on her eighty-seventh birthday, "I'm glad to be on this earth with wonderful friends."[3] She remained vigorously engaged in the things she valued, and in time came to understand that, distilled to their essence, her fundamental goals were art and education. She began to reconfigure the ways in which she participated in these fields, and as she gained confidence as a single woman, she found a new freedom of means and expression.

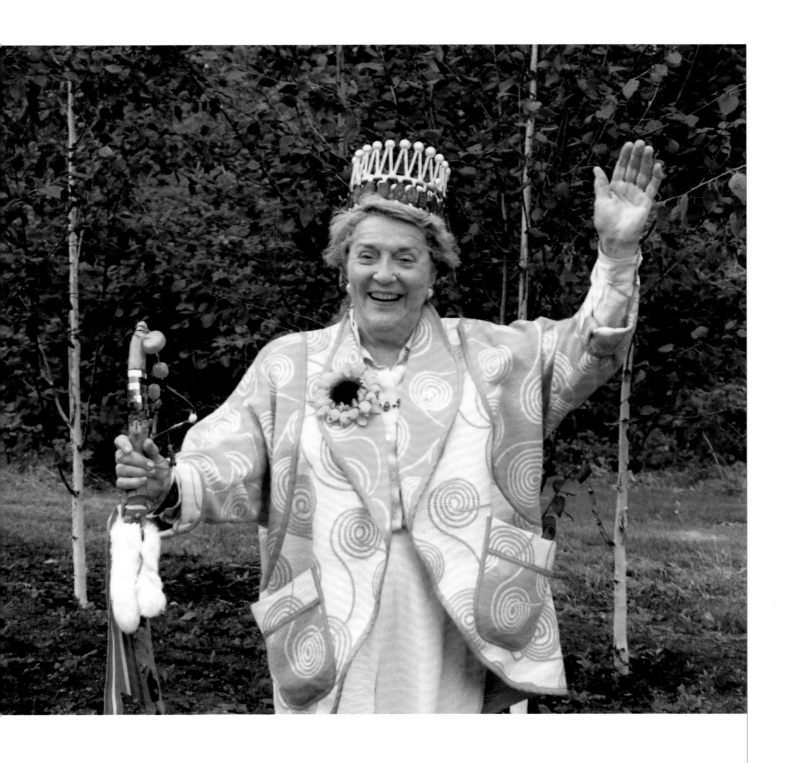

Anne was crowned "Queen of Everything" at Pilchuck Glass School's twenty-fifth anniversary celebration, 1996. The flame-worked and painted glass crown was made by Ginny Ruffner.

During the year she and John were separated and in those following the divorce, Anne's friendships with artists were instrumental in her healing and her ability to look ahead. These friendships grew into warm and lasting bonds and mutual support. Anne's daughter Fay suggests that the artists to whom she was close in effect became her family, a point of view others share.[4] Pilchuck Glass School played a critical role, even as Anne resigned her position on its board of trustees and began to recreate her role on its campus. The summer of 1979, the year of her separation, she enrolled in a stained-glass course taught by the British artist Patrick Reyntiens. It was an experience she savored, sharing the class and campus lodging with Mary Cozad, a longtime friend of both Anne's and John's who was then serving as Pilchuck's librarian. "She had a lot of creative ability," recalled Cozad. "She thought so too! I think she would rather have been an artist than anything else. She had a really good time with the class!"[5] She returned for more. In 1984 she took a class in fused glass (pâte de verre) led by Toots Zynsky, and in 1986, a class in painting on blown glass taught by Ulrica Hydman-Vallien.

Although Pilchuck is now world-renowned, it was only eight years old when Anne took her first class and still redolent of the hippy-era spirit of freedom and experimentation in which it was founded. In spite of her wealth as well as her sorrow, Anne was able to fit in comfortably. Having been part of Pilchuck's inception, she knew the artists, American and foreign, who shared in its originating foment. She visited the campus frequently when these friends were working there, attending the family-style dinners in the lodge and the artists' slide presentations afterward. She made a particular point to visit whenever Dale Chihuly worked on campus. Artist Joey Kirkpatrick holds a vivid picture of her presence: "I used to think, 'Who is that person, who is everywhere?' She was always up there [on campus], she would walk up and down that hill all the time, even if she wasn't taking a class. She seemed to show up all the time."[6] Anne visited the studios to see work in progress, wanting to meet young artists, always curious, always asking questions, excited when she saw

Fused-glass plaque (9 x 9 in.) made by Anne in a class at Pilchuck taught by Toots Zynsky, summer 1984.

new talent, and with longtime friends often staying to sit for a cocktail and conversation. On her day trips to campus, she nearly always brought along friends from the city to introduce to the artists and to Pilchuck's embracing spirit.

Her inquisitiveness became a hallmark. Her creative, freely associative mode of thinking found a warm reception among artists. The circular thought and speech patterns that had frustrated John, and which were often not understood in the

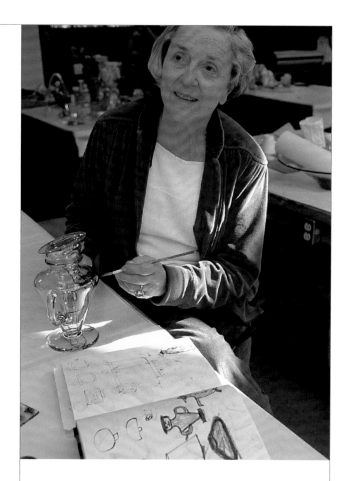

Anne at Pilchuck Glass School in a class taught by Ulrica Hydman-Vallien, summer 1986.

Ulrica Hydman-Vallien at Pilchuck Glass School, summer 1986.

Italian artist Lino Tagliapietra (gesturing at left) with a class at Pilchuck Glass School.

Erwin Eisch, *Telephone*, 1971 (mold-blown glass with luster, 6 ¼ x 8 ⅞ x 7 ⅛). Collection Anne Gould Hauberg.

boardrooms and business meetings where linear thinking was valued, were received with delight in the creative community. "She was in keeping with the free spirit of those days," suggests Benjamin Moore.[7] Artists at Pilchuck appreciated her genuine curiosity and direct, unselfconscious questions about the making of their work. At the dinnertime slide lectures, she was the first to ask questions. The artists in turn usually found they could be candid with her, trusting in mutual intellectual respect whether or not she and they agreed. She wanted the details of a story, and might see through to unexpected connections. Flora Mace recounted the way that

> *Annie would always — no matter whom she was talking to — go further into depth than you ever thought you would. She was so personable. She would make a point to say to the people she was with, "Remember this. This is important." Whomever she's around, if something's happened and she's questioning it, it's almost as if she stops {to say}, "Do you realize what's happening here? . . .Do you realize the bigger picture here?"*[8]

Her own conversations tracked rapidly from one idea to the next. "She can keep three thoughts going in mind at one time; she can switch back and forth and never miss a beat," remarked Paul Marioni, who has known her since Pilchuck's founding years. Marioni values her intellectual playfulness, the "conversations about one subject, off into nonsense, back to sense—such a quick mind. She didn't mind if you went off into fantasies. Then back to business."[9]

Her support was material as well as emotional. She had collected art for years, always motivated by the idea of supporting artists rather than acquiring prized objects, and now she carried on that practice with the freedom of means solely at her own disposal. "She would not look at the potential value of the work so much . . . as the person she was supporting," noted gallery owner William Traver. "Her primary goal would be to support the person, to encourage the person, to give that kind of moral support. And then the by-product was the object, as opposed to the object being of primary importance. That was what Annie was all about."[10] For young artists at Pilchuck whose work she asked to see, her visits were important acts of validation. Her support extended to raising funds for artists' special projects, typically by inviting her friends to meet the artists and buy their work. At the beginning of their careers, when Benjamin Moore and William Morris planned to visit glass facilities in Austria and Sweden, Anne gave a party in her home to help finance their trips.[11]

Sometimes her collecting was a quiet, more private act. "Annie would hear that a young artist was having financial troubles, show up at his studio, and buy something. She doesn't make a point of why she's there," recounted Marioni. "She has done it for me; she

has done it for so many artists."[12] "She has lent me money, paid my rent, bought my work, asked her friends to buy my work," said James Minson.[13] She was a major supporter in 2002 when Minson undertook the establishment of a glass flame-working studio at an orphanage in Guatemala.[14] "She is very generous," added Anne's assistant, Jeanette Whiteman. "I have never known her to say no to an artist who shows a special spirit."[15]

A unique instance of support was her business venture with Moore, a glassblower, and Walter White, a metalworker. In 1984 Anne approached Moore, "Ben, I have all of these architect friends who want good lighting. You make glass. Let me connect you." [16] She proposed to the artists that they design and produce household lamps, which she would buy from them and in turn sell. Moore and White developed designs for custom table lamps and pendant fixtures for the business they named The Light Touch. Anne managed promotion, garnered a few sizable orders, and held several sales of unique pieces at her home. The venture lasted four years, until it unraveled because of the partners' different working and communication styles. Now twenty years later, The Light Touch, in which Anne combined her interests in architecture and glass, seems to have been in the vanguard of the high-design lighting that has since become a widespread product on the market.

The respect and affection the Pilchuck artist community returned to Anne was as great as that she gave, epitomized on a summer day in 1996 when she was crowned "The Queen of Everything." The occasion was the twenty-fifth anniversary of the Pilchuck Glass School's beginnings as an experimental workshop on the raw mountainside meadow. The ceremony took place on a flatbed truck parked next to the hotshop. As a large crowd of friends from past and present looked on and cheered, artist Ginny Ruffner bestowed on Anne a flame-worked glass crown. "She is the reason Pilchuck exists," Ruffner declared. "Annie is the vision that made it happen."[17]

Anne had another vision also, that of young people working alongside professional artists. As she began her life as a single woman, her work at the Pacific Arts Center was already under way, and now she stepped forward to leadership. In the fifteen years since the Seattle World's Fair, Seattle Center had become home to the city's major performing arts organizations through its main-stage theater, symphony, ballet, and opera. Anne and others believed that what was missing was a children's art center that could take advantage of the richness of these resources. In 1977 she had been among those supporting a bond issue to complete the development of Seattle Center. The bond issue, which won voters' approval, provided for the purchase of the Nile Temple building adjacent to the center's grounds, to be converted to an educational facility where students could connect with visiting artists who were performing at the major

James Minson, wreath of lampworked glass, 1999 (22 x 20 x 5 in.). Collection Anne Gould Hauberg.

Benjamin Moore and Walter White, a blown-glass and metal table lamp for The Light Touch, 1985 (16 x 18 in. dia.).

Performance of *Dream Time* at the Pacific Arts Center, 1984, directed by Klauniada, set designed by Diane Katsiaficas.

arts venues. Anne served as a member of the interim board formed to plan the new facility, and when the resulting organization, the Pacific Arts Center, was incorporated in 1980, she became chairperson of the board of trustees. The new Pacific Arts Center was a direct descendant of the creative dramatics program initiated by Ruth Lease in the wartime housing projects of the 1940s. Between the wartime program and the new center were the successive generations of the Junior League's Children's Recreation Project, the Seattle Creative Activities Center, and the annual Arts for Youth Festivals. Anne had participated in them all.

During the formative years of the Pacific Arts Center, the interim board met weekly in Anne's home. She paid close attention

to naming the new organization: it was to be the "Pacific," not the "Children's" Arts Center, and its tagline—"Professional artists and young people together"—continued that emphasis to indicate a seriousness of intent and respect for both students and artists.[18] In 1982, when the Pacific Arts Center opened in the remodeled Nile Temple, as funded by the bond issue, she lobbied for an art gallery in what was originally conceived as a performing arts space. A professional-quality exhibition space was added in 1985 and named in her honor.

The exploratory character of the Pacific Arts Center's mission, as well as its legacy in Lease's creative dramatics, was illustrated in a 1984 production. *Dream Time* was a theater piece led by two

Canadian mimes, Val Dean and Ron Reider, who called themselves Klauniada ("clown play" in Czech). For this, the actors led young people, in a workshop setting, to recognize emotions, create expressive representations of them, and then develop a narrative, which resulted in an improvisational performance. Sculptor and painter Diane Katsiaficas, whose role was to design the set, also learned from the actors, who suggested that the ephemeral yet evolving character of the performance itself could guide her design. "It was fabulous; it stretched me too," she recalled of this time when she was a young artist. "It was exciting to be hooked up with other artists. Instead of dreaming about it, we were told to just do it. No one was yet talking about multidisciplinary work."[19] Katsiaficas, the center's first visual artist-in-residence, was also provided with a studio for several months where she could do her own work as well as the set design. "It was really important to have my own studio at the time," she continued. "Students could come to it. It was a sense of self-worth." Characteristically, Anne too visited Katsiaficas' studio to become acquainted with the artist and her work.

The exhibitions that followed when the Anne Gould Hauberg Gallery opened at the Pacific Arts Center the next year displayed the same interdisciplinary spirit. The center drew students of varied cultural, racial, and economic backgrounds, as the model wartime creative dramatics and its successor programs had done. Its program regularly featured artists of color, a program of inclusion that placed it among the forefront of Seattle arts organizations. The center, however, struggled for financial stability. It had neither the steady patronage of the kind Pilchuck had enjoyed nor a singular artistic leader to channel its purpose and project its message.[20] In 1987 it lost its lease on the building. For a while the organization continued as a traveling program to schools and community centers, as it increasingly focused on youth in underserved communities. While a core group of supporters kept alive the originating spirit, other organizations assumed leadership in providing arts education for youth. Anne never abandoned the effort. She had been active from her wartime involvement in 1945 until the center's last public phase, and her loyalty and energetic commitment have linked her name indelibly with the Pacific Arts Center.

At the same time the Pacific Arts Center was forming, another educational mission captured Anne's attention. She was a member of the founding board of the Northwest School, a new independent preparatory school that gave equal emphasis to arts and academics. It felt natural to her to encourage collaboration between the two organizations, although no cooperative program was realized. Five years after the Northwest School's founding, when a disagreement over educational philosophy broke away a portion of the school's families, Anne was steadfast. "Once she commits, she commits,"

Ellen Taussig, the school's present director, said of Anne's support, adding that Anne did not waiver in her principled belief in the school's leader and their mission.[21]

Anne continued to forge ahead with unabated energy in support of the crafts she had long advocated. In 1980 she established a fund at the Seattle Art Museum to purchase Northwest contemporary craft objects for the museum collection.[22] The same year she participated in a project of the National Crafts Congress, organized in conjunction with the National Endowment for the Arts. The national committee on which she served was charged with talking to craftspeople throughout the country to assess the means of support for the field. It was a formidable but stimulating assignment, for an idealistic vision still reigned that common ground could be found among university-trained studio artists, traditional rural craftsmen, and hobbyists. A year later she was appointed to the Building Arts panel of the N.E.A., then a part of its craft program.

Locally, and in addition to her national involvement, she stayed loyal to the Friends of the Crafts. Although its gallery and office had closed, the organization continued to issue its newsletter, *By Hand*, and tried one more time to determine the level of interest among potential supporters. Anne followed the organization's course to the end, and two years later participated in short-lived discussions to revive and expand the Friends of the Crafts mission into a larger public venue. In subsequent years, the established art museums of the region collected and exhibited craft objects, although none had the dedicated focus that Anne had envisioned for a Northwest art center. The boundaries in contemporary art between craft and art steadily blurred; artists themselves pressed to erase them. Anne held true, however, to her belief in pure craft: she stood by her taste for the handmade object and her conviction about craft's unique attributes and nobility.

.Three art museums in the region captured Anne's attention during these years. Two of them were new institutions, and two of them had a designated Northwest focus. Her hope that she and John would create a rural cultural center dedicated to art from the Northwest had diminished with the closure of the Tatoosh development and died with the divorce. Now she redirected her energy to other efforts.

The first was the Valley Museum of Northwest Art, today named the Museum of Northwest Art. Anne was among a group of people who supported the development of a new museum in La Conner, a town in the Skagit Valley near the foothills where the Pilchuck Glass School is located. Driving the vision was Art Hupy, a photographer and a longtime friend of Anne's, and in 1981 the Valley Museum opened in an historic house under his direction. The museum was singularly dedicated to art from the Northwest, and especially to

Ginny Ruffner, *The Juggler of My Heart in Person*, 1989 (lampworked glass, paint, colored pencil, 26 ½ x 14 x 12 ½ in.). Collection Anne Gould Hauberg.

the legacy of those recognized as its modern masters—Mark Tobey, Morris Graves, Kenneth Callahan, and Guy Anderson, and Hupy took delight in seeking art for the collection. As it became apparent that the old wood-frame house was not an appropriate place to keep a collection, Anne, a founding board member, eagerly promoted a new site and keenly wanted Roland Terry to produce the design. However, as the museum matured, a difference about the organization's governance developed between the board and the director. When the board prevailed and Hupy left, Anne left the board, loyal to her friend. Fourteen years after its founding, the renamed museum moved into a newly renovated storefront building designed by La Conner architect Henry Klein, who had designed the proposed Tobey Museum for Anne and John. Anne was to realize her own desires for Northwest art elsewhere.

The second museum to engage Anne was the Tacoma Art Museum, whose board she joined in 1994 as this museum also began planning a new facility. Through John's business and many shared friends, Anne had long connections to Tacoma, which was the historic headquarters of the Weyerhaeuser Company. Within a few weeks of joining the board, she invited the museum director, Chase Rynd, to visit Morris Graves, then living in Loleta, California. For two days Anne and the artist, renowned for protecting his privacy, reminisced about their long friendship, and on the second day, when Rynd was invited to Graves's studio, he recognized the occasion as a rare honor.[23] Anne's greatest interest was the museum's representation of artists from the Northwest, and she focused her attention on the its regional collection, creating opportunity by such acts as facilitating the Graves visit, inspiring others' interest, and making gifts of her own. She donated pieces of artist-made jewelry, promised a future gift of the glass she had collected since Pilchuck's beginnings, and subsequently committed to the museum such significant works of art as Tobey's *Northwest Fantasy*, a painting she had owned since the construction of the McGilvra house. In later years her glass collecting shifted emphasis as she began to purchase major objects with the knowledge that they would fill a place in the museum collection. And yet her fundamental commitment to individual artists remained, for her foremost consideration was how the artist would and could be best represented in this collection, or that of another museum or educational institution.

Shortly after joining the Tacoma Art Museum board, Anne was asked to be among the founding board of the new Museum of Glass, also in Tacoma.[24] It was an irresistible invitation, given her intimate affiliation with Pilchuck Glass School and her long friendship with Dale Chihuly, Pilchuck's founding artist. Anne was involved from the beginning in the conceptualization of the new organization and was a forceful voice during the design of its building, which

William Ivey, *Untitled*, 1965 (oil on canvas, 72 ½ x 58 in.). Collection Anne Gould Hauberg.

was to be a combination art museum and glassblowing studio. The architect was Arthur Erickson, considered by many the preeminent living architect in Canada. As the board struggled with the costs of the complex building program, she argued fervently in Erickson's favor when she felt cost-cutting undermined the integrity of his design. "She was the defender of the architectural idea all the way through," remarked Erickson. "She was a tremendous support."[25] She embraced the symbolic, iconic value of the building's key design elements: the studio's cone-shaped tower reminiscent of the sawmills that once dotted the West Coast from Oregon to British Columbia, and the rooftop pool that echoed the Thea Foss Waterway alongside the museum site. As Erickson's project architect, Wyn Bielaska, recognized, Anne readily grasped the concept of water as a building material, whose transparency and reflective qualities evoked those of glass. It was largely due to her support that this design element stayed in the plan, and today a pool covers the roof.[26] George Russell, the driving force behind the museum, remarked of Anne's activism on the board, "I'd rather have someone like Anne, who raises all sorts of questions and critiques; then you're likely to reach the right answer."[27]

For a number of years, her relationship with the Seattle Art Museum was less happy. She and John had experienced considerable tension between themselves when John was president of the museum board and promoting a downtown site for a new museum building, a move Anne saw as a betrayal of the existing museum designed by her father. The original plans for the 1933 building included the placement of monumental Chinese tomb sculptures near the entry, which Gould had described to his young daughter: "You should see the great hole and the pile of dirt in starting the foundations for the art museum up in Volunteer Park . . . Dick [Fuller] is going to get two huge Chinese camels for the terrace, lying down, and it will be a grand place to see the Olympic mountains from. Someday maybe you will take your youngsters up there and I hope it will be so beautiful you will not mind saying your Dad was the architect . . ."[28] Since the museum's opening two large camels had flanked the front door, and over the years thousands of children had climbed onto their backs during visits to the museum. In the late 1980s, as a downtown building moved toward reality, the Seattle Art Museum decided the sculptures should be conserved and brought inside the new building. Replicas of the camels were made with state-of-the-art technology to replace the originals that had stood outside the Gould building. To Anne it was heresy. They would never be the same; to her, the "alive" quality was gone. She tried petitions and rallies, to no avail. Her ties to the museum eventually mended, although she never lost her conviction about the camels' proper place. After the opening of a downtown museum in 1991, the Gould building was renovated,

The Museum of Glass: International Center for Contemporary Art, opened in Tacoma in 2002. Arthur Erickson's design features a cone that emulates those of historic sawmills, and a rooftop pool that echoes the nearby waterway. Buster Simpson's sculptural installation, *Incidence*, 2002, was commissioned for the building.

Two stone camels from China (Qing dynasty, 1644–1911) flanked the entry to the Seattle Art Museum since the time of its opening in Volunteer Park in 1933. The originals are now in the museum's downtown site, and the Gould building is the Seattle Asian Art Museum.

restored to its original interior proportions, and is today the Seattle Asian Art Museum.

Amid Anne's work for art museums, art education, and crafts advocacy, an incident again shook her sense of well-being. On October 4, 1984, burglars broke into her home. Her loss was substantial, mostly fine silver. In the aftermath, she decided to move out of the McGilvra house, which belonged to her through the divorce settlement, and to seek a place of greater security. She seems to have considered moving even before the burglary, but this experience was the determining event.[29] She sold the house and purchased a condominium in an elegant 1920s building on Seattle's First Hill, a neighborhood where the mansions of Seattle's first families, including her grandparents, had once stood.

Anne's move to a new home was driven also by the excitement of beginning again, a change charged with creative potential. This time too she had the freedom to conceive the space according to her own wishes. She wanted to open the living and dining room walls so that the comparatively small quarters could accommodate the meetings and parties that were both her business and pleasure. She needed display and storage space for her glass collection and envisioned movable screens across the walls to reveal and conceal shelves full of objects. Upon the recommendation of Alan Liddle, a Tacoma architect and friend, she asked Seattle architect Wendell Lovett to help achieve her vision. Before moving from McGilvra, she had sold a considerable portion of her collection of paintings and ceramics, as well as most of the custom-designed furniture, and now she began to create a new environment once again shaped by art.

The move offered new opportunities to commission work from artists. She asked Paul Marioni and Ann Troutner to create a facing in cast glass for the fireplace. She wanted the hearth to be the center of attention, she told the artists, rather than the television set that too often took its place in American homes.[30] There were painted wall panels by Alfredo Arreguín in the entry, and overhead, translucent, leaf-patterned light panels. She filled her new home with the things she collected, and eventually she could look in any direction and see a colorful, layered, and textured tableau of art objects of varied media. Several years later she redecorated the compact interior, adding silver foil to the ceiling and glaze to the walls to create a rich and enveloping space.

Within a few years of moving, she began a concentrated foray into the commissioning of furniture. The interest in furniture was not new to her; she had a dining table and a complement of chairs by George Nakashima, and for John's office she had made a gift to him of a desk by Sam Maloof. Now she dedicated her attention to woodworkers in the Northwest. She commissioned dining chairs from Michael Strong, a bedroom desk from Jonathan Cohen, a

Dining room. Artists represented (left to right): John Marshall (on small table), Jean Dubuffet (on wall, above), Mark Tobey (on wall, below), dining chairs by Michael Strong, table by Toby Beard, light fixture by Benjamin Moore and Walter White, Dale Chihuly (on table), Karen Willenbrink-Johnsen (on table), Susan Plum (candlesticks), Clayton James (painting and sculpture).

Dining room from another angle. Artists represented (left to right): Ross Day (buffet), Paul Heald (painting), Dale Chihuly, Debora Moore, Susan Plum, and Flora Mace and Joey Kirkpatrick (on buffet), Therman Statom (in wall niche).

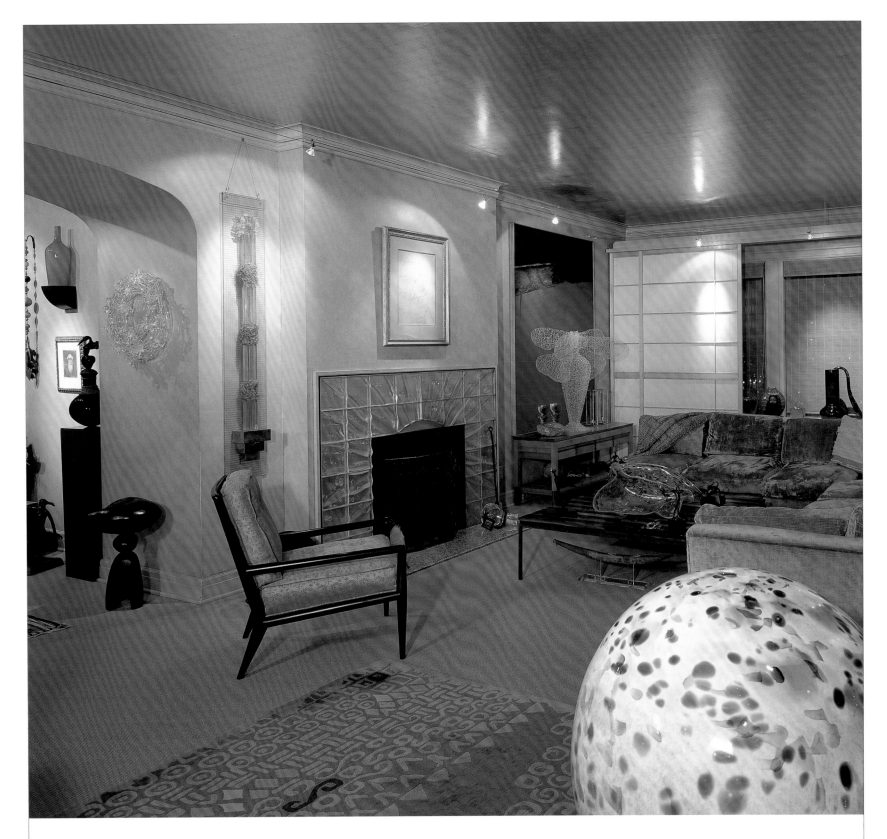

Living room, 2004. Some of the artists represented, clockwise from upper left: Sabrina Knowles and Jenny Pohlman (on wall and pedestal, adjoining room), William Morris (on wall shelf of adjoining room), Camille Pissarro (print, below), George Tsutakawa (sculpture on floor), James Minson (on wall under arch), Nancy Mee (left of fireplace), Henri Matisse (above fireplace), Paul Marioni and Ann Troutner (fireplace facade), William Ivey (painting, right of fireplace), Susan Plum (sculpture in front of Ivey), Dale Chihuly (behind sofa, on table, and in foreground), Lynn Basa (rug). Interior photography on both pages by Lara Swimmer.

Toby Beard built a thirty-six-drawer credenza, 1989, which can be assembled in variable configurations (ash, drawer pulls of fossilized walrus ivory).

cabinet from Ross Day, and, from Toby Beard, two credenzas, two cabinets, and two tables. "I find it interesting that someone close to her eighties would still have such an appetite for supporting artists and for creating something new for her environment," observed Priscilla Beard. "She's never satiated."[31]

For Toby Beard, the opportunity was unexpected and unprecedented. He was working as a carpenter in home renovation when he met Anne. Within minutes of their introduction, she told him she needed a container to store her personal papers and asked if he could make her something, and when he spontaneously drew a scheme for a credenza, she asked him to submit drawings and an estimate for the finished product. Beard had never made a piece of furniture. He had no training in cabinetry or furniture making. Based only upon his reading about furniture-making techniques, he

built a thirty-six drawer puzzle-like credenza that can be configured in variable dimensions.[32] Over the course of twelve years Beard made Anne a dining table, a small table for glass objects, two jewelry cabinets, and a second, very differently styled, credenza. His experience was an outstanding example of her open-minded reception of creative ideas and the risk-taking she willingly supported.

Anne began another remodeling project, the renovation of Topsfield, in 1993. The Bainbridge cottage that had been designed by her father in anticipation of his marriage was now her island retreat. It had been used well by three generations of the Gould family, and since her mother's death in 1976 Anne had shared ownership with her brothers. Once again, and for what would be their last project together, she asked Roland Terry's help in restoring and enhancing the original French country character of the house

and gardens. She reconfigured some of the interior space to make it more practical for contemporary living and opened the kitchen to the parterre garden her father had designed. They replanted the informal gardens along the deck and the east fence. There, views from the house stretch across the meadow where she had run as a child and open expansively to Puget Sound, Mount Rainier, and the Cascade Mountains. In the ensuing years several garden designers, primarily Charles Price and Glenn Withey, helped her enrich the plan. The restoration of the house was a restorative process for her too. Returning there frequently and continuing to cultivate the garden, Anne savors the continuity with the past and the familiarity of the rhythm.

As Anne built her new life as an independent woman, for the first time in fourteen years she lived near both of her daughters. In the summer of 1980 Fay, her husband Nat Page, and their two young children, Carey and Ben, ages seven and three, moved from Boston to Seattle to make a new home. They settled in Mercer Island, a suburban community across Lake Washington from Seattle, while Nat joined John in business at the Pacific Denkmann Company. For the first time, Anne had two grandchildren nearby.

Anne's younger daughter, Sue, lived on her ranch at the tree farm. As Sue moved into her thirties, Anne continued to watch closely over her development and sought John's help in providing her with increasing responsibility at the ranch, which included a boarding stable that earned a small income.[33] Sue also began to train for competitive riding. In 1998, she left the ranch and moved to Kirkland, a Seattle suburb, to be closer to her family, but she began driving each week to Oregon to continue work with her trainer. Her efforts were handsomely rewarded when she won the 2000 Canadian National Championship in her field, and the same year won the national Reserve Championship (second place) in the United States. When Sue reflects today on having learned to ride as a young child, she believes she may have been in the forefront of riding as therapy; because of its ability to develop muscle strength and control, horseback riding is now used effectively with some children with disabilities.[34]

Neither Fay nor Sue had been surprised by the divorce, which left each of them to deal with a divided family in her own way. Fay suggests that the qualities in Anne that others celebrated, such as her rapid assimilation of new ideas, her scattered patterns of thought, the unguarded candor, and her dogged persistence, could be hard to deal with in the intimate context and frequent contact of family life.[35] Anne, nevertheless, followed with pride each of her daughters' accomplishments. Together with her daughters, she also took comfort and pleasure in the extended family of relatives who lived in the Puget Sound area. They were Anne's two brothers, until Carl's death

in 1992, and their wives, Gretchen and Margaret, their children, and grandchildren. On the Fay side were three generations of cousins.

For more than thirty years, Anne employed several women who helped manage her business affairs and were at her side during times of personal need. Holding the little-recognized position of private assistant, they were Gemma Morgan, who worked with Anne during the 1970s; Betsy Russell, employed from 1979 to 1987; Betse Cody King, 1987 to 1991, and from 1991 to the present, Jeanette Whiteman. They participated with discreet but profound support in the events of Anne's life. "I can operate only because of people who are wonderful," Anne said of these women. "They made it possible to do a lot of things."[36]

As years passed Anne pursued her interests with unflagging energy. She was a loyal and intrepid presence at Seattle gallery openings, art events, and an array of special events to support

Topsfield in late summer, 2000.

A silver tea service by John Marshall, 1987 (silver and rosewood, 12 ½ x 26 ½ overall) is among the objects Anne commissioned from artists.
Collection Anne Gould Hauberg.

Flora Mace and Joey Kirkpatrick, two views of *Doll Drawing*, 1981 (blown glass, wire, and glass frit, 12 x 7 ¼ x 7 ¼ in.). Collection Anne Gould Hauberg.

causes. In 1980 she traveled to Paris to celebrate the opening of an exhibition of textile designs by Jack Lenor Larsen, a rare solo exhibition at the Musée des Arts Décoratifs in Paris, where Mark Tobey also had received such an honor.[37] She attended the international Glass Art Society conferences as often as possible, in such places as Amsterdam, New Orleans, and Seto, Japan, where she was revered as both a founder of Pilchuck and a supporter of artists. In 1996 she marked her special friendship with Dale Chihuly by arranging a small party to visit Italy for the opening of *Chihuly Over Venice*, a major installation in the heart of the old city. As she had done during her marriage, she continued to travel frequently with women friends, including such longtime traveling companions as Mary Cozad and Ramona Solberg. She traveled with the same unquenchable curiosity she displayed in artists' studios. Solberg recalled, "You had to keep your eye on Anne—she wanders. In

Yemen, I remember, we were held up in a traffic jam, and so she got out of the bus and was talking to the children and taking pictures and wandering up and down and just having a wonderful time."[38]

The Bahá'í faith remained a source of renewal and affirmation for Anne. Its universalist creed encouraged her penchant for holistic thinking. She began to see that its central message affirmed patterns in her own life. Her dedication to education she found in the Bahá'í's instruction to make "education available to all"; her zeal for making creative connections among people of diverse interests, in Bahá'í's call for the joining of "arts, crafts, and sciences." She identified even the internationalism of the glass community she had helped nurture with the Bahá'í teaching, "Let your vision be world-embracing, rather than confined to your own selves;" in such a way she could imagine how it advanced the principle of the unity of humankind.[39] Among the papers she kept at hand was a lyrical poem by Bahá'u'lláh:

Philip McCracken, *Bow Under Tension*, 1980 (metal, wood, paint, feathers, and wire, 71 x 56 x 15 ½ in.). Collection Anne Gould Hauberg.

Blessed is the spot
and the house,
and the place,
and the city,
and the heart,
and the mountain,
and the refuge,
and the cave,
and the valley,
and the land,
and the sea,
and the island,
and the meadow
where mention of God hath been made,
and His praise glorified.[40]

 She began to create her own legacy as a benefactor. A number of the organizations she supported represented chapters of her past, but in every case her dedication was to education and art. In 1989 the University of Washington initiated an endowment drive for its libraries. As part of that effort, the university proposed the creation of an annual bookmark design, called the Artist Image Series, to recognize artists who had made lasting contributions to the region. Anne's connection to the libraries was compelling; the main building, Suzallo Library, was her father's signature architectural achievement. She made a gift to establish the Anne Gould Hauberg Endowed Library Fund to underwrite the program. Additionally, she established her own goal of securing a work of art by each artist honored for the university, and in 2003 donated Philip McCracken's wall-hung sculpture, *Burning Through*, which now centers the Peterson Room of Suzallo-Allen Libraries. She excitedly described the "overpowering experience" of watching the installation of the sculpture, when "all of a sudden, it was in exactly the right place, and the room was transformed!"[41] Elsewhere at the university she renewed her ties to the Experimental Education Unit, which had originated in 1960 as the Pilot School and was now among the foremost in its field for its combined children and family services, research, and teacher training. She was a founding board member of the James W. Washington, Jr., and Janie Rogella Washington Foundation. The foundation was pledged to preserve the artist's work and open to the public his home and studio, now a City of Seattle Landmark. Years before in the McGilvra house, she had hosted a display of Washington's sculpture and invited him to social events, making strategic introductions in the process of supporting him and his work.

Cappy Thompson, *I Receive a Great Blessing from the Sun and the Moon: I Will Be an Artist and Walk the Path of Beauty*, 1995 (blown glass and fired enamel, 17 x 14 ½ in. dia.).

A crowning success late in her life, once again linking art and education, was the University of Washington's commitment to establish a studio glass program. A number of people, including Anne, had decried the absence of a university degree program in the region that had spawned Pilchuck and fostered the international growth of studio glass. For years the issue hung in the air. In 1990 the University of Washington opened a Tacoma campus in the vicinity where its two new art museums would be built, forming the centerpiece of revitalization efforts in the city's downtown. In late 1999, with an eye to the synchronicity of Tacoma's cultural institutions and the burgeoning interest in studio glass, Anne discussed the question with two University deans, David Hodge and Michael Halleran, and later with Vice Provost Steven Olswang. She began gathering people together with the intent to generate the ideas, network, and synergy necessary to propel such a program. To the individual members, the groups seemed unlikely combinations of people and professional interests. "She was able to bring together this incredible, diverse group of people. None of us really knew who

the other was, what our purpose was, until we all came together, and then suddenly something seemed to grow from it," recalled Bill Traver, whose Seattle gallery features glass.[42] "You'd think, 'How on earth?!' " remarked Elaine Ethier of the University's development department, "and then you'd find out it was the juiciest group of people!"[43] After years of discussion, an economic downturn, and the political shock of September 11, in 2004 the University announced its commitment to a studio glass program. Both the Seattle and Tacoma campuses will participate in the program, projected to begin in 2007, although the location, the relationship between the two campuses, and the collaboration with other glass facilities in the two cities remain to be resolved. Anne was the program's outstanding champion. As in her past involvements, she had seen a need and moved energetically to meet it. "If she hadn't been her courageously, insistently, persistent self, it wouldn't have happened. She is responsible for this happening," Ethier declared emphatically.

As Pilchuck Glass School reached its thirtieth anniversary in 2001, the school planned to create a totem pole on campus to honor the school's founders: Dale Chihuly, Anne, and John. Each was represented in the pole design. It was a unique endeavor, bringing together master carvers from Alaska Indian Arts in Haines, Alaska, and glass artists at Pilchuck. The rough carving of the pole began in Alaska, and in August the pole was shipped to campus for completion of the carving and the production of glass components for it. For the last three-week session of the summer's classes, the totem pole became the focus of a special class and the spiritual center of campus. When the pole was ceremonially raised on August 29, the figure of Anne stood at top, wearing a Northwest Coast–style hat made of blown glass on her head, and the carved patterns of a Chilkat blanket wrapped around her shoulders. At center was Chihuly, with a cast-glass image of the sun. At the base was John, holding a cast-glass ceremonial sword replicating one that was once in his prized collection of Northwest Coast Native art.[44] The speakers remarked appreciatively on the unique and crucial contributions of each of the three: Chihuly's originating idea, Anne's vision of what was possible, and John's sustained financial support.

John, however, was not there. That same day he underwent heart bypass surgery at Seattle's Swedish Hospital. Nine months later he entered the hospital again. This was for an apparently minor procedure unrelated to the heart surgery, but in the process he contracted an infection that jeopardized his life. During his more than two weeks' hospitalization, Anne was frequently with him, and on April 5, 2002, he died. Although it had been twenty-two years since they divorced, his death could not help but be an immense loss, as Anne reexperienced the closing of one of the most important chapters in her life. The totem pole on Pilchuck's campus

Anne, 2000. Pin and earrings commissioned from Nadine Kariya, part of the artist's *Gauntlet* series, 1998 (fabricated green-gold pin, 4 ³/₄ x ³/₄ x ³/₈ in).

represents them together again, symbolic of many of their accomplishments in life.

In the ninth decade of her life, Anne looked back with pride and sometimes surprise at the recognition given her for her accomplishments. Some had come in much earlier years; many more came as the culmination of a lifetime of engagement. Thirty-five years earlier, in 1970, she had been given the Matrix award, being designated as one of seven Women of Achievement for her work in art, craft, and city beautification. In 1972 she and John had received the Washington State Governor's Award for their support of artists and arts organizations. In 1987 she received the Arts Service Award from the King County Arts Commission (now 4 Culture); in 1989, the Seattle Center's Legion of Honor Award; and in 1993 the Aileen Osborn Webb Silver Award from the American Craft Council. For their roles in founding Pilchuck, in 1995 she, John, and Dale Chihuly were honored by the Safeco Art Leadership Award. In 2000 she was given the Visionaries Award, the highest honor bestowed by New York's American Craft Museum (now the Museum of Arts and Design).[45] She is an honorary member of the Seattle Chapter of the American Institute of Architects and the Northwest Designer Craftsmen, which in 2004 recognized her contribution to craft in a documentary video, *Anne Gould Hauberg: Visionary*.

One of her most recent recognitions, in 2002, was the Junior League of Seattle's Dorothy Stimson Bullitt Award, named for another visionary activist and distinguished Seattle philanthropist. Anne's closing words of thanks express her legacy to the people, the city, and the fertility of creative expression in which she so deeply believed:

> *My hope for you and for myself is that our lives are filled with purpose and filled with content, expressed with skill and energy, and most of all that our contributions endure in the memories of those whose lives we touch.*[46]

Anne had grown into her adult life as a talented young woman, instructed and inspired by her father's ethics and creativity and her mother's ebullient sociability and ambition. Reared with the decorum and benefits of privilege although sometimes constrained in means, she married into wealth and used it to create a richly textured personal style. It was a style colored by her passion for art and architecture and warmed by her relationships with artists and designers.

In ways she could not have anticipated, her children comprised the core of her life. Through them she experienced the love, joy, and enduring hope held in the intimate bonds of mother and child. The losses she experienced in childbearing and death were a bleak void she encircled with her own creative energies. She committed herself fearlessly and fiercely to the things in which she believed. Late in her life she exclaimed, "What would life be without the things that give beauty—art, dance, theater, music—the things that make life bearable?"[47]

Founders' Totem Pole, Pilchuck Glass School, 2001 (cedar with blown and cast glass, height 20 ft.). The images (top to bottom) are of Anne, Dale Chihuly, and John.

notes

Anne at the tree farm, PNAC Founders' Day picnic.

Abbreviations used in the notes and
in the illustration credits:

AGH
Anne Gould Hauberg

JHH
John H. Hauberg, Jr.

AGH PAPERS, AGH
Anne Gould Hauberg Papers,
possession of AGH.

AGH PAPERS, UWSC
Anne Gould Hauberg Papers, Accession
2991-3, University of Washington Libraries,
Special Collections.

CG COLLECTION
Carl Gould Collection, No. 426, University
of Washington Libraries, Special Collections.

GF PAPERS
Gould Family Papers, Accession 3516-9,
University of Washington Libraries, Special
Collections.

JHH PAPERS, FHP
John H. Hauberg, Jr., Papers, possession of
Fay Hauberg Page.

JHH PAPERS, PDC
John H. Hauberg, Jr., Papers, possession of
Pacific Denkmann Company.

JHH PAPERS, UNACCESSIONED
John H. Hauberg, Jr., Papers, University of
Washington Libraries, Special Collections.
These are papers from John Hauberg's
estate, which until recently were held by
Fay Hauberg Page; they are now deposited
in the Special Collections Division but not
accessioned as of May 5, 2005. Intermingled
are papers from Anne Gould Hauberg,
which will be separated when the material
is processed.

JHH PAPERS, UWSC
John H. Hauberg, Jr., Papers, Accession
2850-7, University of Washington Libraries,
Special Collections. Subsequent accessions
are identified by number in the citation.

JHH SR. PAPERS
John Henry Hauberg Papers, Accession 27,
Augustana College, Rock Island, Illinois.

MM
Margaret Marshall, transcripts of interviews
with Anne Gould Hauberg, 1995, AGH
Papers, AGH.

UWSC
University of Washington Libraries, Special
Collections.

INTRODUCTION

[1] Janet Paulson, "Let's Think This Over,"
text of presentation to Municipal Arts
Commission, April 27, 1961, p. 1. AGH
Papers\, UWSC, Box 12/Citizens Planning
Council.

CHAPTER 1

[1] "John P. Fay of Seattle, Candidate for
Congressman at Large," election flyer,
1912. AGH Papers, AGH. The Republican
Party split that year into conservative and
progressive tickets, resulting in a widespread
Democratic victory with the election of
Woodrow Wilson.

[2] "John Purinton Fay," reprint from The
Fiftieth Anniversary Report of the Harvard
Class of '85 (1935). AGH Papers, AGH.

[3] Besides Dorothy (1890–1976), they were
Alice Ober Fay Case (1891–1950); Temple
Sedgwick Fay (1895–1965); John Bradford
Fay (1896–1904); Winthrop Herrick Fay
(1898–1915); Jean Bradford Fay (1904–
1986). John died at age eight as a result of a
burn accident; Winthrop died of influenza.

[4] John H. Hauberg, Jr. *Recollections of a Civic
Errand Boy: The Autobiography of John Henry
Hauberg, Junior.* (Seattle: Pacific Denkmann
Company, 2003), p. 157.

[5] Carl F. Gould's life and career are discussed
in an excellent monograph, *Carl F. Gould: A
Life in Architecture and the Arts*, by T. William
Booth and William W. Wilson (Seattle:
University of Washington Press, 1995).

[6] Booth and Wilson, *Carl F. Gould*, p. 55.

[7] The Seattle Fine Arts Society, later
called the Art Institute of Seattle, was the
immediate predecessor of the Seattle Art
Museum. When the new museum building,
designed by Carl Gould, opened in 1933, its
benefactor, Dr. Richard E. Fuller, assumed
leadership of the organization and changed
the name to the Seattle Art Museum.

[8] For a description of the house and its
construction innovations, see Booth and
Wilson, *Carl F. Gould*, pp. 67–69.

[9] Gould's relationship to the university
came to an abrupt halt in 1926 with the
election of Governor Roland Hartley.
A fiery lumberman with little formal
education, Hartley attacked the university's
administrative independence and funding
base, which President Suzzallo ardently
defended. He denounced Suzzallo, and then
moved to have the Board of Regents fire
him, and publicly denigrated Gould for
conflict of interest and excessive fees. Within

a week of Suzzallo's departure, Gould lost his teaching position and Bebb & Gould their campus design work.

With the change of governorship in 1934, Bebb & Gould reestablished their university connection, becoming "supervisory architects" of all campus construction. See Booth and Wilson, *Carl F. Gould*, pp. 101–103, and 164 ff.

[10] Booth and Wilson, *Carl F. Gould*, p. 91.

[11] The building was declared federal surplus and sold in 1981. Today it is owned by Harbor Properties and leased as the headquarters of Amazon.com.

[12] Booth and Wilson, *Carl F. Gould*, p. 71.

[13] Dorothy Fay Gould, *Beyond the Shining Mountains* (Portland: Binfords & Mort, 1938), n.p.

[14] Dorothy Gould to John Hauberg, May 6, 1950. JHH, UWSC, unaccessioned.

CHAPTER 2

[1] Booth and Wilson, *Carl F. Gould*, p. 70.

[2] Ibid., p. 7.

[3] AGH, MM, tape 6, April 27, 1995, p. 7.

[4] John Gould, interview by the author, January 11, 2005.

[5] AGH, MM, tape 4, n.d. [ca April 1995], p. 9.

[6] AGH, in Margaret Marshall, unpublished manuscript about AGH, [ca 1996], p. 22. AGH Papers, AGH.

[7] AGH, MM, tape 1, February 17, 1995, p. 8.

[8] Booth and Wilson, *Carl F. Gould*, p. 70.

[9] Booth and Wilson, *Carl F. Gould*, p. 18. In 1906–07, while working in New York, Gould spent fifteen months in a sanatorium in New York State, recounted in Booth and Wilson, p. 31.

[10] Carl F. Gould to AGH, n.d. [summer 1932], AGH Papers, UWSC, Box 3/1.

[11] Carl F. Gould to AGH, February 3, 1935. AGH Papers, UWSC, Box 3/4.

[12] Carl F. Gould to AGH, May 14, 1934. AGH Papers, UWSC, Box 3/2.

[13] AGH, MM, tape 4, op. cit., p. 2.

[14] The Helen Bush School, catalog for 1936–37, pp. 4, 6. UWSC.

[15] Dorothy Gould, handwritten draft of letter to Vassar, n.d. [ca 1934]. GF Papers, Box 25/20.

[16] AGH, MM, tape 4, op. cit., p. 2.

[17] Booth and Wilson, *Carl F. Gould*, p. 168.

[18] AGH Papers, UWSC, Box 3/8.

[19] AGH, MM, tape 4, op. cit., p. 5.

[20] In a draft of a letter to Vassar, Dorothy Gould pointed out the rigidity of St. Nicholas' rules that deducted credits from Anne's record for days missed on a family vacation and tardiness due to her commute by ferry. Dorothy Gould, handwritten notes, n.d. [ca summer 1934]. GF Papers, Box 25/20.

[21] Fanny C. Steele, Headmistress, St. Nicholas School, to Dorothy Gould, May 29, 1934. GF Papers, Box 25/20.

[22] Miss Porter's Annual Circular, 1934–1935, states, "Parents desiring the prescribed college preparatory course should seek another school for their daughters." After a twenty-year lapse, a college preparatory program was reinstated in 1938. AGH Papers, UWSC, Box 7/Schooldays: Miss Porter's School and Bush, Seattle.

[23] Reference to "starchy" Goulds, JHH, *Recollections of a Civic Errand Boy*, p. 157; her father's advice, Carl F. Gould to AGH, February 16, 1935. AGH Papers, UWSC, Box 3/4.

[24] Dorothy Gould to AGH, undated [ca December 1934]. AGH Papers, UWSC, Box 4/Incoming: Mother (postcards).

[25] Carl F. Gould to AGH, March 22, 1935. AGH Papers, UWSC, Box 3/5.

[26] Dorothy Gould to AGH, April 3, 1935. AGH Papers, UWSC, Box 4/Incoming: Mother.

[27] See, for example, Dorothy Gould to AGH, February 19, 1938. AGH Papers, AGH.

[28] AGH to Dorothy Gould, May 6 [1935]. GF Papers, Box 23/7.

[29] AGH, interview by the author, April 8, 2004.

[30] AGH, MM, tape 6, op. cit., p. 4.

[31] Gowen joined the faculty in 1924, Pries not until 1928, although Gould made the first contacts with him in 1923. Booth and Wilson, *Carl F. Gould*, pp. 82, 205 note 13.

[32] A monograph about Pries is forthcoming by Jeffrey Karl Ochsner, to be published by the University of Washington Press in 2006–07. [PR: to be confirmed]

[33] AGH, interview by the author, July 16, 2004.

[34] An account of Beaux-Arts study in the 1930s is found in Joseph Escherick, "Architectural Education in the Thirties and Seventies," in Spiro Kostof, ed., *The Architect: Chapters in the History of the Profession* (New York: Oxford University Press, 1986). Jeffrey Ochsner provided this reference.

[35] Seth Fulcher, interview by Jeffrey Ochsner, July 28, 1999. Possession of the interviewer. I am indebted to Professor Ochsner for sharing his knowledge and research about the School of Architecture in the 1930s.

[36] AGH, MM, tape 5, May 1995, p. 1.

[37] AGH Papers, UWSC, Box 17/Scrapbook, ca 1937.

[38] George Hazen, interview by Jeffrey Ochsner, August 21, 1999. Possession of the interviewer. The characterization of the school environment is from Ochsner's interviews of Hazen, Seth Fulcher, and Bill Svensson, September 14, 1994; and AGH, interview by the author, July 16, 2004.

[39] AGH, MM, tape 5, op., cit., p. 1. Anne's remark about pencil sharpening is not as self-denigrating as it seems. The task was specific, as described by Joseph Escherick, an architectural student at the same time as Anne: "We worked at first in pencil on yellow detail paper, beginning very much at the beginning, learning how to sharpen pencils (there was nothing available except wooden pencils that had to be sharpened with a knife in those days), learning to control lines, what kind of eraser to use for what purpose, how to keep a sheet clean . . ." Escherick, "Architectural Education," p. 245.

[40] AGH, MM, tapes, op. cit., p. 1, tape 4, op. cit., p. 8.

[41] DFG to AGH, n.d. [ca summer 1937]. AGH Papers, UWSC, Box 4/Incoming: Mother.

[42] AGH to her parents, January 10, 1938. GF Papers, Box 10/11.

[43] Telegram from AGH to Mr. and Mrs. Carl F. Gould, February 8, 1938, GF Papers, Box 10/11.

[44] Dorothy Gould to AGH, October 6, 1938. AGH Papers, AGH.

[45] Carl Gould to AGH, October 23, [1938]. AGH Papers, UWSC, Box 3/10.

[46] Dorothy Gould to AGH, March 6, 1939. JHH Papers, UWSC, unaccessioned.

[47] *Seattle Post-Intelligencer*, January 4, 1939, p. 3.

[48] "Architects Honor Brother, Sister," *Seattle Times*, February 27, 1940, p 15.

[49] John Hauberg (1916-2002) tells his own story in *Recollections of a Civic Errand Boy*.

CHAPTER 3

[1] *Seattle Times*, June 15, 1941, Society, p. 1. AGH Papers, UWSC, Box 11/Wedding.

[2] Within nine months of the wedding, Nakashima, along with thousands of Japanese Americans, would be interned on the West Coast after the American entry into World War II.

[3] JHH, *Recollections of a Civic Errand Boy*, p. 132.

[4] Letter from John H. Hauberg, Sr., to JHH., March 14, 1941. JHH Papers, FHP, 1949 scrapbook.

[5] The house was donated to the City of Rock Island in 1956 and is now the Hauberg Civic Center, under the supervision of the Parks and Recreation Department.

[6] With the addition of East Moline, the region is known today as the Quad Cities.

[7] JHH letter to Dorothy Gould, n.d., quoted in Margaret Marshall, unpublished manuscript, p. 48.

[8] Dorothy Gould to JHH, February 14, 1942. JHH Papers, unaccessioned.

[9] AGH, interview by the author, April 18, 2004.

[10] John H. Hauberg, Sr., December 3, 1942. JHH Sr. Papers, Journals/Notebooks, #126, November 3, 1942–April 3, 1943.

[11] AGH letter to JHH, May 27, 1943. JHH Papers, unaccessioned.

[12] AGH letter to JHH, June 3, 1943. JHH Papers, unaccessioned.

[13] AGH letter to JHH, May 17, 1943. JHH Papers, unaccessioned.

[14] Guggenheim owned the collection, which was assembled under the guidance of Hilla Rebay. The museum, renamed the Solomon R. Guggenheim Museum, moved in 1959 to its present location on Fifth Avenue in an iconic building designed by Frank Lloyd Wright. Rebay worked with Wright on the building concept from 1943 until her retirement after Guggenheim's death in 1949.

[15] "Rhythmic order" or "rhythmic law" was a critical component of Rebay's definition of non-objective art. Rebay, cited in Joan M. Lukach, *Hilla Rebay: In Search of the Spirit in Art* (New York: George Braziller, 1983), p. xii.

[16] AGH to JHH, postmarked June 21, 1943. JHH Papers, unaccessioned.

[17] The United States remained officially neutral until December 8, 1941, a status that prohibited the sale of arms and equipment to either side. The Lend-Lease Act of March 11, 1941, however, encouraged businesses like Boeing to circumvent this proscription by allowing contracts in which the company "lent" funds for the manufacture of equipment, which was then leased to Allies such as Great Britain.

[18] AGH to JHH, February 15, 1944. JHH Papers, unaccessioned.

[19] AGH quoted in Margaret Marshall, unpublished manuscript, p. 53.

[20] JHH to John H. Hauberg, Sr., September 12, 1945. JHH Sr. Papers, Box: J.H. Hauberg Christmas Books 1945, p. 76.

CHAPTER 4

[1] AGH, transcript of interview by Margaret Marshall, tape 7, May 4, 1995, p. 5.

[2] Cynthia Burke, John's cousin, emphasized this point. Conversations with the author, Rock Island, May 4–6, 2004.

[3] AGH, MM, op. cit., p. 5.

[4] The school was governed by an academic advisory board. The board composition suggests the Nursery School's interdisciplinary intentions and the seriousness with which its mission was taken. During the years of Fay's attendance, the board was comprised of the Dean of the College of Education, Dean of the School of Nursing, Executive Officer of the Psychology Department, Director of the School of Home Economics, Director of the Graduate School of Social Work, and Dean of the College of Arts and Sciences.

[5] Evans served as Acting Director of the University Nursery School from 1945 to 1963. Despite the success of the program, she was never appointed to the full position. In 1963 there was a reorganization of the University's child development programs, which included the new Pilot School (see Chapter 5), and the Nursery School was renamed the Laboratory Preschool. See W.U. Education College, UWSC, Acc. 82-163, Box 19/Gatzert Institute of Child Development (I.C.D.) Advisory Board, 1963.

[6] Eleanor Evans, memorandum to Dean Powers, January 9, 1946. W.U. Education College, UWSC, Acc. 82-163, Box 19/ Nursery School, selection of children, interdepartmental correspondence, 1946.

[7] Stevenson Smith to Dean Powers, January 11, 1946. W.U. Education College, UWSC, Acc. 82-163, Box 19/Nursery School, selection of children, interdepartmental correspondence, 1946.

[8] JHH, *Recollections of a Civic Errand Boy*, pp. 159–60.

[9] AGH, ca December 1947, AGH Papers, UWSC, Box 20/Scrapbook.

CHAPTER 5

[1] AGH to John H. Hauberg, Sr., November 27, 1949. Quoted in JHH Sr. Papers, Box: J.H. Hauberg Christmas Books, 1949, n.p.

[2] Brain injury is used here as defined by Glenn Doman, a prominent student of Dr. Temple Fay and the founder of The Institutes for the Achievement of Human Potential. The term pertains to "any child who has had something happen to hurt the brain," from the moment of conception, during fetal development, at birth, and anytime during life. It encompasses a broad range of conditions, including cerebral palsy, mental retardation, developmental delay, Down syndrome, and brain damage. See www.iahp.org/hurt/articles/who_is_brain_injured.html.

[3] AGH, interview by the author, April 8, 2004.

[4] JHH, "Mental Retardation," Presentation for the Diet, March 9, 1971. JHH Papers, UWSC, Box 9/5.

[5] AGH, interview by the author, November 11, 2004.

[6] Jack Lenor Larsen, interview by the author, April 17, 2004.

[7] Several people have made this statement. Those closest to the family are John and Margaret Gould, interview by the author, January 11, 2005, and Myrene McAninch, interview by the author, April 17, 2003.

[8] A current experimental treatment using technology to stimulate brain functions suggests a parallel to Dr. Fay's work. Sandra Blakeslee, "New Tools to Help Patients Reclaim Damaged Senses," *The New York Times*, November 23, 2004, D-1.

[9] JHH to Louis D. Hauberg, October 8, 1951. JHH Papers, UWSC, Box 1/2.

[10] AGH to Dorothy Gould, n.d. [1954], GF Papers, Box 23/7.

[11] JHH to Dorothy Gould, February 8, 1954. JHH Papers, UWSC, Box 1/5.

[12] JHH to Jean Bradford Fay, March 15, 1954. JHH Papers, UWSC, Box 1/5.

[13] JHH to Beulah Dunlap, November 5, 1951. JHH Papers, UWSC, Box 1/2.

[14] JHH to Louis D. Hauberg, June 9, 1953. JHH Papers, UWSC, Box 1/4.

[15] Myrene McAninch, no source or date cited, quoted in Margaret Marshall, unpublished manuscript, p. 66.

[16] Myrene McAninch, interview by the author, April 17, 2003; AGH, interview by the author, April 8, 2004.

[17] JHH to Mr. and Mrs. Carl F. Gould, May 20, 1953. JHH Papers, UWSC, Box 1/4.

[18] JHH to John H. Hauberg, Sr., May 11, 1953.

[19] AGH to Dorothy Gould, n.d. [January 1954]. GF Papers, Box 23/7.

[20] JHH, *Recollections of a Civic Errand Boy*, p. 178.

[21] The account of the early development of classes is from McAninch, interview by the author, April 17, 2003.

[22] JHH to Pearl Bennett, December 13, 1960. JHH Papers, UWSC, Box 1/11.

[23] McAninch's preparations to leave the Pilot School were among the factors that pushed Sue to graduation. McAninch was by then a master's degree candidate and was faced with deadlines for the completion of her academic work. She went on to earn a Ph.D. in Clinical Psychology. She served seven years as director of the Highline/West Seattle Mental Health Center and then joined the national Joint Commission to develop criteria for accreditation of alcohol and drug abuse facilities, whose outreach subsequently expanded to include mental health facilities, and then hospitals.

[24] Eunice Kennedy Shriver, text of speech before Citizens' Committee on Mental Retardation, Seattle, April 4, 1963; JHH Papers, UWSC, Accession 2850-8, Box 4/ Misc. 1963–64.

[25] AGH, interview by the author, December 12, 2004.

[26] Fay Hauberg Page, interview by the author, April 28, 2004.

[27] Donald E. Stafford, M.D., to "Mr. and Mrs. Hauberg," August 20, 1954. AGH Papers, UWSC, Box 2/Condolences: Son Mark.

[28] Anne and Hart Ritz to AGH and JHH, September 5, 1954. AGH Papers, UWSC, Box 2/Condolences: Son Mark.

[29] AGH, interview by the author, April 8, 2004.

CHAPTER 6

[1] Quoted in Marilyn Hoffman, "Multilevel house displays art," *Christian Science Monitor*, December 7, 1966, p. 22.

[2] Jeffrey Ochsner, interview by the author, July 16, 2004.

[3] For a full account of Terry's history and achievement, see Justin Henderson, *Roland Terry: Master Northwest Architect* (Seattle: University of Washington Press, 2000).

[4] Henderson describes this transitional phase at the School of Architecture and its influence upon Terry in Roland Terry, pp. 16–17.

[5] Terry used hemlock flooring, a relatively inexpensive material but one little used because it required several months to cure to a durable hardness. The hemlock was treated with slaked lime to tone the color of the raw wood and to create a long-lasting finish, an English process that Anne credits Morris Graves with describing to them. AGH, interview by the author, March 3, 2004.

[6] Dorothy Brandt Brazier, *Seattle Times* {ca February 1955}. In JHH Papers, FHP, 1955 scrapbook.

7 After graduation, Hill worked briefly in the Bay Area before returning to Seattle, where he headed the interior design program at Cornish. In 1955 he assumed a faculty position at the University of Washington. As a result of the national attention given his furniture designs for 1101 McGilvra, he was invited to Parsons Institute in New York to be one of two instructors recruited to update that school's interior design program. At the same time he earned an M.F.A. at New York University. Hill became director of the UW interior design program upon Hope Foote's retirement in 1967. When the program was terminated in 1987, he taught in the School of Architecture until his retirement in 1993.

8 Guy Anderson to AGH and JHH, November 19, 1965. AGH Papers, UWSC, Box 3/Guy Anderson.

9 Morris Graves to AGH and JHH, March 7, 1955. AGH Papers, UWSC, Box 1/Morris Graves.

10 Quoted in Hoffman, "Multilevel house displays art," p. 22.

11 The construction of this identity has been thoughtfully discussed by scholars. Martha Kingsbury laid the groundwork in "Seattle and the Puget Sound" in *Art of the Pacific Northwest: From the 1930s to the Present* (Washington, DC: Smithsonian Institution Press, for the National Collection of Fine Art, 1974) and "Four Artists in the Northwest Tradition" in *Northwest Traditions* (Seattle: Seattle Art Museum, 1978). Sheryl Conkelton and Laura Landau expanded the investigation in *Northwest Mythologies: The Interactions of Mark Tobey, Morris Graves, Kenneth Callahan, and Guy Anderson* (Tacoma: Tacoma Art Museum, in association with University of Washington Press, 2003). Conkelton presented additional research in an unpublished paper at the College Art Association annual meeting, Seattle, February 21, 2004.

12 Bonifas, his wife, and daughter moved to Utah for his wife's health shortly after his retirement from the UW in 1959. Until 1964 at least, both Anne and John sent financial support to the family, which Bonifas tried but often was unable to repay. AGH Papers, UWSC, Box 3/Paul Bonifas.

13 Guy Anderson to AGH, August 8, 1963. AGH Papers, UWSC, Box 3/Guy Anderson.

14 Don Duncan, "Art Finds Home on 60-Foot Lot," *Seattle Times*, April 5, 1965, p. [XXTK]. Jack Hurley was a prize-fight promoter.

15 The collection was donated to the Seattle Art Museum in 1991. It is documented in the catalog *The Spirit Within: Northwest Coast Native Art from the John H. Hauberg Collection* (New York: Rizzoli, in association with Seattle Art Museum, 1995), organized under the curatorial direction of Steven C. Brown.

16 AGH, undated notes [1957]. AGH Papers, UWSC, Box 1/17.

17 Ibid.

18 Invitation from AGH and JHH, n.d. [1966]. JHH Papers, UWSC, Box 1/17.

19 See for example "A Contemporary House that Restates the Idea of Elegance," *House Beautiful* Vol. 102, No. 11 (November 1960), pp. 204–13.

20 "Have We an Indigenous Architecture?" *Architectural Record*, April 1953, pp. 140–146. The six architects were Paul Thiry, Robert H. Dietz, Perry B. Johanson, John S. Detlie, Victor Steinbrueck, and John M. Morse.

21 Notes for Architecture 360, March 7, 1958. Victor Steinbrueck Papers, UWSC, Acc. 3252-3, Box 2/45.

22 Carlos Arnaldo Schwantes, *The Pacific Northwest: An Interpretive History* (Lincoln: University of Nebraska Press, 1996), p.423.

23 AGH, interview by the author, April 8, 2004.

CHAPTER 7

1 Byron Fish, "Salmon Bake or Fish Dinner? Matter of Ritual," *Seattle Times*, June 2, 1958, p. 4.

2 AGH, MM, tape 10 [undated, ca June 1995], p. 1.

3 Cited in Louisa Peck, "Pacific Arts Center History," unpublished manuscript [2000], p. 30.

4 The story of Lease's work and its later development is told in Peck's manuscript, Chapters 1 to 3.

5 Peck, "Pacific Arts Center," p. 29.

6 The Center opened in a large old house on Capitol Hill in January 1957, when people waiting to register for classes lined two city blocks. Two months later Ruth Lease died of cancer. Peck, "Pacific Arts Center," p. 23. The Center rented the building until 1959, when the owner had it demolished for new construction.

7 "The Seattle Creative Activities Center," n.d. [ca 1957-59]. JHH Papers, UWSC, Accession 2850-8, Box 2/Misc. 1961-62.

8 Dee Dickinson, interview with the author, October 27, 2004. Dickinson was known by her maiden name, Idalice Squire, during her tenure as director.

9 Hans and Thelma Lehmann, *Out of the Cultural Dustbin: Sentimental Musings on the Arts and Music in Seattle from 1936 to 1992* (Seattle: Crowley Associates, 1992), p. 21.

10 Walt Crowley and the HistoryLink Staff, *HistoryLink's Seattle and King County Timeline* (Seattle: History Ink, in association with University of Washington Press, 2000), p. 70.

11 Proposals for a civic center dated back to Carl Gould's early years in Seattle. With the leveling of Denny Hill, the landfill north of downtown created a logical site for such a center, in the opinion of Gould and others.

12 Allied Arts brochure, n.d. [late 1960s], UWSC, Allied Arts, Box 1/Organization.

13 Louis R. Guzzo, "Art Commission Asks More Authority," Seattle Times, date n/a. AGH Papers, UWSC, Box 11/Clippings – AGH or family or related subjects.

14 Undated handwritten notes; information reproduced and augmented in typed notes dated May 1, 1968. AGH Papers, UWSC, Box 12/Committee of 33.

15 Emmett Watson, *Seattle Post-Intelligencer*, July 2, 1970. In AGH Papers, ibid. The Washington Women's Foundation represents a subsequent generation of women's philanthropy. It was established in 1995 under the leadership of Colleen Willoughby to encourage women's informed and active giving and has become a model across the nation.

16 Booth and Wilson, *Carl F. Gould*, p. 57.

17 Act cited in Scott Greer, *Urban Renewal and American Cities: The Dilemma of Democratic Intervention* (Indianapolis: Bobbs-Merrill Company, 1965), pp. 4–5.

18 Greer, *Urban Renewal*, summarized pp. 19–27.

19 AGH to Mark Tobey, September 7, 1960. Mark Tobey Papers, UWSC, Acc. 3593-2, Box 2/35.

20 Louis R. Guzzo, "Rally Called to Speed Action on Historic Sites," *Seattle Times*, January 26, 1961 [p. n/a]. JHH Papers, FHP, scrapbook, 1961.

21 Mary Bard Jensen to AGH, January 28, 1961. JHH Papers, FHP, scrapbook, 1961. Jensen was a nationally known author who wrote under the name Mary Bard.

22 "Culture Unit Rallies to Save Bygone Era," *Seattle Post-Intelligencer*, January 27, 1961, p. 21.

23 The Committee of 33's first three capital projects were in Pioneer Square: Prefontaine Fountain, 1970 (on the periphery of the district); the planting of trees in Occidental Square, 1972; and improvements to the Washington Street Public Boat Landing, 1974.

24 Lehmann, *Out of the Cultural Dustbin*, p. 101.

25 Allied Arts, UWSC, Acc. 737-001, Box 1/Organization. Allied Arts and the Washington Roadside Council mounted repeated campaigns in 1963 and 1965 to fend off threatened impingements, and in 1966 to extend the controls to Seattle city streets.

26 Quoted in Thelma Lehmann, "Art Interest Inspired Collection," *Seattle Post-Intelligencer*, Pictorial Review, October 22, 1961, p. 2.

27 Virginia Burnside, "Superhighways seen as having great effect on Washington economy." Washington Department of Highways, *Highway News*, March-April 1958, pp. 19–20.

28 Quoted in Lehman, "Art Interest Inspired Collection," p. 2.

29 "Planning for Thoroughfares; Central Freeway," City of Seattle Planning Commission, January 3, 1957, p. 25. AGH Papers, UWSC, Box 12/Citizens' Planning Council.

30 "Planning for Thoroughfares," p. 16.

31 See the interview with Paul Thiry by Meredith L. Clausen, September 15 and 16, 1983, Northwest Oral History Project, Archives of American Art, Smithsonian Institution, UWSC, Acc. 3620, Box 2/Paul Thiry. Thiry later resigned from the Planning Commission in protest.

32 Sam Angeloff, "Freeway Marchers Advocate Landscaping," *Seattle Post-Intelligencer*, [date n/a]. JHH Papers, FHP, scrapbook, 1961.

[33] The new plan to cover a downtown section of freeway included construction of the Washington State Convention and Trade Center adjacent to Freeway Park. The building opened in 1988.

[34] JHH Papers, PDC, journal, July 4, 1976.

[35] Herb Robinson, "After 15 years, a victory for downtown 'birdwatchers,' " *Seattle Times*, June 21, 1976, p. A13.

[36] Ralph Munro to AGH, July 2, 1976. AGH Papers, AGH.

[37] Virginia Wyman, interview by the author, March 19, 2004.

[38] AGH to John, Nate, and Bob (John Ashby Conway, a founder and ex-officio member of the Allied Arts board and chair of the new Governor's Council on the Arts; Nate Wilkinson, Allied Arts board member and chair of its Pioneer Square Committee; and Robert Block, president of Allied Arts), May 16, 1961. Anne's letter cites suggestions from Don Yates, Mrs. Andrew Price (Virginia Price, president of the Sunset Club), and Jack Robertson (chair of the Legislative Committee, Washington Roadside Council). Allied Arts Part II, UWSC, Acc. 737-001, Box 6/Incoming Correspondence A–H.

[39] Anne Hauberg, "Future of the City," *Puget Soundings*, April 1961, p. 22.

[40] Unidentified news clipping. AGH Papers, UWSC, Box 12/Citizens' Planning Council.

[41] JHH to Mrs. John H. (Betty) Bowen, September 12, 1961. JHH Papers, UWSC, Box 1/12.

[42] AGH, interview by the author, May 27, 2004.

[43] Letter from Mark Tobey, quoted in minutes of the meeting of Allied Arts, July 18, 1964, p. 2. Friends of the Market, UWSC, Accession 1985, Box 2/1.

[44] The fair was originally planned to coincide with the state's centenary in 1959, but 1962 became a more feasible goal as planning proceeded.

[45] JHH to Pearl Bennett, December 13, 1960. JHH Papers, UWSC, Box 1/11.

[46] AGH to JHH, from Paris, October 17, 1961. JHH Papers, FHP, 1961 scrapbook.

[47] Cited in William C. Seitz, *Mark Tobey* (New York: Museum of Modern Art, 1962), p. 7.

[48] AGH to JHH, from Paris, October 17, 1961. JHH Papers, FHP, scrapbook, 1961.

[49] AGH to JHH, from Greece, October 21, 1961. Ibid.

[50] JHH to Mark Tobey, October 25, 1962. JHH Papers, UWSC, Box 12/16.

[51] In the 1920s and1930s, Tobey did produce several mural-sized paintings, often related to theater or to a specific site. The large paintings of his late career fall almost entirely within the period 1960–63 and include the sublime *Saggitarius Red* and related works, in which the artist maintains the dynamic flow of his articulated brushwork through a masterfully organic composition. The mural does not share this breathing quality, and it may be that the demands of a public art commission ran counter to Tobey's inclination for a more private, meditative kind of art.

CHAPTER 8

[1] JHH to Samuel Hays, March 3, 1961. JHH Papers, UWSC, Box 1/Personal Correspondence 1961.

[2] Fay Hauberg Page, interview by the author, April 28, 2004.

[3] The phrase is from Fay Hauberg Page; interview by the author, January 27, 2004.

[4] Fay Hauberg Page, interview by the author, January 27, 2004.

[5] Kay Redfield Jamison, "Manic Depression: A personal and professional perspective," presentation at the University of Melbourne, July 26, 2000; transcript online at www.unimelb.au/speeches/kjamison26july00.html. Jamison is among the most prominent professionals in the field who write for a lay audience.

[6] Jamison, "Manic-Depressive Illness and Creativity," *Scientific American*, Vol. 272 (February 1995); online at www.wga.org/health/creativity_bipolar.html. Jamison's book on the subject is *Touched with Fire: Manic Depressive Illness and the Artistic Temperament* (New York: Free Press, 1993).

[7] Jamison, University of Melbourne, op cit.

[8] JHH to Mrs. Edward Palmer York (Muriel Gould York), April 30, 1962. JHH Papers, UWSC, Box 1/Personal Correspondence 1962.

[9] JHH journal, June 17, 1966. JHH Papers, PDC.

[10] Their departure for the Peace Corps was delayed by a year when Nat became ill with mononucleosis during training. When Nat returned home to the Boston area, Fay moved there to share an apartment with a friend. It was during this year they decided to marry.

[11] JHH Papers, PCC, journal, June 14, 1968.

[12] JHH Papers, FHP, 1961 scrapbook.

[13] For example, JHH to Dr. Richard E. Fuller, May 22, 1961, proposing an exhibition of freeway designs at the Seattle Art Museum: "I suppose this is a hot potato but it seems to me that it would be a real public service of the Art Museum . . ." JHH Papers, UWSC, Box 1/12.

CHAPTER 9

[1] See, for example, videotapes *Anne Gould Hauberg: Visionary*, Northwest Designer Craftsmen Living Treasures Series, directed by Kay D. Ray (Seattle: Northwest Designer Craftsmen, 2003); and *Humanities Conversations* [interview with AGH], produced by Marty Wilson (Bellevue, WA: Bellevue Community College, 1982).

[2] "Object" is used here to describe a work of art in any medium that is not time- or site-based.

[3] AGH, interview by the author, September 29, 2004.

[4] Ibid.

[5] See Lee Nordness, *Objects: USA* (New York: Viking Press, 1970), pp. 10–20. A characterization of the breadth of Webb's contribution can be found in *Jack Lenor Larsen, A Weaver's Memoir* (New York: Harry N. Abrams, 1998), pp. 143–145.

[6] Penington taught at the University of Washington from 1929 to 1969, and after World War II organized the Department of Industrial Design. A graduate of UW, she attended graduate school at Columbia University Teachers' College, where Arthur Wesley Dow was dean of fine arts. Dow had developed a widely influential program of design principles, promulgated in the book *Composition*, first published in 1899 and expanded in eight subsequent editions.

[7] The exhibitions began in 1953 under the sponsorship of the Seattle Weavers' Guild, the Clay Club, and the women's honorary art society, Lambda Rho. After the Gallery assumed organizing responsibility, they continued annually until 1965 and semiannually through the 1970s.

[8] For a short history, see Lloyd E. Herman, *Looking Forward, Glancing Back: Northwest Designer Craftsmen at 50* (Bellingham, WA: Northwest Designer Craftsmen in association with the Whatcom Museum of History and Art, 2004).

[9] See the exhibition catalog, *Northwest Art Today / Adventures in Art* (Seattle: Century 21 Exposition, Inc., 1962).

[10] JHH to Mark Tobey, December 3, 1964. JHH, UWSC, Box 12/16.

[11] AGH, ibid.

[12] AGH, interview by the author, September 29, 2004; see also *Anne Gould Hauberg: Visionary*. Northwest Designer Craftsmen Living Treasures Series, directed by Kay D. Ray (videotape, Seattle: Northwest Designer Craftsmen, 2003).

[13] That Anne quickly began such discussions is evident in a letter from Paul Bonifas, a ceramist who formerly taught at the university and was then living in Utah. "If your Art Center on Pioneer Square were to come to being into a well thought-out structure and provided with really good professional men, you could draw to it an interesting part of the public attention. . . . The Art Center should function as a collection center west of the Rockies with a jury of selection." Paul Bonifas to AGH, March 22, 1961, AGH papers, UWSC, Box 3/Paul Bonifas.

[14] Donald I. Foster, interview by the author, November 19, 2004.

[15] Jack Lenor Larsen, interview by the author, April 17, 2004.

[16] JHH to Anne Parry, June 3, 1961, JHH Papers, UWSC, Box 1.

[17] Ramona Solberg, interview by the author, February 26, 2004.

[18] Gladys Rubinstein, interview by the author, November 15, 2004.

[19] JHH, *Recollections of a Civic Errand Boy*, p. 290.

[20] Joe McDonnal, interview by the author, July 31, 2004.

[21] AGH, interview by the author, November 18, 2004.

[22] LaMar Harrington, interview by the author, November 18, 2004. Harrington

began at the Henry Art Gallery when she was one of two staff members and stayed to become associate director.

23 Priscilla Beard, interview by the author, March 22, 2004. Beginning in 1977, Beard (then Priscilla Fenton) represented the Seattle Symphony on the organizing committee for the Pacific Arts Center, and from 1983 to 1985 served as the director of the Pacific Arts Center when Anne was chair of its board.

24 AGH, interview by the author, December 21, 2004.

25 Ibid.

CHAPTER 10

1 JHH to Imogen Cunningham, March 28, 1972. AGH Papers, UWSC, Box 2/Map/Boundary.

2 JHH to Colin Graham, June 8, 1972. JHH Papers, UWSC, Box 21/PNAC.

3 The Virginia Wright Fund donated *Parnassus* to the Seattle Art Museum in 1974.

4 Interview with John H. Hauberg by Tina Oldknow, July 13, 1994. Transcript courtesy of Tina Oldknow, Corning Museum of Glass.

5 JHH to John Ormsbee Simonds, December 1, 1964. JHH Papers, UWSC, Box 1/15.

6 Jack Lenor Larsen, interview by the author, March 21, 2003.

7 Anne and John had first consulted Dr. Doll in 1954 regarding the two younger children.

8 Mary Cozad, telephone communication with the author, September 17, 2004.

9 Fay Hauberg Page, interview by the author, June 8, 2004.

10 Ramona Solberg, interview by the author, February 26, 2004.

11 *Skagit Valley Herald*, December 3, 1976. AGH Papers, UWSC, Box 12/Victoria Village.

12 Letter from AGH to participants, January 7, 1977. AGH Papers, UWSC, Box 12/Victoria Village.

13 Tom Bosworth, interview by the author, August 10, 2004.

14 JHH journal, August 1, 1971. JHH Papers, PDC.

15 AGH, interview by the author, March 3, 2004.

16 Ibid.

17 Ibid.

18 Ibid.

19 Ibid.

20 "The PONCHO 'Peanut' House." [brochure, 1970]. AGH Papers, UWSC, Box 11.

21 Ibid. Eventually the house was given to Pilchuck Glass School and named Tatoosh.

22 Ibid.

23 JHH journal, May 4, 1970. JHH Papers, PDC.

24 AGH, interview by the author, March 3, 2004.

25 JHH handwritten document, n.d. [ca 1971]. JHH Papers, UWSC, Box 31/19.

26 Tom Bosworth, interview by the author, August 10, 2004.

27 Ibid.

28 JHH to Mark Tobey, March 8, 1967. JHH Papers, UWSC, Box 12/16.

29 JHH to Mark Tobey, January 24, 1969. Ibid.

30 JHH to Mark Tobey, June 23, 1970. Ibid.

31 AGH to Mark Tobey, August 18, 1969. Mark Tobey Papers, UWSC, Acc. 3893-2, Box 2/35. Arthur Erickson would be the architect of the Museum of Glass in Tacoma in 2002 (see Chapter 12); Donald Winkelmann had designed one of Anne's modular houses.

32 Tobey left two wills upon his death in 1976, one leaving his estate to the PNAC (now within the Seattle Art Museum), the other to his companion, Mark Ritter. After a suit that also involved claims by two nieces, a settlement was reached that provided a process for the division of works of art by Tobey. Additionally his personal effects and his collection of work by other artists went to the Seattle Art Museum in recognition of his agreements with the Haubergs.

33 JHH journal, August 5, 1973. JHH Papers, PDC.

34 JHH journal, February 26, 1971. JHH Papers, PDC.

35 See, for example, the draft copy of "Pacific Northwest Arts Center, Report on Plans for 1974," prepared for PNAC President Joseph L. McCarthy by Mimi Pierce in consultation with Tom Wilson and Hope Stroble. Betty Bowen Papers, UWSC, Accession 2441-1, 2, 3, Box 25/21.

36 JHH journal, May 7, 1970. JHH Papers, PDC.

37 JHH journal, July 5, 1970. JHH Papers, PDC.

38 Jack Lenor Larsen, April 17, 2004.

39 Dale Chihuly, interview by the author, September 9, 2004.

40 The history of Pilchuck Glass School is told in Tina Oldknow, *Pilchuck: A Glass School* (Seattle: University of Washington Press, 1996).

41 "Pacific Northwest Arts Center, Report on Plans for 1974," p. 8. Betty Bowen Papers, UWSC, Accession 2441-1, 2, 3, Box 25/21.

42 Patricia M. Baillargeon, interview by the author, August 26, 2004.

43 JHH to the author on his eighty-fifth birthday celebration at Pilchuck Glass School, June 19, 2001. (His birth date was June 24.)

44 Dale Chihuly, September 9, 2004, op. cit.

CHAPTER 11

1 Emmett Watson, "Anne Hauberg: A 'Princess' to Many in Seattle," *Seattle Post-Intelligencer*, October 4, 1975, pp. A-1, A-8.

2 Ibid.

3 JHH, *Recollections of a Civic Errand Boy*, p. 325.

4 The words are John's. JHH journal, June 2, 1975, JHH Papers, PDC. Willis Woods noted "several that were clearly sub-standard, of minor importance, or duplicative." Special report by Willis F. Woods, Director, Minutes of Meeting of Seattle Art Museum Board of Trustees, June 24, 1975, Seattle Art Museum, Acc. 2636-20, Box 8/Board of Trustees – Minutes 1975.

5 R. M. Campbell, "Art Museum May Trade Tobey Paintings to NY," *Seattle Post-Intelligencer*, June 6, 1975, p. A-3.

Campbell's article lists the six paintings purportedly proposed for trade, such paintings as *Agate World*, 1945, and *Serpentine*, 1955. Over time, these have proven among the most significant of Tobey's works in the collection. A painting by Paul Klee was included in the negotiation at the suggestion of its donors.

6 "Viewed dispassionately," Woods reported to the Board, "the proposed transaction seemed legitimate and well within the limits of accepted museum practice. It is apparent that, at least in Seattle, one cannot view Tobey dispassionately." Willis F. Woods, June 24, 1975, op. cit.

7 JHH journal, June 22 and 24, 1975, JHH Papers, PDC.

8 JHH journal, June 23, 1975, JHH Papers, PDC.

9 JHH journal, Dec. 14, 1975, JHH Papers, PDC.

10 For the Tobey estate, see Chapter 10, note 32.

11 The Seattle Art Museum, fifth on a tour of five U.S. venues, studied other museum's production of the exhibition and planned a major presentation drawing on those models. The exhibition in Seattle ran five months, from June to November 1978, and far exceeded expectations, drawing well over 1,200,000 visitors.

12 Gemma Morgan, who had been Anne's assistant, quoted in Elizabeth Rhodes, "Arts controversy: a matter of opinion that really matters," *Seattle Times*, June 22, 1980, p. E2.

13 Elizabeth Rhodes, "Arts controversy," ibid.

14 Anne Parry, interview by the author, March 4, 2004.

CHAPTER 12

1 CFG to AGH, October 2, 1934. AGH Papers, UWSC, Box 3/2.

2 CFG to AGH, October 17, 1934. AGH Papers, UWSC, Box 3/2.

3 AGH to the author, November 11, 2004.

4 Fay Hauberg Page, interview by the author, January 27, 2004.

5 Mary Cozad, telecommunication with the author, September 17, 2004.

6 Joey Kirkpatrick, interview of Kirkpatrick and Flora Mace by the author, August 20, 2004.

7 Benjamin Moore, interview by the author, September 27, 2004.

8 Flora Mace, interview of Kirkpatrick and Mace by the author, August 20, 2004.

9 Paul Marioni, interview by the author, September 27, 2004.

10 William Traver, interview by the author, September 10, 2004.

11 Benjamin Moore, September 27, 2004, op. cit.

12 Paul Marioni, September 27, 2004, op. cit.

13 James Minson, interview by the author, October 16, 2004.

14 Minson, together with Elsa Asturias, founded the Misioneros del Camino Glass Studio in Sumpango, Guatemala. Minson and Asturias had met at Pilchuck Glass School in 2001, when Elsa indicated interest in starting a glass program in her native country. After a visit to Guatemala, Minson persuaded her that a program for homeless and orphaned youth was a worthy goal.

15 Jeanette Whiteman, interview by the author, October 25, 2004.

16 Recounted by Benjamin Moore, September 27, 2004, op. cit.

17 Ginny Ruffner, telecommunication with the author, October 5, 2004.

18 Priscilla Beard, interview by the author, March 22, 2004. Beard, then Priscilla Fenton, represented the Seattle Symphony on the interim organizing committee and was the director of the Pacific Arts Center from 1983 to 1985.

19 Diane Katsiaficas, interview by the author, June 1, 2004.

20 Patricia M. Baillargeon draws an analogy between Pilchuck Glass School and a three-legged stool, noting that Pilchuck had the three-way support of Anne, John, and Dale Chihuly, and could not have stood were any one of them missing. The Pacific Art Center, by extension, did not have this foundation. Interview by the author, August 26, 2004.

21 Ellen Taussig, interview by the author, November 12, 2004.

22 Anne stepped back her social participation at the museum in deference to John's leadership role there, and in lieu of a high-level membership designated her contribution to be used for the purchase of crafts.

23 Chase W. Rynd, telecommunication with the author, November 8, 2004.

24 The Museum of Glass: International Center for Contemporary Glass, which had several names during its formative phase, opened in 2002.

25 Arthur Erickson, telecommunication with the author, January 20, 2005.

26 Wyn Bielaska, interview by the author, November 18, 2004. Erickson confirmed the statement on January 20, 2005; op. cit.

27 George F. Russell, Jr., telecommunication with the author, January 14, 2005.

28 CFG to AGH, n.d.[ca 1932]. AGH Papers, UWSC, Box 3/1.

29 Anne had written John in 1981, "Not only you but Roland and others said I was 'no way to sell this house!' " AGH to JHH, August 29, 1981. AGH Papers, AGH.

30 Paul Marioni, interview by the author, September 27, 2004.

31 Priscilla Beard, interview by the author, March 22, 2004.

32 Toby Beard, interview by the author, December 3, 2004.

33 AGH to JHH, August 29, 1981; October 7, 1982; n.d. [ca June 1983]. AGH Papers, AGH.

34 Sue Hauberg, interview by the author, December 7, 2004.

35 Fay Hauberg Page, interview by the author, April 28, 2004.

36 AGH, interview by the author, July 16, 2004.

37 Roy Lichtenstein and Dale Chihuly are the only other Americans to have had solo exhibitions there.

38 Ramona Solberg, interview by the author, February 26, 2004.

39 Bahá'u'lláh, Epistle to the Son of the Wolf, trans. Shoghi Effendi (Wilmette, IL: Bahá'í Publishing Trust, 1988; first copyright 1941). "Let your vision be world-embracing . . ." from "Basic Facts of the Bahá'í Faith,"

Erich Reich Enterprises, reprinted by permission of the Bahá'í Publishing Trust, [n.d.].

40 Bahá'u'lláh, no title given, text retyped on notebook paper. AGH Papers, AGH.

41 AGH, interview by the author, July 16, 2004.

42 William Traver, interview by the author, September 10, 2004. About 1977, when Traver had been in the gallery business only a year, Anne asked if he would be willing to show the work of the artists at Pilchuck. In future years the gallery would become widely known for its representation of glass. "I was brand new at the gallery business and said sure, I would do it," recalled Traver. "And we did Pilchuck shows, year after year, for 25 years."

43 Elaine Ethier, interview by the author, November 8, 2004. Ethier is Director of Development for the Arts, College of Arts and Sciences, University of Washington.

44 In an act of repatriation, John had returned the sword to Tlingit tribal elder Mark Jacobs, Jr., and had been honorarily adopted and named in gratitude.

45 Others receiving the Visionaries award at the same time as Anne were artists Magdalena Abakanowicz and Lenore Tawney, theater director and designer Julie Taymor, Francis and Priscilla Merritt, founders of the Haystack Mountain School of Crafts, and homemaking guru Martha Stewart.

46 AGH to the Junior League of Seattle, March 2, 2002. Mary Anne Mackin wrote the text based upon conversations with AGH. AGH Papers, AGH.

47 AGH, interview by the author, October 26, 2004.

selected bibliography

ARCHIVAL SOURCES

All are from the University of Washington Libraries, Special Collections, unless noted.

Allied Arts, Accession 737-001.

Bowen, Betty, Accession 2441-1, 2, 3.

Friends of the Crafts, Accession 3885.

Friends of the Market, Accession 1985.

Gould, Carl, Collection, No. 426.

Gould, Dorothy Fay, Accession 3172-3.

Gould Family Papers, Accession 3516-8.

Hauberg, Anne Gould, Accession 2991-3.

Hauberg, John Henry [Sr.], Accession 27, Special Collections, Augustana College, Rock Island, Illinois.

Hauberg, John H. Hauberg, Jr., Accessions 2850-7, 2840-8, and unaccessioned papers.

Hill, Warren T., Accession 5320-1.

Holmes, J. Lister, Accession 3789.

Nelsen, Ibsen, Accession 4007.

Penington, Ruth, transcript of interview by LaMar Harrington, February 10–11, 1983, Northwest Oral History Project, Archives of American Art, Smithsonian Institution, Accession 3620.

Seattle Art Museum, Accession 2636-20.

Steinbrueck, Victor, Accession 3252-3.

Thiry, Paul, transcript of interview by Meredith L. Clausen, September 15–16, 1983, Northwest Oral History Project, Archives of American Art, Smithsonian Institution, Accession 3620.

Tobey, Mark, Accession 3893-2.

W.U. (University of Washington) Child Development and Mental Retardation Center, Accessions 83-5, 88-31.

W.U. Education College, Accession 82-163.

PUBLISHED SOURCES

The papers of Anne Gould Hauberg, John H. Hauberg, Jr., and Betty Bowen contain a wealth of newspaper articles, some identified with source and date, others not. Only a few are listed individually here.

"A Contemporary House that Restates the Idea of Elegance," *House Beautiful*, vol. 201, no. 11 (November 1960), pp. 204–213.

Anne Gould Hauberg: Visionary. Northwest Designer Craftsmen Living Treasures Series. Directed by Kay D. Ray. Videotape. Seattle: Northwest Designer Craftsmen, 2003.

Art of Tomorrow: Fifth Catalogue of the Solomon R. Guggenheim Collection of Non-Objective Paintings. New York: Solomon R. Guggenheim Foundation, 1939.

Bahá'u'lláh. *Epistle to the Son of the Wolf.* Trans. Shoghi Effendi. Wilmette, IL: Bahá'í Publishing Trust, 1988; first copyright 1941.

"Basic Facts of the Bahá'í Faith." Erich Reich Enterprises, reprinted by permission of the Bahá'í Publishing Trust, n.d.

Booth, T. William, and William H. Wilson. *Carl F. Gould: A Life in Architecture and the Arts.* Seattle: University of Washington Press, 1995.

Cava, John, ed. "The Idea of Regionalism." *ARCADE: The Journal for Architecture and Design in the Northwest*, vol. 20, no. 1 (Autumn 2001), pp. 14–25.

Crowley, Walt, and The History Link Staff. *HistoryLink's Seattle & King County Timeline.* Seattle: History Ink, in association with University of Washington Press, 2001.

Easton, Valerie. "A 'Bowl Full of Flowers.'" Photographs by Jacqueline Koch. *Seattle Times,* August 26, 2001, Pacific Magazine, pp. 10–13.

Farr, Sheila. "Film honors art patron who helped shape Seattle." *Seattle Times*, January 30, 2004, p. 47H.

Fenton, Priscilla J. "Anne Gould Hauberg: Visionary," *Puget Soundings*, December 1985, pp. 6–11.

Frampton, Kenneth. "Towards a Critical Regionalism: Six Points for an Architecture of Resistance," in Hal Foster, ed., *The Anti-Aesthetic: Essays on Postmodern Culture.* Port Townsend, WA: Bay Press, 1983, pp. 16–30.

Gourney, Isabelle. "Architecture at the Fontainebleau School of Fine Arts, 1923–1939," *Journal of the Society of Architectural Historians*, vol. 45 (September 1986), pp. 270–286.

Gould, Dorothy Fay. *Beyond the Shining Mountains.* Portland, OR: Binfords & Mort, 1938.

———. "David Douglas." Reprinted from the Garden Club of America, *Bulletin*, ser. 10, no. 9 (November 1946). Chicago: 1946.

Greer, Scott. *Urban Renewal and American Cities: The Dilemma of Democratic Intervention.* Indianapolis: Bobbs-Merrill Company, 1965.

Grindeland, Sherry. *Art. A Fair Legacy, The Journey from Fair to Museum.* Bellevue, WA: Bellevue Art Museum, 2003

Guggenheim, Peggy. *Out of This Century: Confessions of an Art Addict.* New York: Universe Books, 1979.

Hauberg, Anne. "Future of the City." *Puget Soundings*, April 1961, pp. 14–15, 22.

Hauberg, Anne Gould. "Annie Westbrook Gould Hauberg: An Autobiography," in Hauberg, John Henry, ed. *A Midwestern Family, 1848–1948.* Rock Island, IL: 1950, pp. 351–357.

Hauberg, John Henry, Jr. *Recollections of a Civic Errand Boy: The Autobiography of John Henry Hauberg, Junior.* Seattle: Pacific Denkmann Company, 2003.

"Have We an Indigenous Architecture?" *Architectural Record*, April 1953, pp. 140–145.

Henderson, Justin. *Roland Terry: Master Northwest Architect.* Seattle: University of Washington Press, 2000.

Herman, Lloyd E. *Looking Forward, Glancing Back: Northwest Designer Craftsmen at 50.* Bellingham, WA: Northwest Designer Craftsmen in association with the Whatcom Museum of History and Art; Seattle: University of Washington Press, 2004.

HistoryLink.org: The Online Encyclopedia of Washington State History. www.historylink.org.

Hoffman, Marilyn. "Multilevel house displays art." *Christian Science Monitor*, December 7, 1966, Women Today, p. 22.

Humanities Conversations (interview with Anne Gould Hauberg). Produced by Marty Wilson. Videotape. Bellevue, WA: Bellevue Community College, 1982.

Institutes for the Achievement of Human Potential, www.iahp.org/hurt/articles/who_is_brain_injured.html.

Jamison, Kay Redfield. "Manic Depression: A personal and professional perspective," presentation at the University of Melbourne, Victoria, Australia, July 26, 2000, www.unimelb.au/speeches/kjamison26july00.html.

———. "Manic-Depressive Illness and Creativity," *Scientific American*, vol. 272 (February 1995), www.wga.org/health/creativity_bipolar.html.

———. *Touched with Fire: Manic Depressive Illness and the Artistic Temperament.* New York: Free Press, 1993.

Johnston, Norman J. *The College of Architecture and Urban Planning, Seventy-Five Years at the University of Washington: A Personal View.* Seattle: 1991.

Kostof, Spiro, ed. *The Architect: Chapters in the History of the Profession.* New York: Oxford University Press, 1986.

Kreisman, Lawrence. "An Apartment for Art." Photographs by Richard S. Heyza. *Seattle Times/Seattle Post-Intelligencer,* Pacific Magazine, November 12, 1989, pp. 39–41.

———. "'An Armful of Flowers.'" Photographs by Greg Gilbert. *Seattle Times/Seattle Post-Intelligencer*, May 9, 1993, Pacific Magazine, pp. 22–27.

Larsen, Jack Lenor. *Jack Lenor Larsen: A Weaver's Memoir.* New York: Harry N. Abrams, 1998.

Lehmann, Hans, and Thelma Lehmann. *Out of the Cultural Dustbin: Sentimental Musings on the Arts and Music in Seattle from 1936 to 1992.* Seattle: Crowley Associates, 1992.

Lehmann, Thelma. "Art Interest Inspired Collection." *Seattle Post-Intelligencer*, Pictorial Review, October 22, 1961, p. 2.

Levine, Rabbi Raphael. *Profiles in Service: Stories of People Who Help People.* With Anne Barlow. Seattle: Evergreen Publishing, 1985.

"Looking Ahead on *Sunset*'s 75th Anniversary: *Sunset*'s editors talk to two dozen distinguished Westerners all involved with change, all involved with tomorrow. . . ." *Sunset Magazine*, May 1973, pp. 104–111.

Lukach, Joan M. *Hilla Rebay: In Search of the Spirit in Art.* New York: George Braziller, 1983.

Martin, Harry. *Contemporary Homes of the Pacific Northwest.* Photographs by Dick Busher. Seattle: Madrona Publishers, 1980.

Mills, David Douglas. "Living." *Seattle Times*, November 11, 1979, Pacific Northwest Magazine, pp. 38–77.

Nordness, Lee. *Objects: USA.* New York: Viking Press, 1970.

Northwest Designer Craftsmen. Seattle: Northwest Designer Craftsmen, 1976.

Ochsner, Jeffrey Karl, ed. *Shaping Seattle Architecture: A Historical Guide to the Architects.* Seattle: University of Washington Press in association with the American Institute of Architects Seattle Chapter and the Seattle Architectural Foundation, 1994.

Oldknow, Tina. *Pilchuck: A Glass School.* Seattle: Pilchuck Glass School in association with University of Washington Press, 1996.

Peck, Louisa. "Pacific Arts Center History," unpublished manuscript (privately distributed), Seattle: [2000].

Rhodes, Elizabeth. "Arts controversy: a matter of opinion that really matters." *Seattle Times*, June 22, 1980, p. E2.

Schwantes, Carlos Arnaldo. *The Pacific Northwest: An Interpretive History.* Lincoln: University of Nebraska Press, 1996.

Seattle Arts Commission. "Seattle Arts Commission Celebrates 25 Years: 1995 Annual Report." Seattle: City of Seattle, 1996.

Seitz, William. *Mark Tobey.* New York: Museum of Modern Art, 1962.

Washington State Highway Commission, Department of Highways. Twenty-Eighth Biennial Report, 1948–1960.

Watson, Emmett. "Emmett Watson's Fascinating People, Anne Hauberg: A 'Princess' to Many in Seattle." *Seattle Post-Intelligencer*, October 4, 1975, pp. A-1, A-8.

index

contributors

This important biography was funded by many in Annie's wide circle of friends and family. The Anne Gould Hauberg Book Committee and the University of Washington Press wish to acknowledge the following individuals, foundations and businesses for their generous support.

benefactors

Nancy and Buster Alvord
Priscilla Beard
Dale and Leslie Chihuly
Committee of 33
Sue Bradford Hauberg
Fay P. Michener
Nathaniel B. Page and Fay Hauberg
 Page, Catherine B. Page,
 Benjamin H. Page
Derek R. Paulson in memory of his
 mother Janet McDonald Paulson
Victoria and Gary Reed and the
 Kulakala Point Foundation
The Russell Family Foundation
Jon and Mary Shirley
Virginia and Bagley Wright
Wyman Youth Trust

patrons

Don and Jane Abel
Eve and Chap Alvord
Lucius and Phoebe Andrew
Becky and Jack Benaroya
Alan and Sara Black
T. Wm. and Beatrice Booth
Paul and Debbi Brainerd
Beth and Mike Davies
Mary Davis and Doug and Kit Granum
Mildred K. Dunn
Jim Egbert
Lyla Fluke
Polly Friedlander and Robert Thurston
Peter and Hope Garrett
Katharyn Alvord Gerlich
Vicki and Gary Glant
Gretchen Nott Gould
Laura Ingham
William P. and Ruth L. Ingham
Nancy Kinnear
Leonard and Norma Klorfine
 Foundation
Jackie and Skip Kotkins
Patrick Kuo
Alida and Christopher Latham
Mark Levine Foundation
John and Burdette McClelland
Methodologie
Nancy S. Nordhoff
Margaret and Philip Padelford
Margaret L. Perthou-Taylor
Cyndie Phelps in memory of her
 mother Patty Phelps
Greg Robinson and Steve Charles

Lee and Stuart Rolfe
Sam and Gladys Rubinstein
Sam and Gladys Rubinstein
 Foundation
Herman and Faye Sarkowsky
Martin Selig
Dottie Simpson
Janet and Peter Stanley
Bill and Bobby Street
Aron and Sara Thompson
Thurston Charitable Foundation
Anne Traver
William Traver
George and Wendy Weyerhaeuser
Thomas T. Wilson
H. S. Wright III and
 Katherine Ann Janeway
Ann P. Wyckoff
Deehan Wyman
Virginia Wyman and Joe McDonnal

supporters

Ken and Marleen Alhadeff
Michael and Marjorie Alhadeff
Robert M. Arnold
Wyn Bielaska
David and Inez Black
Jerry L. Dahlke
David and Jane Davis
Hugh and Dee Dickinson
Mary and Jim Dunnam
Meade and Deborah Emory
Kim, Michelle and Marika Gould
Pamela K. Green
Lynn and Barbara Himmelman
Ro Ho
Lucia Lawrence
Thelma Lehmann
Karen Lorene
Mia McEldowney
Beverly McKoin and George W. Martin
Carol F. Padelford
Mimi Pierce
Susan Steinhauser, Dan Greenberg
 and the Greenberg Foundation
Janet Taggares